EISENHOWER PUBLIC LIBRARY

3 1134 00339

MW01204402

DUSTY DIABLOS

FOLKLORE, ICONOGRAPHY, ASSEMBLAGE, OLÉ

MICHAEL DEMENG

NORTH LIGHT BOOKS

Cincinnati, Ohio

Michael deMeng
Oaxaca, Mexico

Dusty Diablos Copyright © 2010 by Michael deMeng.
Manufactured in China. All rights reserved. No part of this
book may be reproduced in any form or by any electronic or
mechanical means including information storage and retrieval
systems without permission in writing from the publisher,
except by a reviewer, who may quote a brief passage in review.

Published by North Light Books, an imprint of F+W Media,
Inc., 4700 East Galbraith Road, Cincinnati, Ohio 45236.
(800) 289-0963. First edition.

14 13 12 11 10 5 4 3 2 1

Distributed in Canada by Fraser Direct
100 Armstrong Avenue
Georgetown, ON, Canada L7G 5S4
Tel: (905) 877-4411

Distributed in the U.K. and Europe by David & Charles
Brunel House, Newton Abbot, Devon, TQ12 4PU, England
Tel: (+44) 1626 323200, Fax: (+44) 1626 323319
E-mail: postmaster@davidandcharles.co.uk

Distributed in Australia by Capricorn Link
P.O. Box 704, S. Windsor, NSW 2756 Australia
Tel: (02) 4577-3555

Library of Congress Cataloging-in-Publication Data

deMeng, Michael.
 Dusty diablos / Michael deMeng. -- 1st ed.
 p. cm.
 Includes bibliographical references and index.
 ISBN-13: 978-1-60061-350-0 (pbk. : alk. paper)
 ISBN-10: 1-60061-350-0 (pbk. : alk. paper)
 1. Handicraft. 2. Found objects (Art) 3. Mexico--In art. I.
Title.
 TT149.D448 2010
 745.5--dc22

Editor:
Tonia Davenport

Designer:
Geoff Raker

Production Coordinator:
Greg Nock

Photographers:
Christine Polomsky,
Ric Deliantoni

Photostylist:
Jan Nickum

fw
media
www.fwmedia.com

Dedication

To Judy
(a.k.a. bebe)

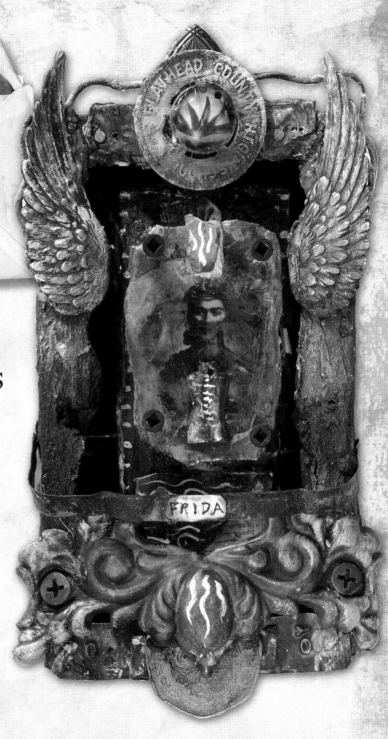

Acknowledgments

This was a very special book for me to write. It is always special when you can share something (or someplace) that you care about. So, special thanks goes out to all those people who, through the years, have made my experiences in Mexico nothing short of magical: Steve, Bev, John, Kathy, Paula, David, Cindy, Juan, Colleen, and all the great students who come to Oaxaca every year with me to celebrate Dia de los Muertos. A special thanks goes to my editor Tonia for her help in making this special book a possibility. Salud!

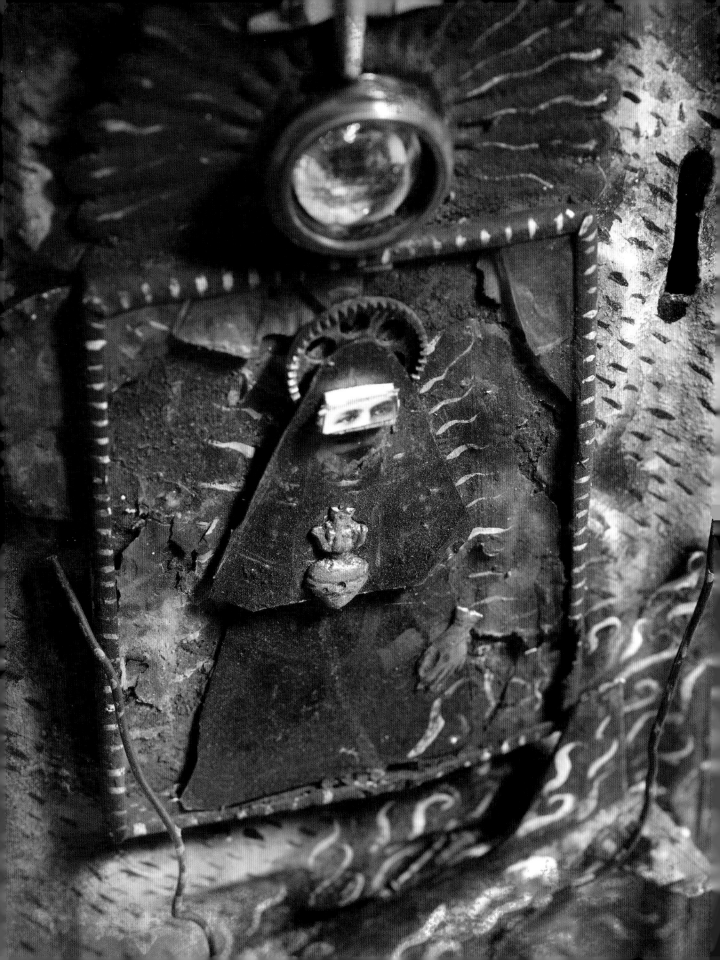

CONTENTS

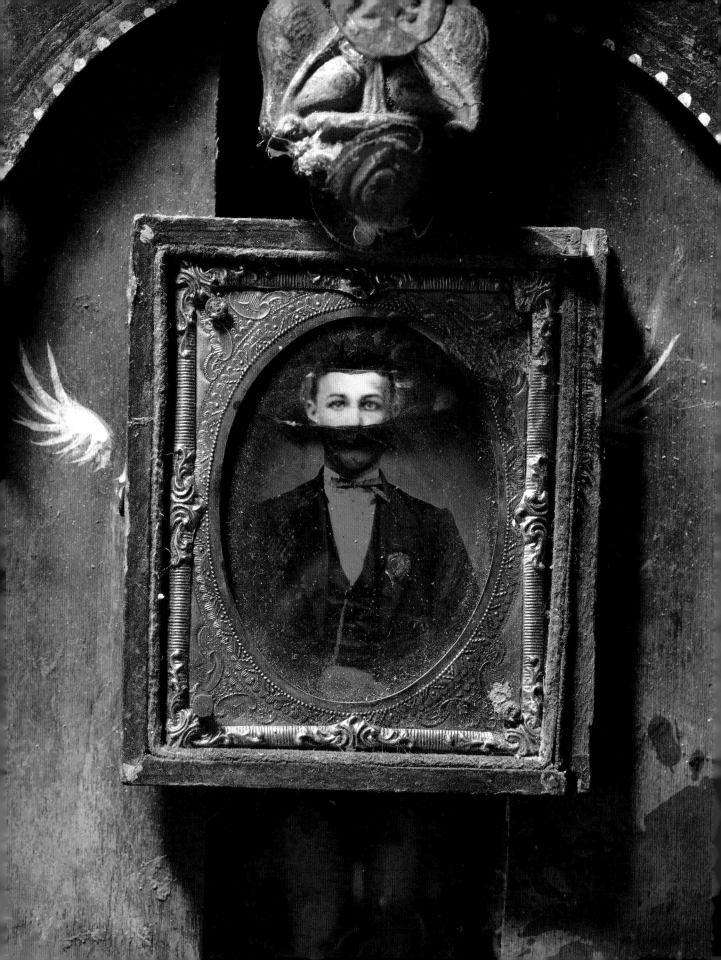

A Gringo in Mexico

AMBROSE BIERCE, a famed journalist from over a century ago, wrote, "If you hear of my being stood up against a Mexican stone wall and shot to rags, please know that I think that a pretty good way to depart this life. It beats old age, disease, or falling down the cellar stairs. To be a Gringo in Mexico—ah, that is euthanasia!"

I've often pondered this quote—not as my own mantra but because it reminded me of someone that I think felt exactly this same way—a University of Montana art professor, Don Bunse. A quiet little instructor who would wander around the Life Drawing class, periodically saying, "That's a keeper" as someone manically sketched away.

Don died in 1994, but as I wrote this book I found myself thinking about him often because he had quite a lot to do with my passion for Mexican culture. I had just graduated from the University and wanted to travel. He said, "You need to go to Oaxaca. You NEED to go." Don had just spent some time down there involved with an artists' exchange from Montana, and fell in love with the place. So, on his advice, I went, and yes, it was the most formative art experience in my life. I found Oaxaca miraculous; a "Latin-American Paris," where the contemporary and ancient arts mingled and a place where music and life filled the air. As for the artistic lighting, sorry Tuscany, you got nothin' on this place.

After Don's retirement from the university, it was his goal to move to Oaxaca. I remember speaking to him and he had it all planned out. He kept talking about how happy he was when he was there. Unfortunately, not long after that conversation, Don passed away. He had been ill for some time, and it has always saddened me that he never made it to Mexico to spend his last moments as an artist. To be a gringo in MexicoIt would be inappropriate to say that Don wanted to go down there to die—rather, he wanted to go down there to live. He wanted to go down there because it made him feel *alive*.

And this is why it was so important for me to write this book. Like Don, Mexico makes me feel alive and I want to share some of that magic with you. I want to show you some of my favorite haunts and allow you to relive with me some of my most memorable adventures. I want to share some of my inspirations, experiences and creations associated with a place that has become part of my soul. Every artist needs to find a method to replenish creative juices, in my case, Oaxaca is where I go to drink from the artistic "Fountain of Youth".

Funny thing is, whenever I return, I feel like my old mentor Don is there, too. I sense that he is lurking in some café, invisibly drinking his vodka tonics. I hope so. That is where he belongs, and if so, maybe someday I'll join him for a drink.

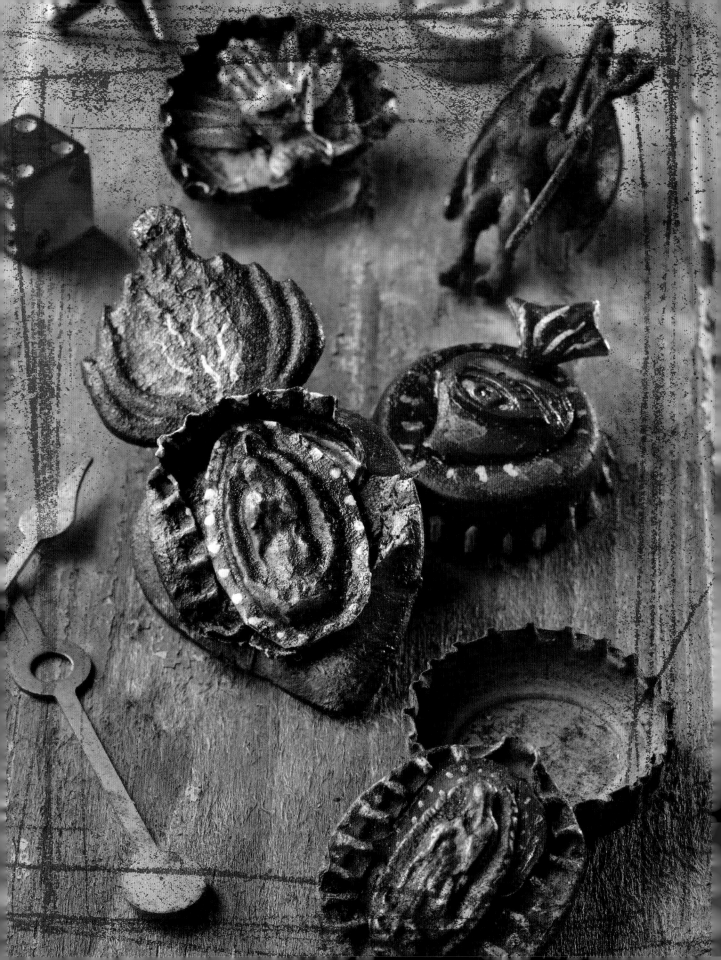

Bottle Cap Milagros

Everyone needs a good miracle now and again. Milagros are symbolic of just that—little emblems that represent a wish or a prayer. These tiny, metal, devotional charms depict a variety of symbols, which stand for a variety of ailments or needs. There are little eyes for those ailments associated with sight. There are little lungs for breathing problems, and, of course, little hearts for not only heart disease but also romantic ailments. If you're a farmer you may need to make sure your cow stays healthy to produce milk, so a little cow charm might come in handy. A full range of these little charms are used to give a boost to one's wishes or needs.

I should mention an interesting story. I met a woman who now lives in Toronto, but was born in Mexico. She, of course, was very familiar with Milagros and their uses, and she set out to collect them. Now it would be easy enough to go online or go to a store and purchase whatever Milagros she wanted, but she had a mission. She would go church to church, claiming she had an ailment or need and would be given a Milagros for the need. It wasn't that she was cheap; it is just that she wanted to go through this process. It made it more legitimate, even though there was a bit of fibbing going on. After hearing about that process, I was fascinated, mostly because of the artistic merit of the process. It's one thing to buy an object; it is quite another thing to earn it through the procedure. In fact, I thought that I, too, would go on a similar Milagros quest, but I chickened out. My superstitions got to me. I started to think that to ask for a charm to cure an ailment that you did not have might be pushing the karmic envelope. So my quest never occurred. As for my friend, well, as far as I know, she suffered no bad mojo. Then again, maybe she did, but if she did, the Milagros she acquired might have kicked into gear and eradicated any ill effects as quickly as they came. You never know.

Bottle cap quest

Let me pose a Seinfeld-ian question, "What's the deal with Mexican bottle caps?" I have seen my share of American bottle caps and I can't say they look anything like the ones I find south of the border. What I'm talking about are those nice rusty ones that are squooshed into interesting shapes. I often use old bottle caps in my art, and, try as I might to replicate the effect, I always fall short. So, on my last journey to Mexico I decided I needed to get to the bottom of this mystery. Some of you may remember the Leonard Nimoy series *In Search Of.* In search of the Loch Ness Monster, UFO's, Bigfoot Well that was me on this last trip. In Search of the Oxidized Smooshed Mexican Bottle Cap.

So what makes the Mexican bottle cap so different from the North American breed? Well, at first I thought it was the material. I figured that perhaps American bottles used aluminum since it doesn't rust. So it was time to go to my studio and try a little mad scientist action.

For this experiment you'll need:

- Bottle of beer (just get a six-pack)

- Lime cut in wedges (this is for beer made in Mexico. Science doesn't always have to be so serious. Some of the world's greatest scientific discoveries were made under the influence of beer. OK, I made that up.)

- Homer Simpson bottle opener—the kind that says "D'oh!" when you open the beer

- 1 cup vinegar

- 1 cup hydrogen peroxide

- bottle caps (Mexican, if you feel like taking a trip to Mexico to do your own hunting; and also American—for which you can just use the ones from the six-pack.)

- Spoonful of salt

- Chips and salsa

- *Lord of the Rings* trilogy DVDs (this experiment may take awhile, my precious)

Take the vinegar, salt and hydrogen peroxide and put it all together in a container. Add bottle caps. For my experiment I threw a few different beer brands in the mix to see if this made a difference. I got a little nervous that the paint on the top of the bottle caps, as well as the plastic coating inside, might prevent the experiment from work-ing so I set a few aside to heat with a torch. (You could also throw them on the barbeque grill.) If you try this, do the torching outside. You never know what sort of fumes might come off this stuff. Okay, time to start the movie and let the rusting stuff do its work.

One hour later: Liquid mixture has turned a murky, rusty-red color with a white froth floating on top. Also, I notice a vinegar smell . . . oh, I guess that makes sense. Unheated bottle caps have no change. Torched bottle caps, starting to darken. Not really rust-colored but a dark gray, though hints of a pale red starting to appear in some spots.

My beer is empty.

Need more salsa.

Frodo is bummed about leaving the Shire.

Four hours later: Liquid is blood-red—*purdy*. Unheated caps—still no change. Torched bottle caps turned rougher and a darker gray.

I'm stuffed—can't believe I ate a whole bag of chips

I wish Sam would just call Frodo "Frodo." What's with this Mister Frodo stuff?

What seems like a million hours later: Liquid is a thicker blood-red. Unheated: no change. Torched: a gradual darkening still.

Have Frodo's eyes gotten bigger?

Now I remove my little old caps from the solution and see what happens. The torched caps turned a nice orange-rust. Unheated caps are the same as when I put them in.

Conclusion: Based on this highly-controlled experiment, two things seem clear. One, bottle caps acquired in the USA must be roughed up or heated in order to rust. Two, Mexican bottle caps are more cheaply made and more prone to rust.

The One Ring in the film would most likely not be affected by my vinegar/salt/hydrogen peroxide mixture.

Hypothesis: the One Ring is made from the same material as American bottle caps.

Okay, knowing what I now know, I headed to Mexico in search of bottle caps. (Okay, I'll admit, I was already going—it's not like I took a special trip in the name of science.)

Sure enough, wandering through the streets I find that bottle caps abound. I gather a bunch up. It is apparent that they are pretty roughed up and therefore, based on my experiments, more prone to rust. Cars and pedestrians must wear these little guys down to make them more likely to oxidize. Therefore, streets are not swept as often in Mexico, thus allowing time for the change to take place, but as I was pondering this, I saw a man in a cowboy hat sweeping an adjoining street with an old-fashioned broom (the kind that looks like a bunch of branches tied together). Okay . . . so my next assumption was that those brooms aren't as effective. Wrong. After a quick inspection of the street the man just swept—spotless, and NO bottle caps. Hmmm. Maybe the street I was on isn't maintained or cleaned? It is pretty spotless and I know I have seen the sweepers on this street. Then it dawned on me. This was the biggest "Duh" ever. Cobblestone. Of course. Where I was finding bottle caps were in the nooks and crannies of the cobblestone. It made perfect sense. They get caught in the cracks and cars, shoes and even brooms wear them down, so any paint or protective coating is worn off. It is only after this, that the process of oxidation can do its thing. Suddenly, I knew where to hone in on my Mexican bottle caps.

Photo: Connie Cox

Bottle-Cap Hunting Tips

- *Cobblestone streets are prime hunting ground. Rough sidewalks or public courtyards can also be good.*

- *The less touristy the area, the better, for two reasons: One, they are less likely to get swept as often, so there's more chance of finding these little treasures; two, there's less chance of competition. Other American tourists who may also have Mexican-bottle-cap fetishes can reduce your booty.*

- *Look up once in awhile. Walking into sign posts, other pedestrians or cars can be a problem.*

- *If you come across other hunters and gatherers, be courteous. No tackling.*

- *Purchasing a twelve-pack of Corona and parking yourself on a Mexican sidewalk with the intention of starting your own harvest might just land you in less pleasant accommodations—at least for a night.*

- *Don't put your bottle caps in the same pocket as your digital camera or phone . . . I've got some nice scratch marks to show you why this is a bad idea.*

- *Don't worry if the locals look at you weirdly; after all, you're looking for bottle caps for crying out loud!*

- *Not everything brown on the ground is a bottle cap.*

Milagros Bottle Cap

So what on earth do you actually do with your newly-acquired plethora of rusty caps? Of course, there are many embellishment options when it comes to creating art, but one of my favorite uses for bottle caps is making little Milagros out of them.

Stuff You Need

rusty bottle cap (see note about American vs. Mexican, page 10)

Milagros

epoxy

charm

Dremel tool

acrylic paint (your choice)

paintbrush

water

heat gun

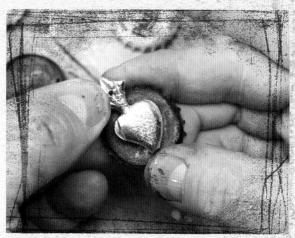

1 These nifty little embellishments are created to go on larger pieces. For this example, I first glued a heart Milagros to the top of a cap, using epoxy.

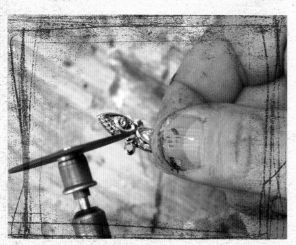

2 I'm now dissecting a charm that had two eyes, because I want only one. I use the Dremel to cut the charm.

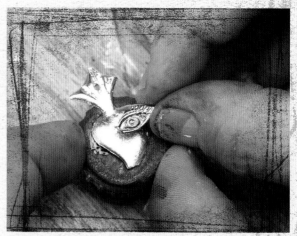

3 Then, I glue the eye to the heart.

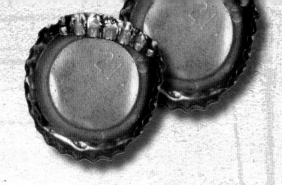

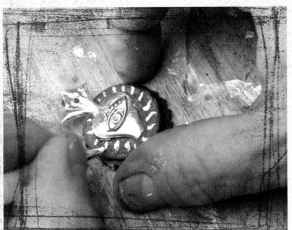

4 I will now start adding some paint details, like these squiggly lines, but feel free to add whatever works with your own charm.

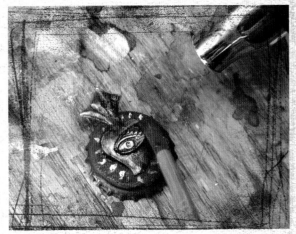

5 Next, add a wash of paint. (See pages 22–25.) I chose Serial Killer Red, but again, the choice is yours. Here I'm heat-burning it on, using a heat gun.

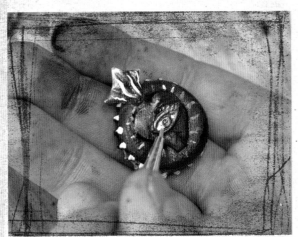

6 Add any final details, such as these veins on the heart and some highlights to the eye.

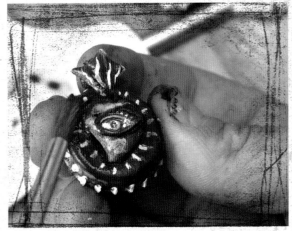

7 And finally, a Warm Uszhhh wash over the whole thing. (See page 23 for more on the Uszhhh.)

Make it Rusty

Needless to say, I enjoy far more rusty things than just bottle caps. When I can't leave something in the street for a few months to get a nice natural rusty look supplied by time, I often resort to "forced rust" as an alternative. Even skeletons can rust—who knew?

Stuff You Need

object to rust

metal paint (Modern Options, Iron)

rusting solution (Modern Options)

paintbrush

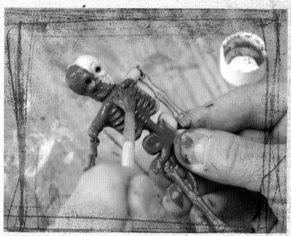

1 To rust something, begin by giving it a coat of metal paint. Here I am using iron paint.

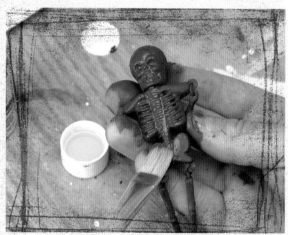

2 When the piece is dry or almost dry, brush on the rusting solution.

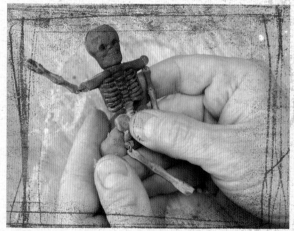

3 Set the piece aside for the solution to take effect. After several hours, you will see the rustyness come to fruition.

14

On Blackened

You won't find too many shiny, new-looking elements in my work, and blackening solution is often just the, well, solution, to getting a great tarnish on something that is fresh out of the package.

Stuff You Need

shiny metal charm

blackening solution (NovaBlack)

small brush

sanding block

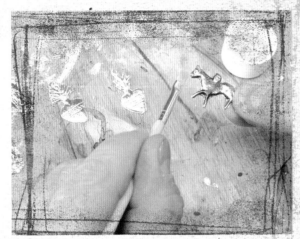

1 Shiny charms can be instantly aged by brushing blackening solution such as NovaBlack onto them.

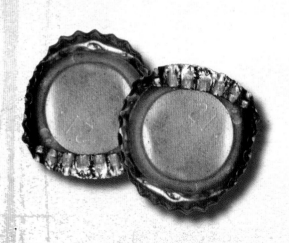

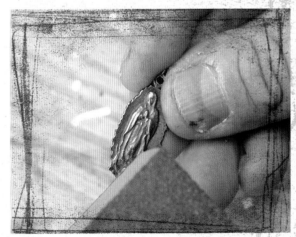

2 If they end up too black, you can always go back in and sand them to polish and bring back their original shine in the raised areas.

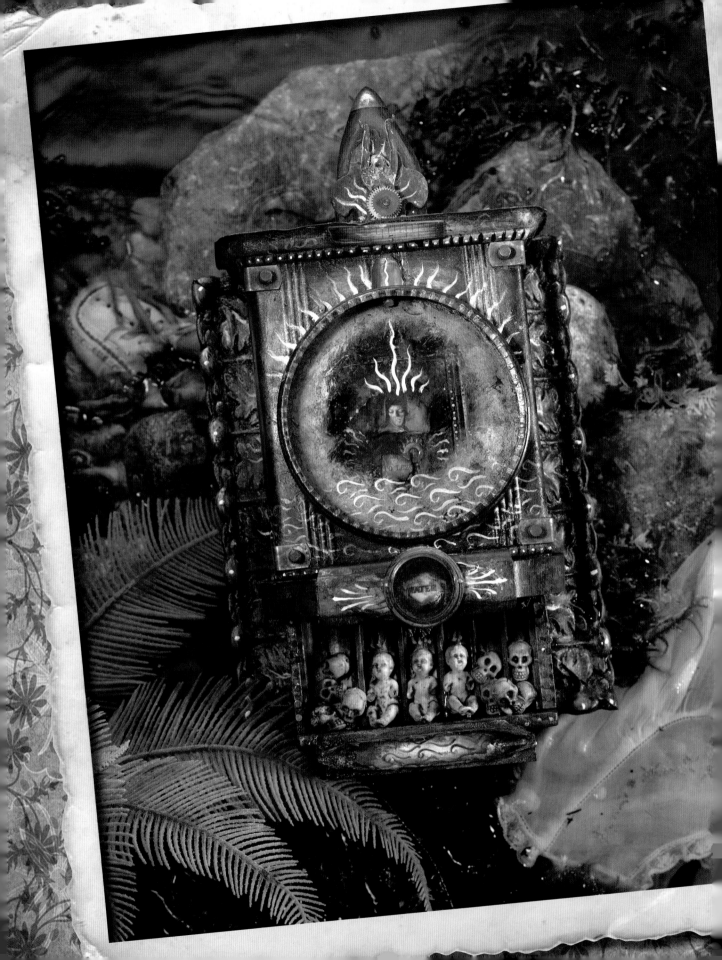

La Lloróna

This sad story has several different versions throughout Mexico and Latin America, but the basic idea is the same in each of the tales.

The version of the Lloróna legend that was first told to me involves a beautiful Mexican woman that I will call Maria. She was a widow with three children who was left in poverty after her husband's death. Exhausted from a life of wanting, she decided to find a suitor to help elevate her status and means. Eventually, she found a handsome—and more importantly, wealthy—man that struck her fancy. At first he reciprocated the interest and Maria's goal seemed realized. That was, until she mentioned her three children. At that point the nobleman's romantic inclinations vanished, and he told her that he could never raise another man's children. The widow was filled with despair. In a moment of madness, she gathered her children and took them to the riverbank where she drowned them. After this horrible deed, she returned to the nobleman, telling him that she was now free of her children. Horrified, the man fled. It was at this point that Maria realized her dark deeds. Panicked, she rushed to the river to find her children. They were gone. Crying out, "Ay, mis hijos!" (Oh, my children!), Maria threw herself into the river and drowned herself. Condemned to wander the waterways searching for her children she became the spirit, la Lloróna. It is said that she is garbed in white or black, and can be heard wailing. Children playing at the water's edge, beware, because it is said that la Lloróna confuses them with her own drowned offspring.

La Lloróna is one of the most famous ghost stories in Mexico and Latin America. Interestingly enough, I came across a place outside Mexico City that seemed to be somewhat connected. It was called Isla de las Munecas (The Island of Dolls) and it was downright creepy. This little island is situated in the sole tributary, which, during and prior to the Aztec empire, was Lake Xochimilco. Back in the 1920s, three young girls were playing on this island and one drowned. Since that time, the place is said to be haunted by the ghost of the young child. A hermit named Don Julian moved to this place and started hearing the ghost of the child. To ward off (or perhaps as a way to befriend) her spirit, he started adorning the island with dolls. It is said that he scoured trash heaps for old dolls. Apparently, his story became known, and later he would trade produce that he grew on the island for dolls. Now thousands of dolls decorate the island. Don Julian passed away in 2001, but his nephew is now the caretaker of this unusual place.

I took a special trip to Mexico just to see this place. I had just finished the la Lloróna piece for this book and by happenstance I heard of this unusual place. I needed to go. After having worked on a piece of art that related to the sad tale of la Lloróna, I couldn't help but to think the little girl who drowned on the island might have been a victim of this legendary "wailing woman of the waterways."

To get to this island you must go to the area of Xochimilco and catch a gondola-type flat boat. These boats are painted extraordinarily bright—even by Mexican standards. It's a two-hour trip up the canals, past other boats that occasionally nestle up to you, offering food, drink or serenades from mariachi bands.

During my ride, after a nice leisurely float, I suddenly heard a large number of birds

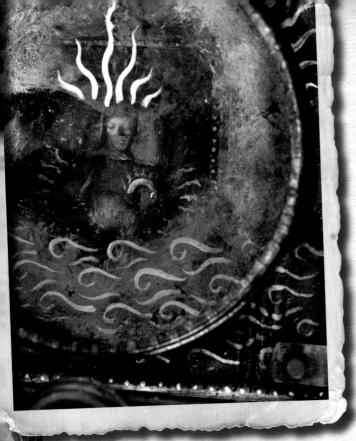

was that they were all in various states of decay. Some were burnt, some were bleached from the sun, and some were covered in webs. In all cases they were definitely a bit disturbing, to say the least. Nighttime would be an interesting experience . . . especially for the easily spooked.

Initially, I wandered around the island with a tongue-in-cheek attitude. It was an amazing bit of Mexican kitsch that was difficult for me to take too seriously. After some time, however (I spent two hours on the island photographing it), my perspective changed a bit. I started admiring the ritual behind the place. I started thinking that perhaps, being a hermit, Don Julian had been more comfortable with dolls and a ghost than he would have been with other people around. I started to admire his devotion to the deceased girl, and wondered if in some ways he didn't adopt this spirit. Did he do this because he feared the ghost, or because he befriended the ghost? The more I thought about it the more I was left with questions.

And the more time I spent on the island, the more saddened I became—perhaps because I have always found discarded toys heartbreaking. Something of childhood lost, I think. But what I really found interesting was that I started noticing relationships between the dolls. I started noticing how they seemed to have interesting gestures towards each other. It reminded me of the frozen poses of Pompeii; unmoving gestures held for eternity—final gestures. For me, the dolls were no longer seen as playthings left as offerings, but rather, the ghost-child herself, and this saddened me more. Perhaps there is a ghost here, and perhaps la Lloróna did once wander the shoreline. I can't really say this place is haunted or not, but what I can say is that this place is haunting—in a beautiful way—because this is an unusual place where the living and the dead play together.

screeching. As they did, we turned a bend and there was the island. Was that really the sound of birds, I mused? Or was it the dolls sounding a warning? Perhaps it was la Lloróna herself . The dock was adorned with dolls—most prominently, an oversized Barbie. The nephew of the late Don Julian greeted me and walked me into the museum. I use the term "museum" loosely because it is really a rough structure with a dirt floor, dolls hanging everywhere and spiders. In the center of the room was a shrine with a large Patty Play Pal doll sitting in the center. She was adorned with all sorts of items, such as rosaries, ribbons, necklaces, glasses and a hat. She was apparently the symbol of the little girl who drowned. At her feet was a pile of items including dolls, mementos and religious cards left by visitors as an offering.

Dolls of every shape and size covered this tiny island. Some were just arms, or torsos; others, just heads. What was great about these dolls

Process

I knew right off the bat what I was going to use when I started la Lloróna. In my stash I had an old-fashioned flashlight—more of a lantern, really. The kind with a large plate-sized lens and a handle. At the time I began thinking about this piece, I didn't know why I wanted to use it; I just knew that I did. Now as I write this, it dawns on me: La Lloróna is searching for her children, so what could be more perfect? It's funny how the subconscious mind is always chugging away, even without your knowing it. For me that's part of the fun. More often than not, I find symbols in my work after I've finished—sometimes years after I've finished. Someone will say something, or I'll read something and the lightbulb goes on: Oh, that's why I did that!

The other things I knew I needed were three children dolls or figurines. My concept was that la Lloróna would be behind the lens of the flashlight, and on the lower portion I'd have three children, symbolically sub-aquatic. Behind the lens I concocted a collaged wailing woman. (Perhaps in this case, not so much wailing as sad, and eyes down as if scanning the shoreline.)

One mention of my idea to my partner Judy Wilkenfeld, and next thing I knew, I had a care package straight from Australia. In it I found some porcelain "frozen Charlotte" figures and three figurines of seated toddlers. Originally, I thought of using something made of white porcelain; the whiteness, I thought, would give it a ghostly quality. Seeing the figurines in the care-package confirmed my idea. I decided on the seated figurines because they seemed to have more emotion behind their gestures.

I found an ancient drill-bit holder for extremely large bits. It had nice long slots along which I could seat the babes. With a few screws and, of course, some glue, I attached the wooden holder to the bottom of the flashlight lantern. I started adding the babies and they seemed so re-laxed in their poses. It was at this point I decided to stir it up a bit. I found some skeletal toy parts and laid them in the nooks beside the seated figurines. I loved the contrast of the children with the skeletons. It was like they were resting on the bottom of the riverbed—perfectly at home with other dead souls.

Various other items were added and then I got ready to paint. I wanted this piece to be cool. (Not in the "groovy" sense of the word, but in color tone.) I envisioned very pale blues—icy, dirty, blues. I didn't want to lose the white of the figurines, yet I wanted to make them seem not only under water but also give a sense of death. I had the perfect color combo for that: I call it Goth-ish Black—a water wash of Van Dyke Brown mixed with Anthraquinone Blue. Van Dyke Brown is one of my recent color acquisitions—a rich translucent brown. Anthraquinone Blue is also translucent and is a blue somewhere between Phthalo Blue and Ultramarine Blue. In combination they create a black, but the sort of black you'd see under moonlight—a "Tim Burton" black, if you will: dirty yet with the coolness of the night. (I just realized I should write for some J. Peterman-ish art catalogue.)

I applied this wash-of-the-night to the toy bones and babes, and I made sure it was nice and watery. I quickly took a towel to sop up some of the extra paint. I wanted the nooks and crannies filled with paint but I also wanted some of the glow of white to show through. When I got them to the right coloring they were perfect. The feature of the faces showed up nicely after the excess paint was removed.

For the most part, the piece was finished. One thing I especially liked was the subtle change of color from the mother's realm to the children's realm. La Lloróna seemed isolated in her cursed environment, while her children, though close, were lost to her forever.

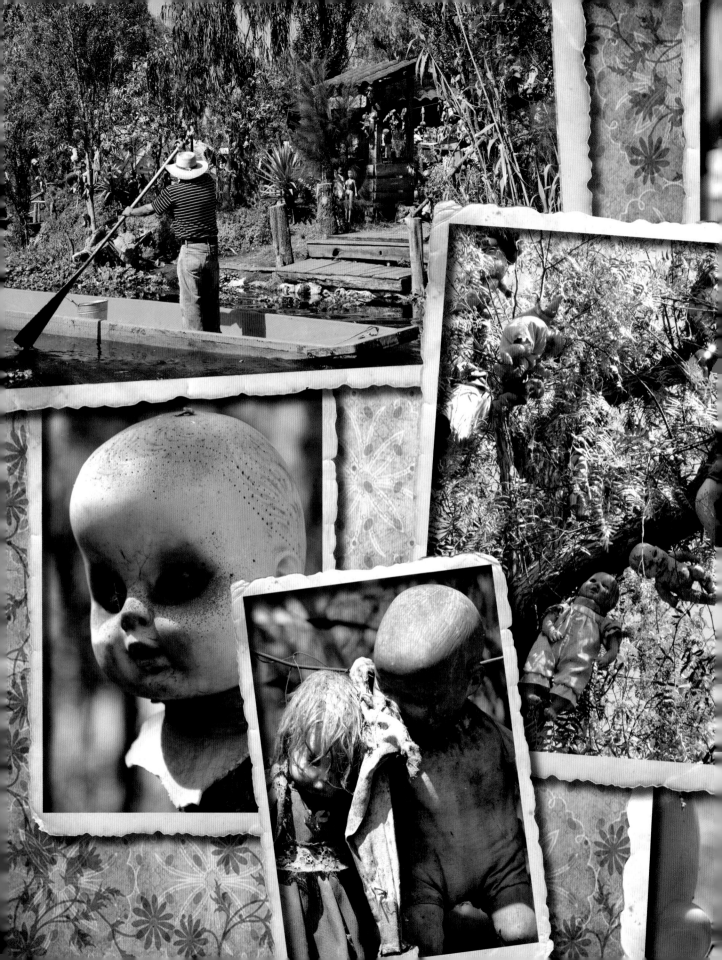

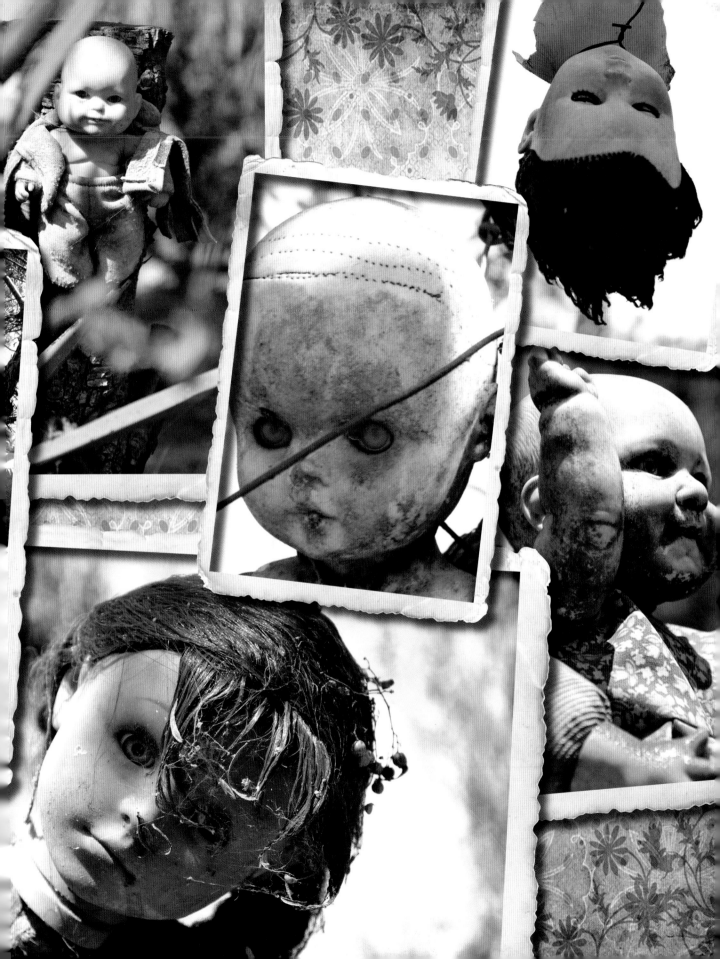

Paint Washes

Washes are a great way to add depth and interest to your work. I like to make a wash over a surface that has a lot of texture because I like the effect that's created when the color pools into nooks and crannies.

Stuff You Need

clear or white caulk

heat gun

white acrylic paint

paintbrush/water

Mars Black acrylic paint (Golden)

Quinacridone Gold acrylic paint (Golden)

Van Dyke Brown acrylic paint (Golden)

Anthraquinone Blue acrylic paint (Golden)

Dioxazine Purple acrylic paint (Golden)

Phthalo Green acrylic paint (Golden)

Quinacridone Crimson acrylic paint (Golden)

- - - - - - - - - - - - - - - - -

1. Begin by applying clear or white caulk to the surface and tap out some texture on it.

2. Heat with a heat gun until the caulk bubbles. Let dry and cool.

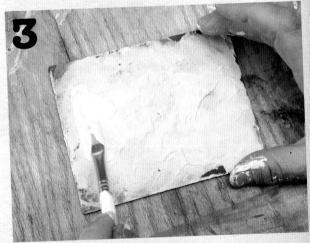

3. Add a coat of white paint over the textured caulk when it has dried.

Uszhhh

As in the usual. This is the color mix I have come to coin as the Uszhhh because it's what I *uszzz*-ually use. It's a combo of Mars Black and Quinacridone Gold.

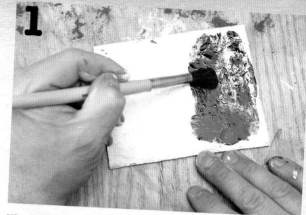

- - - - - - - - - - - - - - - - - - - -

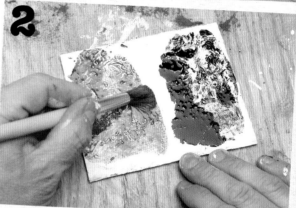

1. Heat the white paint until it is bubbly as well. To begin painting, apply a wash of black on one side.

2. Apply a wash of Quin Gold on the other side and mix the two together gradually.

3. Presto—Uszhhh!

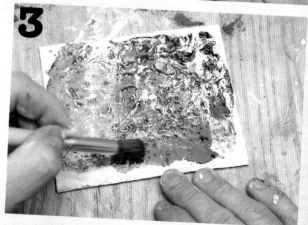

4. Another combination I like to create is Warm Uszhhh (a.k.a. Van Dyke Brown and Quin Gold).

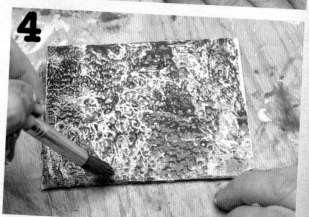

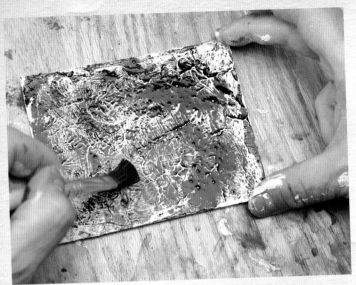

Gothic Black

Mix Anthraquinone Blue and Van Dyke Brown.

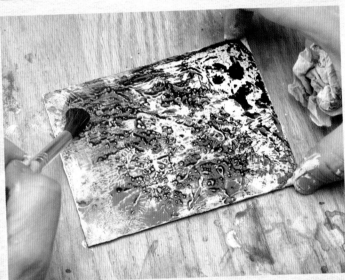

Midnight Garden

Mix Dioxazine Purple and Phthalo Green.

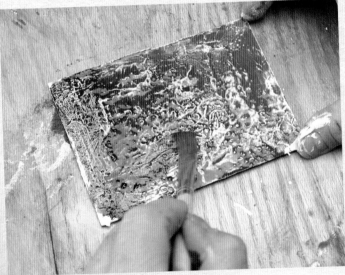

Serial-Killer Red

Mix Quin Crimson and Quin Gold.

Rusty Water
Mix Quin Gold and Dioxazine Purple.

Sea Wash
Mix Anthraquinone Blue and Quin Gold.

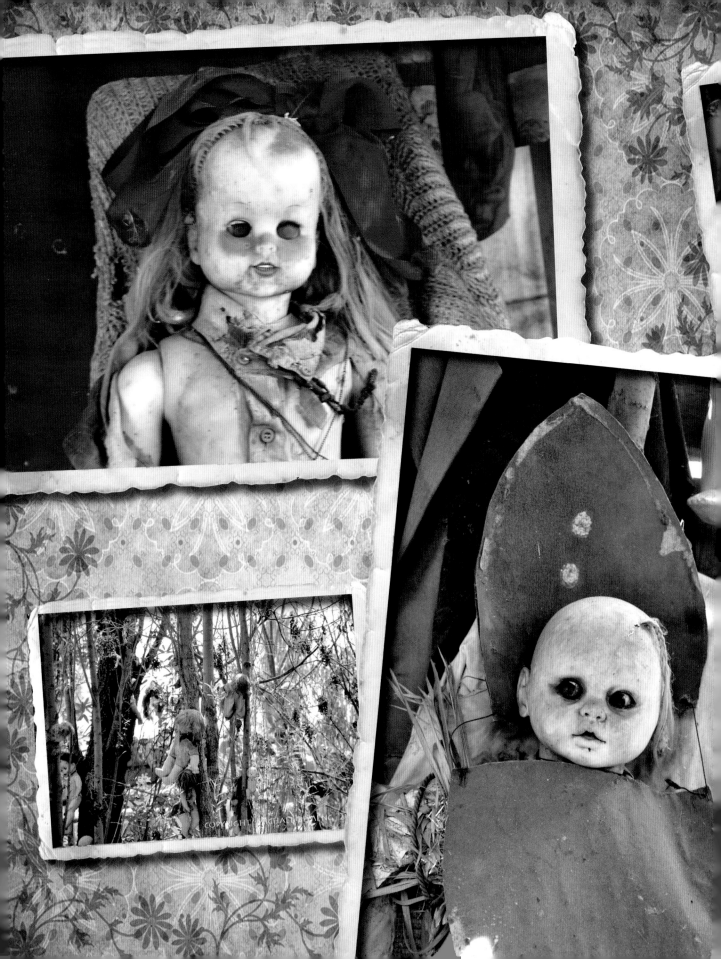

COPYRIGHT MICHAEL PAING

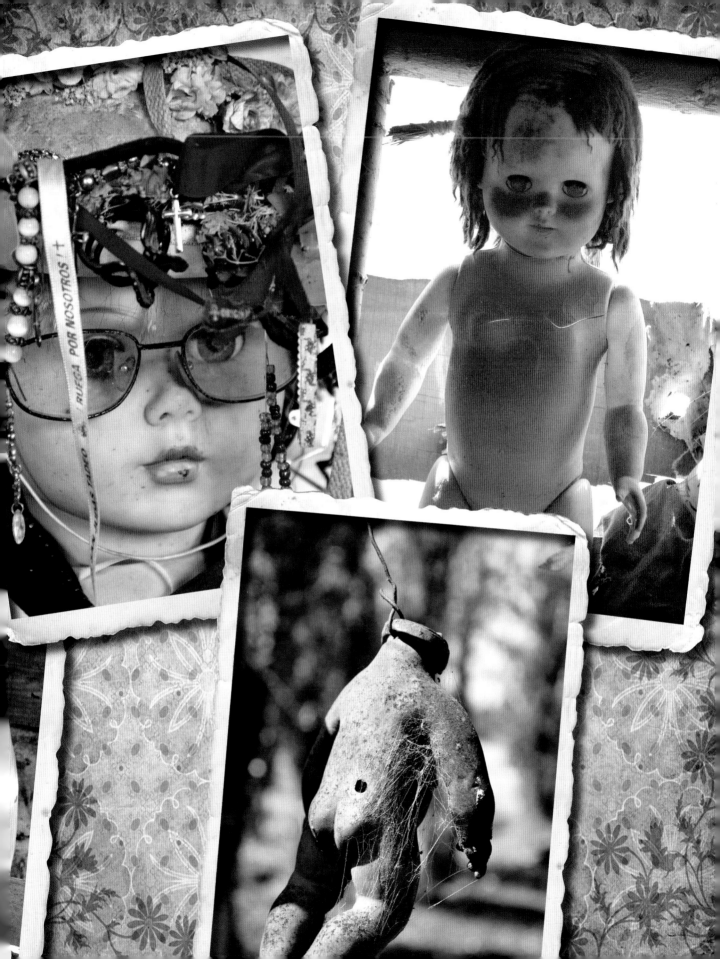

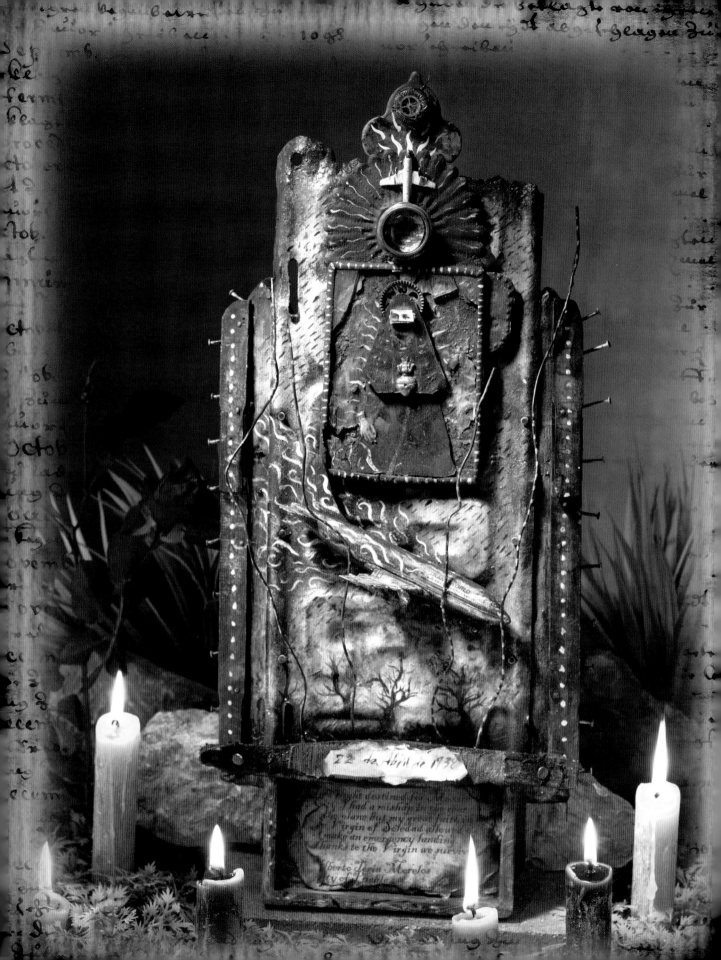

22 de Abril de 1938

...ght destined for...
...had a mishap in the river
...lane but my great faith...
Virgin of Soledad allowed...
...make an emergency landing...
...hanks to the Virgin we surv...
...berto Feria Morelos
...ty of Puebla

Ex Voto

Have you ever had one of those experiences where something bad was about to happen, and then something unexpected happened instead that changed what seemed to be an inevitable tragedy into an unexplained miracle? I remember being on the freeway, a number of years ago, in the Bay Area, driving along at excessive speed in the fast lane, when a car in front of me slammed on the brakes. This in turn led me to slam on my brakes. Next thing I know, I'm spinning. I'm spinning past the center lane, and out of the corner of my eye I see a large semitruck cruising along in the slow lane.

At this point, time was moving pretty slow, and I was being pretty rational. I had already accepted that the truck was going to plow into my side and no more me, but as I said I was pretty calm . . . at least on the inside. Next thing I know, I am stopped. I am facing the wrong direction and in front of me is that semi, also stopped about one car distance from my car. How he stopped, you got me on that one, but it is one of those strange moments where you feel that something reached in to intervene on your behalf.

I'm sure everyone has at least one moment that they can point to when that occurred in their life. Now in Mexico, there is an art form that addresses such events—ex votos. Ex votos are small paintings, typically on tin and often not much larger than twelve inches either direction. They are depictions of a moment of tragedy, or potential tragedy, that was thwarted by Divine Intervention. Somewhere toward the top of one of these tiny paintings would be the Saint responsible for the miracle. On the bottom is a written description of the miracle with the date and location of the event. This was an art form that really thrived in the 1800s. A miracle would occur, the recipient would convey the information to a local artisan who would in turn paint the scene with a written description. The ex voto would then be hung in a church with a simple nail in the top.

I remember being in a tiny church outside San Miguel de Allende that had an amazing ex voto collection. Some relatively new, some so old that rust had deteriorated the work in a very interesting way (which,

needless to say, was very appealing to me). It's extremely impressive to see these paintings when they are displayed in large collections. I mean, one ex voto—eh, big whoop—but the power of dozens upon dozens of these stories is moving, to say the least.

On my last visit to Frida Kahlo's home/museum, it dawned on me how much her work was influenced by this art form. It occurred to me in a stairwell that leads to her studio (which is one of the most amazing studios. I want to move in. Do you think they will let me?). Along that stairwell are dozens—maybe a hundred plus—ex votos. It was here that I saw how her paintings were her own votos, relating to the various tragedies of her life, most specifically, her accident. Not only are there conceptual consistencies, it also became apparent to me that aesthetically she even adopted the severe horizon line and the often overly-posed figures. She even occasionally has a little written something on the bottom of her paintings that is not unlike the descriptions in ex votos.

For those interested in collecting these little treasures: I have heard it said that Frida purrrrloined (as Catwoman, or, Mujer de Gato, might say) some of her collection from church walls. Well, I'm not going to recommend that. I have seen some amazing ones that I would die to have, but that would be some seriously bad mojo. That said, original ex votos are increasingly rare and/or expensive. The reason for their rarity has to do with the fact that they are painted on tin, and unlike diamonds, tin is not forever. I remember seeing an ex voto in a Oaxacan gallery for two-thousand pesos (at the time two-hundred bucks) and this thing was literally a crumbling third of its original size, and I'm sure that in a few years even more would crumble away. There are, however, artists who do replicas, and they do paint them on rusty tin, so that they have that authentic feel. Now before you go about poo-poo-ing the replica artists, I must say that they do play an important role. I own a number of replicas that tell quite a vast number of strange and unusual tales of Mexican miracles. Without these artists retelling the stories, these miracles would be lost like the rust that the originals are painted on.

Process

When I approached the concept of creating an ex voto, I initially thought that I would take an instance from my past and re-create it in this format. I then got to looking at my own ex voto collection and thought it might be fun to play the role of replica artist and transform one into a slightly three-dimensional version. Part of the reason for this change in concept had to do with a purchase I made in Mexico.

Obviously, I am always on the prowl for art-making fodder wherever I go; always looking for the good fleamarket or antique store. In Oaxaca there is a small little plaza filled with various artists selling everything from ceramics to paintings to weavings. In this plaza there is a dried-up circular fountain whose stone ledge acts as a showcase for antiques and secondhand goodies. It is manned by an elderly couple, and they always seem to have some great items. A few years back I purchased a beautiful wooden retablo with a little saint inside glass. One day I stopped by and an annoying American (other than me) was shopping . . . or should I say hoarding. I leaned down to look at some of the items on the ledge and he said, "Those are mine. I'm buying those . . . and those over there too." Knowing perfectly well that he probably wasn't going to buy everything, I looked to the elderly vending woman and rolled my eyes at the pushy man. She smiled and caught my drift. Next thing I knew, she said something to the American; the only word I recognized was something with the root "comprar": to buy. Apparently, she wanted him to figure out what he was definitely buying and what he wasn't. Flustered, he shot me an annoying wince, and gave up two thirds of his original booty. I ended up promptly purchasing quite a few of the recently liberated items—beautiful old Mexican apothecary bottles, old doll parts and some toy airplanes. Meanwhile, el Jerko still vacillated and watched intently as my items were wrapped up. He was annoyed; and that's okay because he was annoy-ing.

I mention this little exchange because I bought the airplanes because they reminded me of an ex voto in my collection involving a plane crash; fire billows out of the rear of the plane as it heads for the jungle below. Above floats the image of the Virgin of Soledad, my favorite, mostly because of her ensemble: an exaggeratedly triangular black dress with gold designs throughout.

One of the dilemmas I faced when confronting this project was trying to balance the traditional format with that of my style. I knew that I wanted the story written on the bottom, the Saint at the top and the action in the center. There is a storybook quality about this art form—almost childlike. So I thought a toy plane might be an ideal way to bridge this work into the third-dimension. To assist in this, I opted out of using a basic rust rectangle for a base and decided on something with a little more spatial oom-pah-pah—a license plate for a little subconscious reminder of the tactile world. This old license plate had been lying about for an eternity and the fact that I hadn't found something to do with it was beginning to annoy me, so this worked out well.

I started assembling. First the plane, then the area where I planned on putting the text. I decided instead of writing the story by hand, I would print it out and antique the paper so that it looks like parchment. The easiest way to do this was to burn the edges with a lighter and then use a really watered-down earth-tone wash over it. The best combo for this is the Uszhhh. It is important that the wash is really, really watery, because if it has too much paint it will cover over everything and make the text unreadable. If it needs to be darker, lay a wash down then dry it, then add another layer. Repeat until it is as dark as you need it. It is easier to darken than it is to lighten, so start light. Aside from changing the color, a light wash will also help age the paper by giving that nice water-damaged texture.

In this case, I decided not to do the burnt edges because there is a tendency for the burnt paper to flake off. Instead, I used what I call . . . The Tricky Burnt Paper Routine.

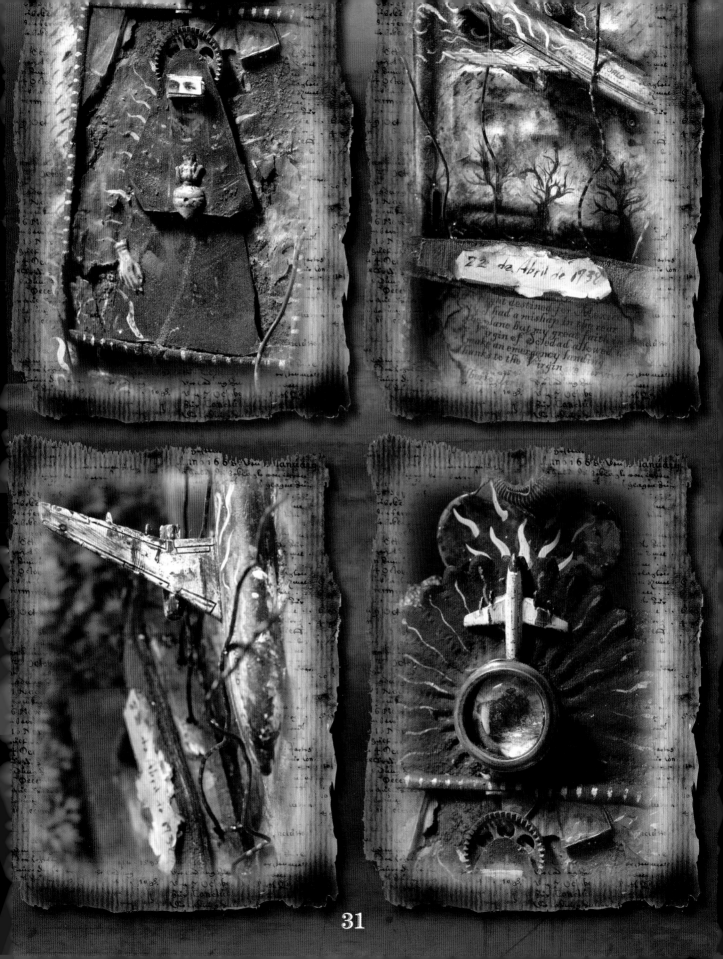

22 de Abril de 1938

I destined
I had a mishap in the rear
plane but my great faith
Virgin of Soledad allowed
make an emergency landing
thanks to the Virgin

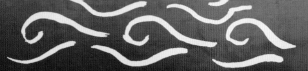

Tricky Burnt Paper Routine

Personally, I always enjoy the opportunity to risk a little fire hazard if there is one, but alternatively, I came up with the painting method of making paper appear singed without having to light up. Another bonus to this tricky routine: The finished product isn't as fragile around the edges as the real deal.

Stuff You Need

- paper to "burn"
- Dioxazine Purple acrylic paint (Golden)
- Quinocridone Gold acrylic paint (Golden)
- Mars Black acrylic paint (Golden)
- paintbrush/water

1 Find a piece of paper you want to look burnt. It can be old, but something brand-spankin' new will work too. Tear the edges. Make sure they are nice and uneven like fire might create.

2 Put a really, really, really watery wash of "Uszhhh" (see page 23) over the paper. You want this wash to be a "cat-pee yellow" color: less Quinacridone Gold and more black. Remember, lots of water.

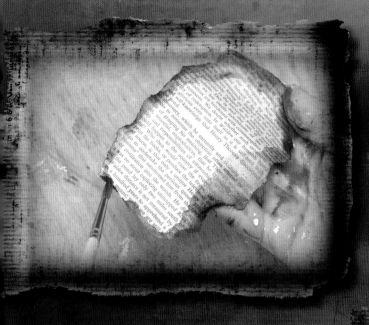

Dry the paper, which should buckle in an interesting way from the water. Take pure Dioxazine Purple and paint around the edge of the paper. Dilute it toward the center of the paper, using a watery brush—dark, pure purple on the edge, lightening toward the center. The idea is that you want it to seem as if the purple seamlessly gradiates into the cat-pee yellow. The diluted purple should be almost entirely transparent and clear at about ½" to 1" from the edge.

3

Dry the purple. Take pure Quinacridone Gold and do exactly what was done with the purple, right on top of the purple. So, pure Quin Gold on the outside edge and gradiate and dilute it towards the center, just like the purple. In fact, this layer covers over anything that is purple. What will happen is the Quin Gold in combination with the purple layer below will transform into a rich burnt-brown.

4

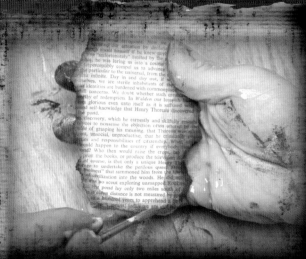

Dry. It should look like burnt paper. For a bit more darkness, take a brush and apply a tiny amount of undiluted Mars Black around the edge of the paper. It's best to paint the side of the paper as opposed to the surface. The idea is to add just a tiny bit of darkness without painting over the rich brown wash created in the previous steps.

5

The rest of the work went pretty smoothly; no humongous dilemma. One problem I was faced with, though, was attempting to visually join the plane with the rest of the piece. Physically, connecting it is a no-brainer. I ran a couple of bolts through the back of the license plate, and, after drilling the same size holes in the side of the plane, slipped it into place—oh, and glue; I don't do anything without a little E–6000 anymore. Simple enough, but the real dilemma came with making different objects feel like they were part of the same thing. This is what I call a "visual bridge." It's the same idea of my taking a Barbie Doll and gluing it to a chessboard; initially they look very different and don't belong together, but if I put them outside for five-hundred years, the layers of time would visually join them. The rain, the mud, the dust storms—all visually break down the differences between the objects because they have physically gone through the same experiences. If you don't have five hundred years to wait, there are artistic ways of doing this.

Techniques to Age Stuff in Less Than Five Hundred Years

1. A wash with watered-down paint—covering the different objects gives a sense of unity.
2. A painted transitional between the different objects also creates unity. I commonly do this with a verdigris color (though it could be any opaque color). For instance, I would add a little to the airplane and continue that color onto the license plate. This softens the edge between the objects and creates the illusion of their being unified. Typically, I do this with a dry brush to make it rougher in appearance and then do a light wash over that.
3. Design patterns are another trick I use—running my little squiggle through the different objects. The pattern moving through various items gives the impression that the items are part of the same thing.

4. Physical objects placed in the foreground of the disparate objects is another trick. Screen or mesh is a good example of this. By placing something like wire or mesh in the foreground it encapsulates the separate objects but visually holds them together. This could be done with wire, string, rope, basically anything that can be placed in front of the various objects.

In the case of the Ex Voto I used all of the above.
Wash? Check.
Painted transitional? Check.
Design patterns? Check. (For this I painted little smoke designs on the toy plane and then continued them onto the background. This piece is a plethora of my various painting patterns that seem to creep their way into my work.)
Since the ex voto scene is about a plane crashing, I decided to add a storm to the scenario and use my rain pattern detail. Next, I added a bit of vegetation to the scene. Physically I did this with wire rising up to the toy plane, but I also did this with painted vines. A few waves, a few spermy shapes
Physical objects in the foreground? Check. (Here I use rebar growing up from the bottom to create vine-like forms that encapsulate the scene.)

When I finished with the piece, I compared my version with that of the original inspiration. What I decided was that my scene seemed a bit more foreboding. That was okay, because that's what made it interesting. In some ways, it brought to mind the basic difference between folk art and fine art. Folk art is perpetuation of style and tradition that is consistent through time. It is a window into the past because the style, usually, is the same or similar artist to artist, person to person. Fine art is a different approach—it places the individual over the tradition. In fact, it asks that the tradition be reevaluated and reinvented. Neither is better than the other; each is just a different way of approaching art. Personally, however, I doubt I would fair very well if I was raised in a society of folk artists. I like to break too many rules.

Burning Flesh Trick

Just for fun, here is one more burning technique, in case you really feel the need to play with fire. Needless to say, this effect is good for other looks besides that of burnt flesh.

Stuff You Need

- object to cover with tape
- masking tape
- crème brûlée torch
- fire-retardant surface

1 Apply several layers of tape to your surface—small, ripped pieces.

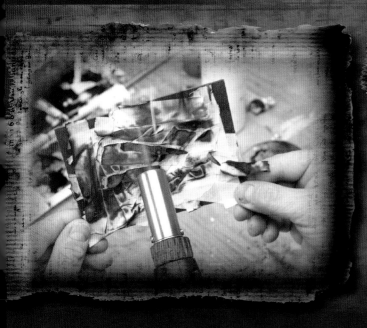

2 Then torch it and blow it out, repeatedly, until you have the effect you want.

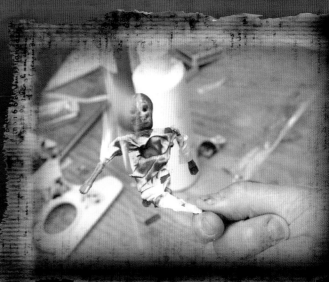

3 This can be done on many different surfaces—flat or dimensional.

Painting Patterns

Over the years, I have come to rely on some pretty consistent standbys when it comes to adding final painting touches to my pieces. Here are four that I use most often, but experiment with your own and see how fun it is to personalize your work with your own brand of mark making.

Stuff You Need

- acrylic paint
- detail brush

Spermy Shapes

This is a design that I use a lot. I use it in a variety of ways, sometimes as actual spermy shapes, but more often than not I use it as a sort of halo. It is a design that I stole from the patterns used in the representations seen of the Virgin of Guadalupe. The way I used it here was the same premise. In this ex voto I wanted to create a radiating glow emanating around the Soledad image. This is a simple snake-like design using a detail brush. Like the viny shapes on the next page, the brushstroke starts heavy and pressure lightens at the end. The key difference is that the design is an outline around a figure or head to create the sunburst effect.

Rain Pattern

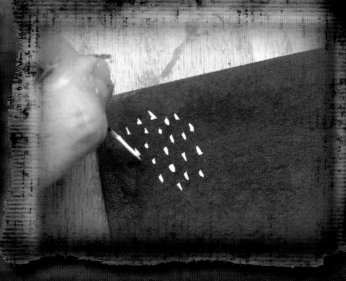

This is one of the easiest patterns in the world. Starting with a detail brush, add little dashes of paint. Here's an important thing: I find that Rain Pattern is more convincing on a slight angle. I've tried the pattern straight up and down and it just doesn't say "rain" to me. Add a few degrees tilt and you're in business.

Salt Water

Viny Shapes

When a massive tsunami isn't really necessary, this pattern suggests water and flow. Extra pressure on the brush creates more of a crest to each wave, while soft-flowing curves between the waves are made with lighter touch.

For this I use a fairly virgin detail brush—it definitely needs to keep a point. I take a bit of fluid acrylic paint and draw snake-like designs. To do this, the brush should have more pressure at the beginning of the stroke and lighten and lift away by the end of it. This will make the line smaller and more detailed as it is lifted. After the snake shapes are drawn, I go in with my detail brush and add tiny little leaves to each of the vines. For this the process is similar but shorter. Basically, the leaves are like snakes that just swallowed a pig—a fat line that quickly tapers off to a point.

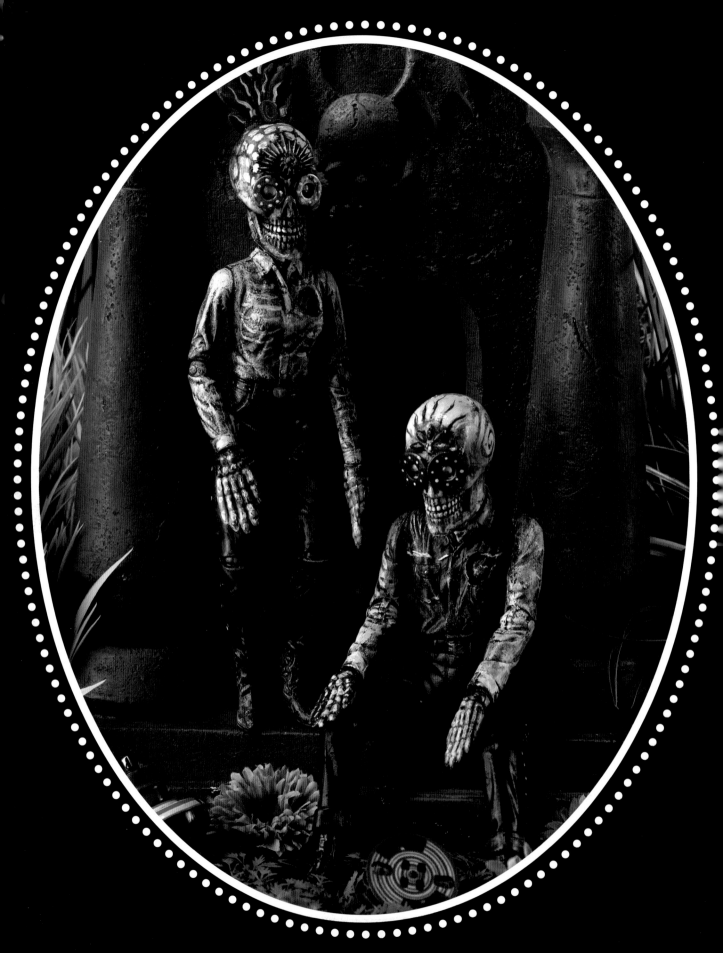

DIA DE LOS MUERTOS

My sister is paranoid about dying; she got this from my father. My mother and I, on the other hand, seem to have the "no big whoop" attitude. This was extremely clear one morning when my studio was flooded with water. I walked out to the studio, ironically enough, to work on some Dia de los Muertos figures for this very book. It had been sub-zero weather and a pipe had broken, so instead of making art, my day began with pumping water out. Don't get me wrong; it's not that my studio didn't need a good cleansing, but it's really not how you want to start your day—especially before coffee. After I finished up the oozy, drippy, yucky process, I got to my phone and saw that I had ten missed calls—all from my sister. The first message was from the night before asking about some Christmas-related topic or the like. The next one was in panic: "Where are you? Are you dead?" And each message got more and more panic-stricken as they progressed: "OK . . . I'm sending the cavalry. Dad and Cris (my brother in-law) are coming over if you don't call me back right now!" Of course,

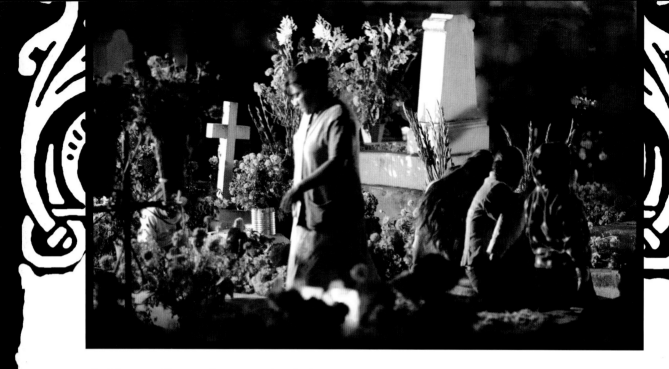

all of this started because the previous day I had mentioned to my sister that I was overdue for a physical.

Mortality has never really been a big deal for me, or perhaps I should say I don't obsess over its inevitability. Actually, I am pretty fascinated by the cycles of life and death and perhaps that's why I have always been fascinated by the Mexican celebration of Dia de los Muertos (Day of the Dead). For me, if I had to choose one holiday to celebrate every year, it would be this one, hands down.

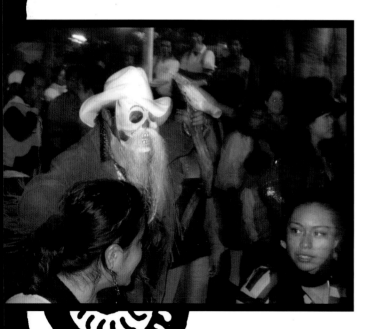

The premise behind Dia de los Muertos is that every fall deceased loved ones and relatives are remembered and celebrated. It is how they are celebrated that makes this remarkable. Each town and village is a bit different, but typically on November 1 and 2 the graves are cleaned and decorated and vigils are held. I vividly remember the very first time I walked into a cemetery during a Dia de los Muertos celebration. I had never seen anything more beautiful in my life. It was about 9PM in the village of Xoxocotlan. Outside the cemetery walls was a carnival atmosphere (some cemeteries take this to the nth degree with rides, cotton candy and my favorite, the BB-gun shooting gallery where you hit the target and little mechanized puppets dance and shimmy to music). Inside the cemetery walls flowed a sea of candlelight. Imagine a cemetery of thousands of graves, most of them adorned with candles, the traditional orange marigolds (cempasúchil), small skeletal toys and sometimes sand paintings (tapetes). The first time I experienced it, I was entranced, literally; I wandered around mesmerized by the visuals. Families gathered by the graves, some quietly remembering the deceased, while others played music and laughed and sang. At first I felt like an intruder, but soon I realized that I was welcome here. I remember a beautiful grave

40

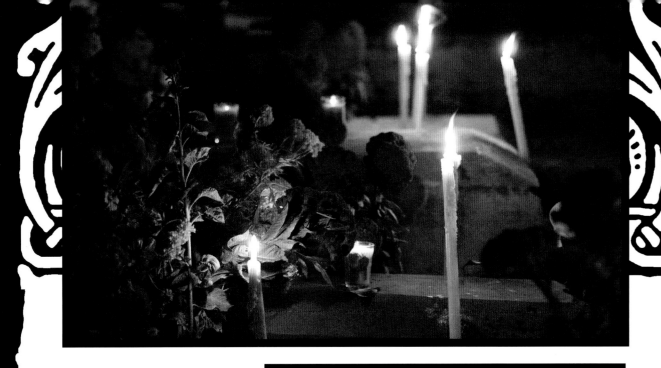

adorned with a massive amount of flowers and a number of little skeletal figures arranged on the grave like a small funeral procession. I walked up to take a gander. As I did, a man walked up to me holding a small plastic cup and a bottle of mescal. He promptly poured me some, and wanted me to toast with him. We raised our glasses and drank—drank not only to his dead relatives, but also with them. To the celebrants, the deceased family is not only there physically but spiritually as well.

There is another aspect to this celebration—a comedic aspect. Life in Mexico can be hard. It has a history of violence, sadness, poverty and tragedy. Death is certain, but during this time of year death can also be mocked. It's almost like saying, "Neener, neener.

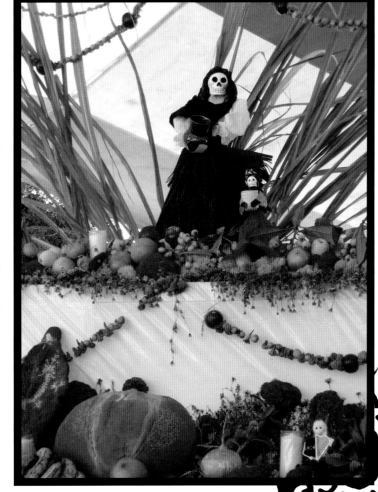

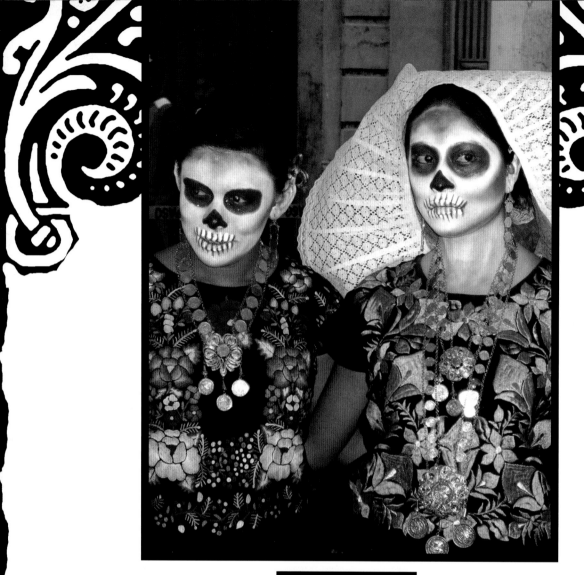

Another year has come and gone and you didn't get me." Of the famous Mexican artists, perhaps the one that most brought this to light was José Posada and his images of skeletons living everyday lives.

A few years back in the Oaxaca Zócalo there was a large group of ballroom dancers all adorned in various skeletal ensembles. It was comic, yet simultaneously, tragically beautiful. It was otherworldly and felt as if the dead had indeed come back to dance for us on this particular evening; eerie yet oddly comforting.

Comforting, because they seemed to be having a good time.

Through the years I have collected many Dia de los Muertos toys. These are typically skeletons (Calaveras) engaged in humorous situations. The skeletal husband walks in on the unfaithful skeletal wife, with the skeletal lover hiding underneath the bed. My favorite are the little coffins with a little string that when pulled lifts the deceased to sit upright. Sure these toys are morose, yet, like the dance, they punctuate the idea of mortality.

PROCESS

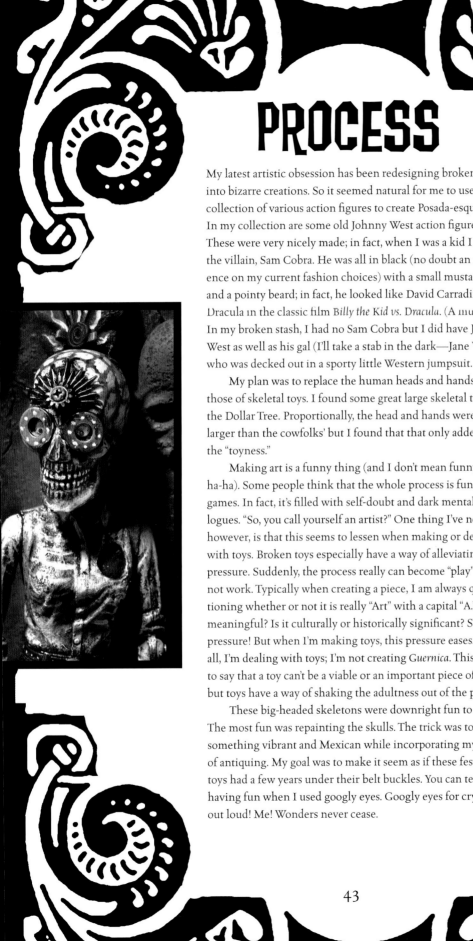

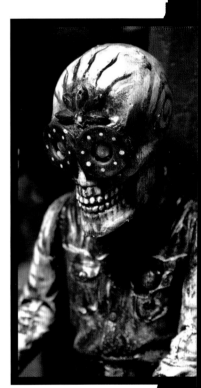

My latest artistic obsession has been redesigning broken dolls into bizarre creations. So it seemed natural for me to use my collection of various action figures to create Posada-esque toys. In my collection are some old Johnny West action figures. These were very nicely made; in fact, when I was a kid I had the villain, Sam Cobra. He was all in black (no doubt an influence on my current fashion choices) with a small mustache and a pointy beard; in fact, he looked like David Carradine as Dracula in the classic film *Billy the Kid vs. Dracula*. (A must see!) In my broken stash, I had no Sam Cobra but I did have Johnny West as well as his gal (I'll take a stab in the dark—Jane West?), who was decked out in a sporty little Western jumpsuit.

My plan was to replace the human heads and hands with those of skeletal toys. I found some great large skeletal toys at the Dollar Tree. Proportionally, the head and hands were a bit larger than the cowfolks' but I found that that only added to the "toyness."

Making art is a funny thing (and I don't mean funny, ha-ha). Some people think that the whole process is fun and games. In fact, it's filled with self-doubt and dark mental dialogues. "So, you call yourself an artist?" One thing I've noticed, however, is that this seems to lessen when making or dealing with toys. Broken toys especially have a way of alleviating the pressure. Suddenly, the process really can become "play" and not work. Typically when creating a piece, I am always questioning whether or not it is really "Art" with a capital "A." Is it meaningful? Is it culturally or historically significant? So much pressure! But when I'm making toys, this pressure eases. After all, I'm dealing with toys; I'm not creating *Guernica*. This is not to say that a toy can't be a viable or an important piece of art, but toys have a way of shaking the adultness out of the picture.

These big-headed skeletons were downright fun to make. The most fun was repainting the skulls. The trick was to make something vibrant and Mexican while incorporating my style of antiquing. My goal was to make it seem as if these festive toys had a few years under their belt buckles. You can tell I was having fun when I used googly eyes. Googly eyes for crying out loud! Me! Wonders never cease.

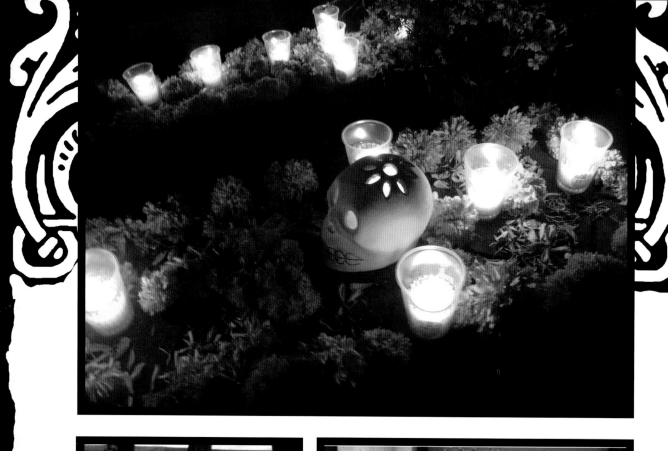

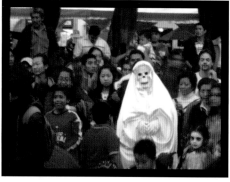

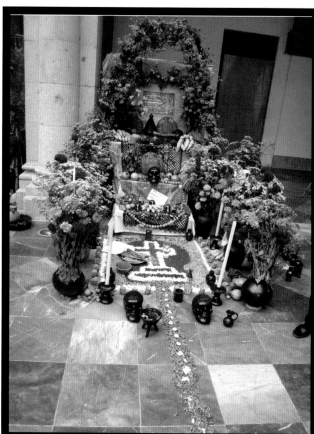

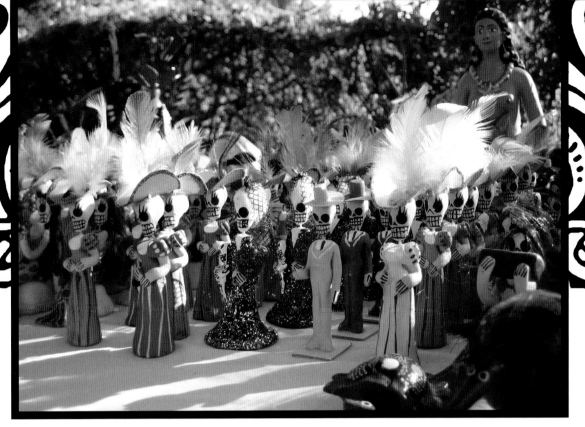

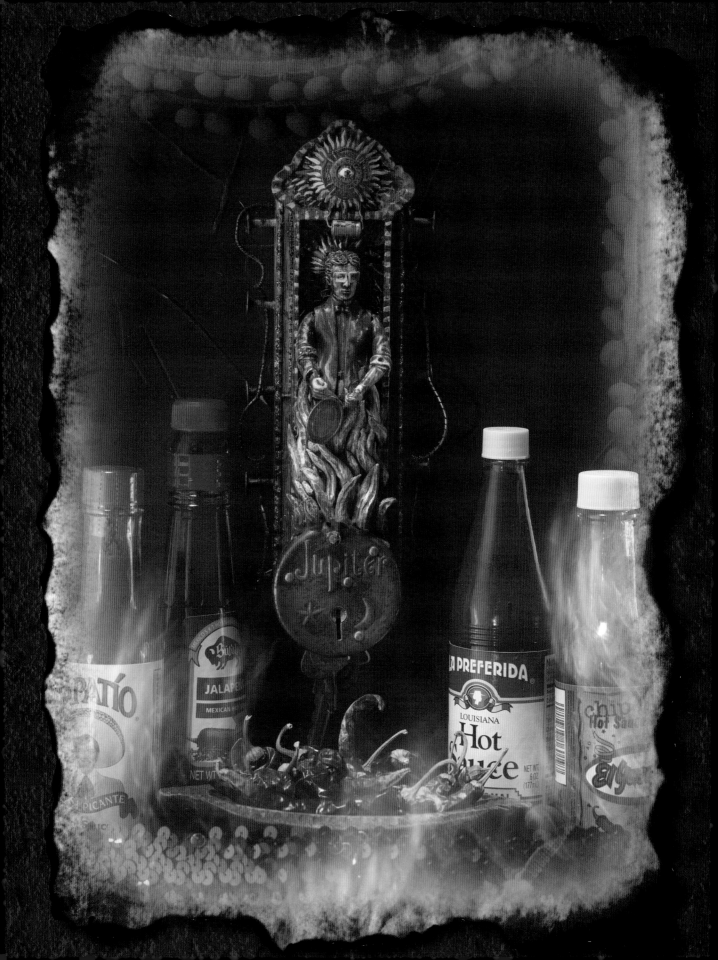

ANIMA SOLA

One image you can't help but see all over Mexico is that of the *Anima Sola* or "Lonely Soul." This image features a woman (sometimes a man—though male versions are less common) consumed by flames from the waist down, hands bound by chains and often there is an indication of prison bars in the background, from which the woman appears to have escaped.

This represents an ancestral soul awaiting judgment in purgatory; the fires of hell rage, but the hope of heaven is present. What's not to love about this image? I have never been one for subtlety and there is nothing subtle about this. It is so dramatic—better yet, it is *operatic*. You can almost hear the voice of a mournful Latin singer belting out a soulful Mexican ballad as you look at it. I recently happened upon a very cool nicho depicting a male version of this scene, built into the exterior of the Cathedral Metropolitana in Mexico City. Oddly enough, I had walked down this street a bazillion times and never noticed it before.

The very first time I took note of the Anima Sola was about a decade ago, in the giganto Alabastros market in Oaxaca. It is crazy in there, especially during the big Saturday Market. There should be a sign that reads, "Maximum Occupancy: A Hundred Million Gazillion." Amongst the teeming masses, you might happen upon a few pickpockets, or should I say, they might happen upon you.

It's dense—jungle-dense. Goods are strewn all over the place and, given that my height is several inches taller than the average Southern Mexican, banging your head on everything from belts to hammocks, to fruits, to pig heads, is a real possibility. (Yes, I really have found myself face-to-face with a not-so-happy swine.) A machete might not be a bad idea if you venture in. The combination of stuff and people is overwhelming. If you're claustrophobic, let me be clear on this, you will wig out! And if you're with non-claustrophobes, you will freak them out. I've been in there with a claustrophobe and the problem is, once you're in, there is no easy way out. As the sign to Hell says in Dante's *Inferno*: "All hope abandon ye who enter here." Well, that might be a bit of an exaggeration.

Personally, I really enjoy the experience. Where else can you buy a goat hoof bottle opener or get a beer out of a vending machine? What is really amazing is watching the seamless flow of the locals amidst all of the mazy-craziness. And the colors! Bright, vivid colors everywhere, from clothing to crafts, to flowers and the produce section with all those amazing dried peppers. Then, of course, there is that amazing aroma . . . if dirt smelled beautiful, this would be the smell.

Somewhere in the heart of this jungle are the *botanicas*. These religious-store/herbal-medicine-store conglomerates are where you can find natural cures as well as *curanderismo*—cures in the form of white magic that are a combination of spiritual folk traditions, Catholicism and I'm not sure what else. From Virgin Marys to

Buddhas, incense to peppermint (isn't that a song?), candles to amulets and, my favorite, the potions and polvos (powders) section—it's all here. You can find little bottles or packets with amusing, comic-book-like labels that will take care of everything from poverty to broken hearts, getting even with enemies, dominating your man (if that's what you're into) or imploring the Anima Sola.

Now that I have segued my way back to the Lonely Soul, it was in such a botanica that the Anima Sola first registered with me. There was a nice, elderly gentleman running the shop, and I spent what seemed like hours looking at all the different powders and cracking up at the different amusing labels. What I didn't understand in Spanish, I could get a sense of with the picture. (The "dominating your man" powder has a woman in high heels stepping on her man.) As I browsed, my hands became full, and the shopkeeper came over to relieve my burden. He went on to explain the various potions I had picked out. Of course, ninety percent of what he said didn't quite register with my less-than-great Spanish, so he did a lot of gesturing and drawing pictures in the air. I kind of understood what he was saying . . . *blah blah blah, saint, blah, blah, blah*, very important, *blah, blah, blah, blah,* cheese . . . ? Hmmm? Maybe I wasn't exactly following him, but he seemed content explaining and I was content pretending I understood. Occasionally he would jump into a bit of his limited English. Nodding and responding, I would periodically say "Sí." Finally, I asked him about the Anima Sola image and he led me to some plaster figurines; then, speaking in broken English, explained that this image is invoked when a loved one or family member dies in sin. It is used as a plea for their release to Heaven from the chains of Purgatory. On a more malicious note, the Anima Sola can also be implored to send enemies or ex-lovers to the temporary state of suffering in Purgatory. Talk about getting burned. I have to admit that I found this idea very sad—the concept of a loved one stranded between Heaven and Hell needing your assistance. That's a tough order to fill—a true labor of love.

The storekeeper continued to help me. At one point he pulled me over and whispered something to me. I think it was "bolsista," which I learned later means pickpocket. I know he said something concerning my "bolsa," my bag. He pointed to a scrawny teenager wearing a Spiderman T-shirt who had been lurking around his stand. I had noticed the kid earlier and he did give me the willies. In fact, I seemed to notice him when I was over buying dried peppers.

Well, apparently he was the vulture and I was the rotting carcass, ripe for the pickin'. Next thing I knew, the storekeeper grabbed a broom and began reprimanding the boy. The boy tried to argue back, but the old man would have none of that and started aggressively sweeping at the teenager's feet. The more the boy argued back, the more the man pushed at his feet with the broom. Finally, the alleged pickpocket left, humiliated. The elderly man came back to the counter and threw down the broom, mumbling angrily. (As a side note, I'm not sure if broom-sweeping thieves is a Mexican custom, but it got the point across—my hero!) So there I was in symbolic purgatory. I was the Lonely Gringo in a huge maze of a market as the flames of Pickpocket Hell lapped at my feet. Jokingly, I asked if he had any potions to ward off pickpockets, but my broken Spanish didn't seem to get the point across. Too bad; I would have purchased some. After all, I had to navigate myself out of there. Maybe I should have purchased a broom.

PROCESS

It's funny how different works of art begin. In my case, it usually begins with a vague notion. In this case, my "vague" notion was a *torrid* Anima Sola scene. I initially thought of taking a Barbie doll, slicing her in half (not out of malevolence but out of artistic necessity) and creating a fiery scene around her. In my studio I have a drawer of broken body parts—I should clarify, broken toy doll parts. (The real body parts are kept under the house.) I rummaged through my stash and nothing really struck me as the right fit for the concept. Barbie wouldn't cut it. If I used a Barbie, her cheery demeanor would make it seem like she was really diggin' the whole fiery Hell scene—Inferno Barbie with pretty pink shackles. Instead, I decided to check out my secret stash—a collection of kitsch toys that I have in my den. I sometimes resort to this in emergencies. I wasn't sure this was an emergency, but I knew I didn't feel like doll hunting all over town.

The first thing I saw was my Houdini doll—never out of the package—complete with straightjacket, chair and, best of all, manacles. Big dilemma. He was one of my favorite toys, but, on the other hand, he was ideal for the project. He did look like the male Anima Sola I saw in Mexico City (except that the Mexico City version was nude and the Houdini had a tux—small matter). So my project began. Symbolically, it couldn't have been more perfect. Houdini, Master of Escape, to represent someone trying to escape the flames of Hell. Add to that the obsession he had with trying to contact the spirit world. Yes indeed, it was quite ideal. Oh sure, I had to sacrifice my toy, but, as I write this, I just checked online to see if more of this doll are available; and sure enough, they are. In fact, I noticed that this particular toy store also carries an Edgar Allen Poe and a Marie Antoinette (with ejecting head) doll. I've just ordered all three. Okay, so I digress. The big question was: What was I to do with my little escape artist?

One item that had haunted my studio for a long time was a cool little metal housing for an old thermometer. It was quite shrine-ish, and in fact, it sort of reminded me of a holy water font. The best part was that Houdini fit inside it perfectly! Before I set him in, I decided on a nice red sequined-fabric background. Sequins?! That's right, I said sequins. It should be noted that it is not easy for me to use spangley things, being more of a grungy guy. I like to make things look old, but I decided that with this series I should try to use a bit of the glittery stuff, since it is part of the Mexican tradition. It also goes well with the showmanship associated with Houdini. Even so, the sparkle and glittery stuff is a tough pill for me to swallow . . . but wait, there was a solution! In this case, I took the sequin-covered material and singed the sequins, using a small crème brûlé torch. I had never tried this before and was amazed at the killer effect. It melted and singed the edges of the sequins and gave them a nice snakeskin texture, as well as adding a burnt look to the whole thing.

Speaking of fire, I had pondered what to do for the flames that are a necessary visual element in any Anima Sola. I decided the best solution was Apoxie Clay. If you have not tried this yet, get some. It is made by Aves and it is a two-part clay with a pretty quick drying time (can be painted in about two hours). I've used this stuff in a variety of ways, but since I started playing with broken toys, it's a nice little compound to swap out body parts. For instance, if you wanted to put a donkey head on a Ken doll, you just use this stuff to smooth out the transition between the toys. It can be carved and shaped, and when it dries it is really, really hard.

I decided to use this nifty stuff to make flames. How, you may ask, did I do that? Easy: Snakes. Everyone knows how to make snakes with clay, by rolling them into a long line. That's what I did here—lots and lots of snakes. After I attached my "Great Dude-ini" with an inconspicuous screw and some E–6000, I started adding layer after layer of my roly snakes. I made sure that they had a nice flame-like curve to them. Initially, they looked a bit like . . . well, snakes, but not to worry; once they were dry, I knew I could de-snake-ify them by using the Dremel and an engraving bit. This allowed me to draw little lines and patterns into the clay forms. As I did this, a song kept going through my head: "It's Beginning to Look a Lot Like Christmas." This was not random. It was because after carving a bunch of the clay pieces, the resulting shavings all over the place resembled flurries of snow. So I don't recommend doing this in the kitchen; it is messy. (As if that ever mattered to me.)

SINGED SEQUINS

Let's face it, bling just isn't my thing. If you're like me and you want to suggest the presence of something showy without it being too sparkly, this is one way to tone it down—burn it!

Stuff You Need
· crème brûlée torch
· sequin fabric
· fire-retardant surface

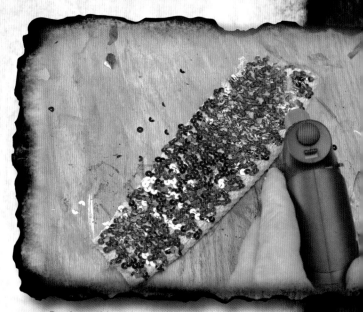

Don't try this at home. (Unless you really want to.) Sequins are a great thing to torch!

BITS OF SYNCHRONICITY

It's not unusual for me to finish working on a piece and, afterwards, see subtle symbolic references that I wasn't consciously aware of while I was in the heat of battle. This piece was no different.

HOUDINI

As it turns out, I have a thing for Mexican magicians. One of my very favorite pieces of art is by an artist named Mario Mizrahi, and is called "Professor Alba: El Hombre Que Juega con la Muerte," which translates to "Professor Alba: The Man who plays with Death." It is a modified poster from the 1930s of the famed Spanish magician of the same name. The image is that of a magician (in stereotypical magician tuxedo and slicked back hair), and behind him stands a skeleton with a scythe. Mizrahi's piece uses a bit of Mexican kitsch to bedazzle the poster. Glitter and sequins adorn the work, and my favorite part is that the skeleton has googly eyes.

JUPITER LOCK

One item I used in the piece was something I found in an antique mall in North Carolina: a very nifty padlock with images of stars and the word "Jupiter" on it. Originally I added the lock because it was symbolic of the prison of my little "Lonely Soul." As it turns out, it also relates to something amusing that happened on my last trip to Oaxaca. It was late one night and my friend Colleen and I were leaving the Zocalo after an evening of procession after procession after procession of Dia de los Muertos celebrators. In front of the Cathedral, a man had a telescope, and for a small fee you could take a gander at "hoo-piter." At first I didn't know what he meant, then it dawned on

me; duh . . . *Jupiter* . . ."*J*" is pronounced like "*H*" in Spanish. Of course, after hearing the Spanish pronunciation, I couldn't get the image of Mr. Hooper, the shopkeeper from Sesame Street, out of my head. Now, whenever I notice a planet in the sky, my mind immediately conjures up fuzzy colorful Muppets on the strange and overly optimistic planet "Hoopiter."

LITTLE EYE

On the piece, I created a tiny ornate crest using a tiny glass eye. It wasn't until a few days later that I realized it looked remarkably like something I saw above a doorway in an abandoned building in Mexico. Turns out, this building had been a Masonic Temple. That's right, a Masonic lodge in Oaxaca, Mexico. Above the boarded-up door was a beautiful cast-iron symbol with an eye painted in the center. If I had my cordless Dremel with me, I might have considered liberating it from the building.

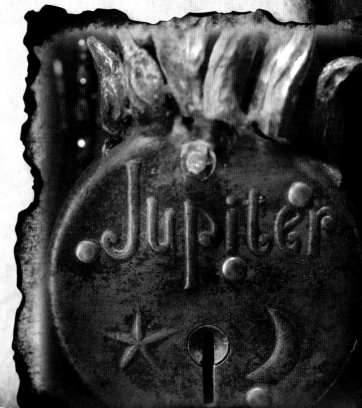

Peppermint Gum 12 PIECES
ARTIFICIALLY FLAVORED

Chiclet gum is a Mexican staple.

Children vendors roam the streets with an assortment of peanuts, cigarettes and Chiclets. If you go, you will probably hear them calling out "chicle." What they are not saying is Chiclet. Chicle is the Spanish word for chewing gum but was derived from the Nahuatl (language of the Aztecs) word, tziktli, which directly translates as "sticky stuff," referring to the rubbery sap from trees. It turns out that the famous Mexican General, Santa Anna (remember the Alamo), used to chew chicle and introduced it to Thomas Adams, who in the 1870s patented a machine for the manufacturing of gum and produced Chiclets.

I was excited to learn that Mexico had some part in Chiclet history. Unfortunately, last time I tried to buy Chiclets in Mexico, I got Clorets—which aren't any different really, but there's just not the same sense of tradition, you know?

I should mention a funny tale involving the purchase of "chicles." It was an evening in late October, and I was with my ex-wife and some friends, hanging at the Zocalo, enjoying tamales, cerveza and maybe a bit of mescal, too. The square was buzzing with anticipation for Dia de los Muertos. Processions of wandering mojigangas (giant papier-mâché puppets) moved through the streets, along with musicians and costumed participants. Even the children selling Chiclets were in masks, and were carrying little plastic jack-o'-lanterns. One of the strange happenings in the last number of years is that Halloween has seeped its way into Mexico, especially in areas with a fair amount of tourists. The children say "Halloween, Halloween" and hold out the little pumpkin, looking not for treats but pesos.

Well, on such a night, Chiclet-selling, pumpkin-holding children were hanging out at our table. Cindy loved to practice her Spanish on the children. She was talking to little Maria Lucia, who had a pumpkin filled with pesos and was now resting in a chair at our table. She was obviously tired. A wave of more Halloween-ers came by (obviously friends of Maria Lucia) and suddenly she was perky and bright, and off she went. As she disappeared into the night crowds, we realized she left behind her little jack-o'-lantern. My friend David was upset. He felt very sad for her. I figured she would come wandering back in a bit and we could give it to her then. An hour went by and no Maria Lucia. A group of young vending boys came by—all donning masks, ranging from devils to werewolves to Chucky. David asked if they knew Maria Lucia, and explained to them why he was asking. They all said "sí" and that they would take the pumpkin to her. David may be a gringo, but he wasn't born yesterday. Suspiciously he said, in his decent Spanish, "So you know where Maria Lucia is, huh? Okay, take me to her." The boys agreed, but for a fee. The negotiations were on. Fifty pesos, they said. David got it down to ten, which is about a buck. So off into the night David wandered away with a group of masked boys, holding a jack-o'-lantern.

About fifteen minutes passed before David returned, no longer holding the orange orb, and looking a little dejected. He told us that the boys did indeed know Maria Lucia, and they took him

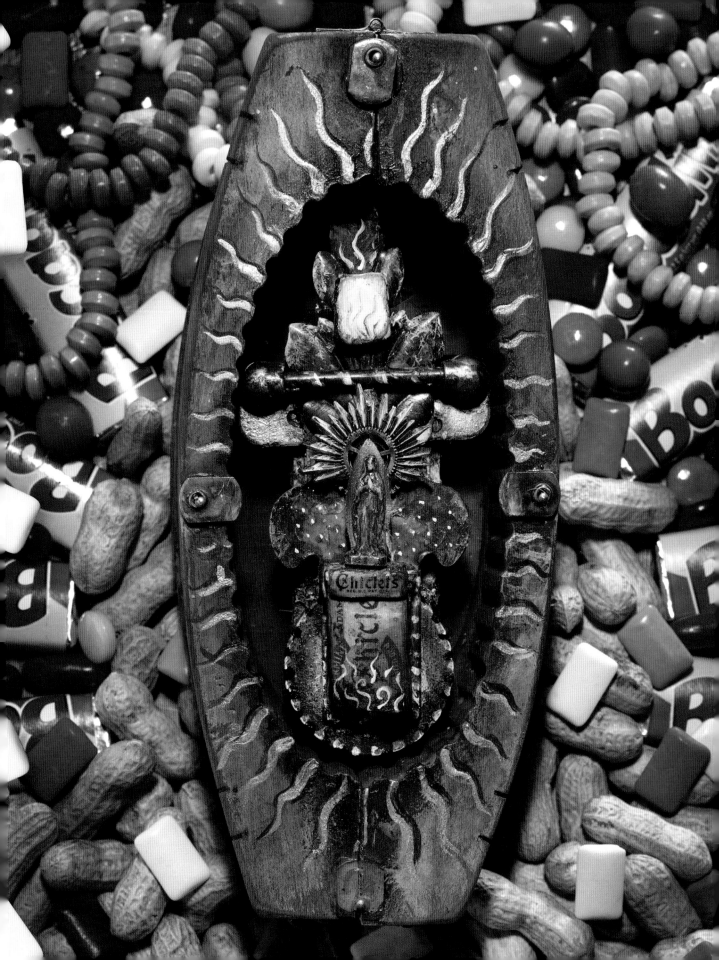

to an area just off the square. She was sleeping up against her mother, who sat on the ground amidst her multi-colored weavings. David approached as if he held the Holy Grail. He had imagined himself the heroic Gringo, who would someday be written about in folk songs. He approached, and the mother nudged the daughter awake. Maria Lucia looked at David with sleepy eyes. He handed her the pumpkin. She took it and looked at him as if to say, "You woke me up for this?" and went back to sleep. Oh well, it may not have ended as he expected, and perhaps Maria Lucia doesn't remember that American Gringo who returned her pesos, but David has a charming adventure to always remember.

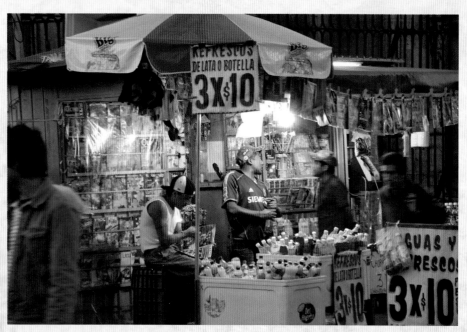

Messiness is Next to deMeng-iness

My partner, Judy, is very organized. Her studio is amazing in terms of its orderliness. Everything is in jars and cabinets. If she needs something, she knows where to look. I am the antithesis to this. I have to rummage for anything and everything. Do I like being this way? No. Have I tried not being this way? Yes. It just doesn't seem to stick. I have a friend with the same problem who owns a brewery and he said that it isn't him—it's his brain. I liked this. It's my brain that is disorganized, not me. I'm telling you, it would be heaven if I could have things in their ordered places, or, better yet, if I could do this and it would stay that way.

I really got to a point of frustration when I started using fewer random objects and more objects of value (monetary or symbolic). The problem was that I would get items and put them somewhere and they would disappear off the face of the planet for years. There is an advantage to this approach in that, when you find those long-lost goodies, it brings the same excitement as when you originally discovered them. Problem was, certain things I was collecting needed to be found.

This became clear to me when I came across an old coat that I hadn't worn for over a decade. It was a lightweight coat that I had worn on my very first trip to Mexico. Inside one of the pockets was a little packet of Chiclets. The packet was worn, but it was that way when I found it in Guadalara viewing the murals of José Clemente Orozco. I was sitting on a bench looking around, and then noticed this little treat next to me. Not that I wanted chewing gum, but I thought it a nice little memento of the place and time when I had enjoyed viewing the work of one of my favorite artists.

When I found it recently, I decided it was necessary for me to start a new holding place for items such as this, so that the items would be available visually and not require memory to locate them when I needed them. I decided on letterpress printing trays—lots of little spaces for all sorts of different-sized items. I purchased about ten of them and started filling them. The very first item retrieved from this organized system was that little Chiclet package.

I mention this story because when I created my little Chiclet Virgin, it was proof that my newfound process actually worked. Of course, using the little gum packet saddened me a little—part of me liked the little Chiclet in its cubby. In its little nook it became more extraordinary than it really was— much more special than in the bottom of a drawer with other bric-a-brac lying about. That's the unfortunate side effect of the trays; suddenly, all the objects are much more precious, thus more difficult to use in art. Alas . . . you just can't win sometimes.

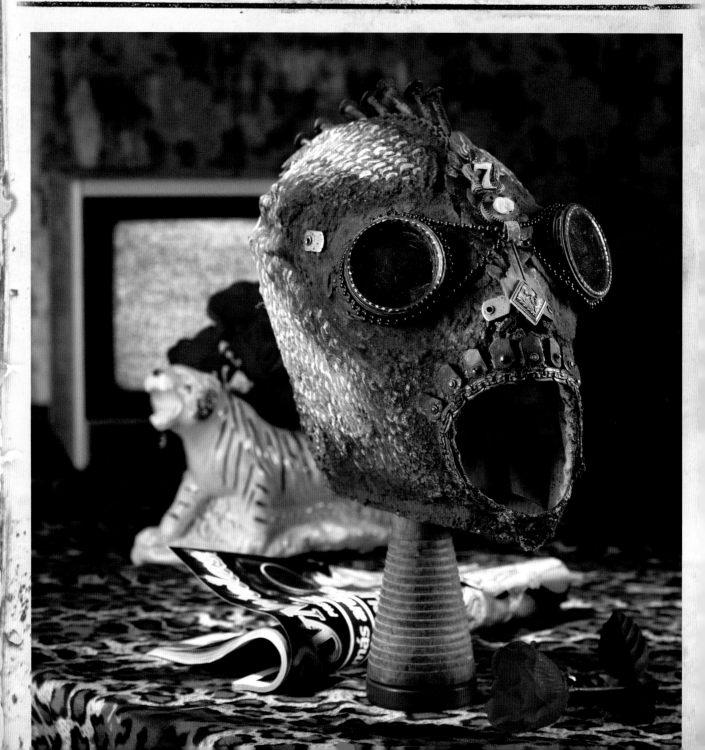

¡Luchador!

A few years back, I was in Oaxaca teaching a workshop. I had consumed something that, well, should not have been consumed. I knew I should have stuck with mescal or tequila, but one night, out with the students, I saw some beautiful looking Piña Coladas go by on a server's tray. I have two typical food rules when going to Mexico: 1. Street-vendor food is okay, only if I am okay with the risk of stomach problems. (I usually wait until I'm done teaching before seeking out my flower-blossom empanadas—amazing and worth the risk.) 2. No blended drinks. In general, ice is not a good idea down there.

Well, of course, the Piña Colada contained ice, and POW—I was down for the count. The upside was that while lying in bed I got to watch the Mexican film channel, la Pelicula. One show that had a lasting impression on me was *El Charro de las Calaveras* (The Cowboy of the Skulls). It's a 1963 B movie by the writer and director Alfredo Salazar, whose films were primarily horror films, wrestling (lucha libre) films, or a combination of both. He had been involved with such classics as *The Rock n' Roll Wrestling Woman vs. the Aztec Mummy* and *Santo & Blue Demon vs. Dracula & the Wolfman.*

El Charro de las Calaveras is in the very prevalent film genre of western-horror—yes, I'm being sarcastic. El Charro is a mysterious man who dresses in black mariachi garb, donning a black mask and wearing skull emblems on his coat.

In my hotel bed I watched in amazement as El Charro battled a werewolf with a really bad mask, a big-eared, furry-faced vampire that turned into a rubber bat, and a headless horseman, whose very convincing talking rubber head was kept in a box.

Of course, by now you are probably wondering why I bring up El Charro when I should be talking about Lucha Libres. Well, the reason is that they are related. Many of the horror films of the sixties were vehicles for the wrestling stars of the day. The most famous Luchador was El Santo. In fact, I was in a post office and they had El Santo stamps. He also had quite an extensive film history. *El Santo vs. the Diabolic Brain, El Santo vs. the Vampire Women*, and *El Santo vs. the Martian Invasion*. The whole Lucha Libre thing is crazed in Mexico. The wrestlers are typically divided into heros (técnicos) and villains (rudos)—as one would expect. Sometimes, in tag-team wrestling, a técnicos and a rudo might set aside their differences and team up for a match—very exciting!

But back to El Charro. As I was watching El Charro take on the entire universe of movie monsters, I started to notice that El Charro was really just a Luchador in a big sombrero. This was especially true when he went to battle Vampiro. El Charro and el Vampiro fought just like Luchadors. The moves were classic wrestling moves (as if I'm an expert), except that they tussled in the dust. Once the sombrero fell off, El Charro's black, full-face mask would have fit right. As for el Vampiro, he was no ordinary vampire in the Count Dracula sense of the word—more of a man-bat, and his bat mask seemed very Lucha Libre'esque (except for the fur and the giant ears). This got me thinking about costume design. I started thinking the current wrestling uniform is fine and dandy for the técnicos, but the rudos need to be more villainous, like el Vampiro. Fur, fangs, horns, spikes—now that would be a rudo to fear.

lo á las moliendas de caña, trigo, metales &⋅., como también á los desagües y dirección de embarcaciones, porque las fuerzas se pueden aumentar o isminuir á proporcion del mas ó menos peso de ueda volante de la expresada máquina.

Por tanto, á V. E. suplico provea como lle o dicho, por ser justo y conforme á la citada ley. uro lo necesario.—*Manuel de Nava.*

SECRETARIA DE GUERRA Y MARINA.

CAPITANIA DEL PUERTO DE TAMPICO.

Exmo. Sr.—Tengo el honor de participar á ⁷. E. para su superior conocimiento, lo ocurrido n este puerto desde el 4 á la fecha.

ENTRADAS.

Dia 5. Goleta americana *Halcion*: su capitan ulian Williams: de N. Orleans, en 9 dias: cargamento ropa y abarotes: á la consignacion de los ires. Zorrilla y compañia: tripulacion 9: toneladas 110: pasajeros: Lazaro Levi, francés comerciante. Fernando Sernudo, español id. Pedro Juan, rancés carpintero.

Idem. Pailebot nacional *S. Luis*: su capitan Manuel Castañeda: de N. Orleans, en 13 dias: cargamento ropa: á la consignacion de D. Pedro Valejo: tripulacion 8: toneladas 35: pasageros: Agusin Torres, genovés carpintero. Vicente Prohias, cubano negociante. Matias Zamudio, mexicano sirviente.

Dia 6. Ancló fuera de la barra la barca paquete de S. M. B. *Lira*: su capitan D. Diego S. Ihon: de Inglaterra y Veracruz, en 77 dias del rimer punto, y 7 del segundo á este: con correspondencia y 150 frascos azogue: pasageros: Francisco Elguero, mexicano comerciante. Juan Davvis, nglés id. Guillermo Droegue, id. id. Rosavia Melina, con dos niñas.

Idem. Goleta nacional *Segunda Juana*: su capitan Miguel Cortazar: de Veracruz, en 6 dias: cargamento frutos del pais: á la consignacion de os Sres. Rodriguez y Alsedan: tripulacion 7: toneladas 91.

Idem. Pailebot nacional *Rosalia*: su capitan José Maria Nadales: de Veracruz, en 8 dias: cargamento frutos del pais: á la consignacion de D. José de la Lastra: tripulacion 5: toneladas 47: asageros: D. José Pardo, capitan del batallon de Tuxpan, con un soldado preso José Maria Amalor. D. Francisco Gomez, capitan del batallon de Tampico. Sebastian Heredia, mexicano comerciante. Raymund Berdier, francés id. José Gonzalez, mexicano zapatero. Francisco Anzures, con su esosa y cuatro niños, id. empleado de este resguardo. Desideria Castillo, con dos niños.

SALIDAS.

Dia 6. Bergantin inglés *Lorino*: su capitan Robert Magúl: para Lóndres: cargado de palo de moral y zarza: tripulacion 7: toneladas 145: pasagero Pedro Coller, inglés comerciante.

Dios y libertad. Santa Anna de Tamaulipas marzo 7 de 1836.—*Juan Sosa.*—Exmo. Sr. mi-

lo á las moliendas de caña, trigo, metales &⋅., como también á los desagües y dirección de embarcaciones, porque las fuerzas se pueden aumentar o isminuir á proporcion del mas ó menos peso de ueda volante de la expresada máquina.

Por tanto, á V. E. suplico provea como lle o dicho, por ser justo y conforme á la citada ley. uro lo necesario.—*Manuel de Nava.*

SECRETARIA DE GUERRA Y MARINA.

CAPITANIA DEL PUERTO DE TAMPICO.

Exmo. Sr.—Tengo el honor de participar á ⁷. E. para su superior conocimiento, lo ocurrido n este puerto desde el 4 á la fecha.

ENTRADAS.

Dia 5. Goleta americana *Halcion*: su capitan ulian Williams: de N. Orleans, en 9 dias: cargamento ropa y abarotes: á la consignacion de los ires. Zorrilla y compañia: tripulacion 9: toneladas 110: pasageros: Lazaro Levi, francés comer-

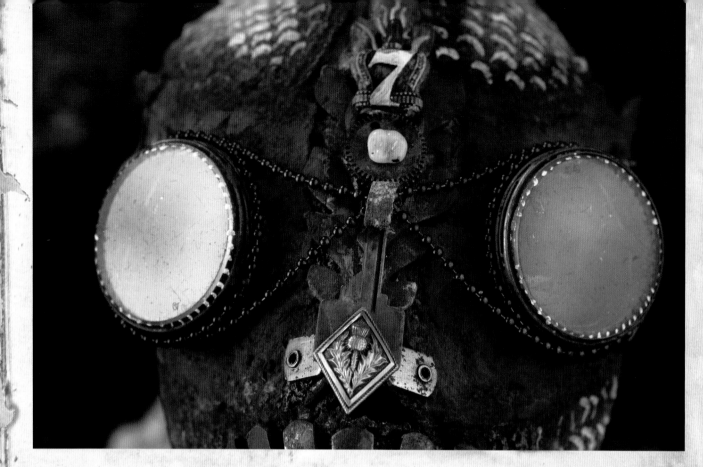

lo á las moliendas de caña, trigo, metales &c.., co-
no tambien á los desagües y direccion de embar-
aciones, porque las fuerzas se pueden aumentar ó
isminuir á proporcion del mas ó menos peso de
ueda volante de la expresada máquina.

Por tanto, á V. E. suplico provea como lle-
o dicho, por ser justo y conforme á la citada ley.
uro lo necesario.—*Manuel de Nara.*

SECRETARIA DE GUERRA Y MARINA.

CAPITANIA DEL PUERTO DE TAMPICO.

Exmo. Sr.—Tengo el honor de participar á
'. E. para su superior conocimiento, lo ocurrido
n este puerto desde el 4 á la fecha.

ENTRADAS.

Dia 5. Goleta americana *Halcion:* su capitan
ulian Williams: de N. Orleans, en 9 dias: cat-
amento ropa y abarotes: á la consignacion de los
res. Zorrilla y compañia: tripulacion 9: tonela-
las 110: pasageros: Lazaro Levi, francés comer-
iante. Fernando Sernudo, español id. Pedro Juan,
rancés carpintero.

Idem. Pailebot nacional *S. Luis:* su capitan Ma-
uel Castañeda: de N. Orleans, en 13 dias: car-
amento ropa: á la consignacion de D. Pedro Va-
lejo: tripulacion 8: toneladas 35: pasageros: Agus-
in Torres, genovés carpintero. Vicente Prohias, cu-
ano negociante. Matias Zamudio, mexicano sir-
iente.

Dia 6. Ancló fuera de la barra la barca pa-
uete de S. M. B. *Lira:* su capitan D. Diego S.
hon: de Inglaterra y Veracruz, en 77 dias del
rimer punto, y 7 del segundo á este: con cor-
espondencia y 150 frascos azogue: pasageros: Fran-
isco Elguero, mexicano comerciante. Juan Davvis,
nglés id. Guillermo Droegue, id. id. Rosavia Me-
lina, con dos niñas.

Idem. Goleta nacional *Segunda Juana:* su ca-
pitan Miguel Cortazar: de Veracruz, en 6 dias:
argamento frutos del pais: á la consignacion de
os Sres. Rodriguez y Alsedan: tripulacion 7: to-
eladas 91.

Process

First things first. I needed to create a prototype. Using a mask I purchased from a recent trip to Mexico, I began. It was a cow Luchador mask. Yes, I agree, it is strange to think that a Luchador would be intimidating wearing a cow mask. I lop off the floppy ears and start coating the piece in molding paste. I do this to add some nice texture to it. Also, I want to hide some of the seams. My goal is to make this a rusty, corroded disguise. I want it to have the impression of weight. Another thing, I decide, is that I really want to give this a steampunk, industrial quality; so I thought eye protection might be appropriate, as well as handy for the Luchador. (This is one rudo who won't have his eyes poked out. Of course, it's the rudos who are the ones who would probably do the poking, but I digress.) In my studio I have a pair of old goggles from who-knows-when. They look like something out of a mad scientist movie, and I have often used them as comic relief when teaching as I explained the importance of eye protection when using power tools. I have to admit, I was a bit hesitant to dismantle them, but as I've said before, nothing is sacred if it's in my studio. I remove the eyepieces and wire them in place.

Now, if I were a wrestling villain, I would want a mask that I could get some mileage out of. In other words, I would want a mask that I could cheat with. With this in mind, I add some old railroad nails, down the center of the scalp, to resemble fins. If this were a mask used in an actual ring, I would make sure that the spikes were removable for optimal villainous behavior. Okay, I know you're thinking that my version of Lucha Libre is more like a Quentin Tarantino film, but it would sure spice it up.

After all the molding paste is dry, I decide to apply a rusting solution, made by Modern Masters. It's a two-

part formula. You start with the metal paint, meaning that the paint has some metal in it. You paint it on any-thing—plastic, wood, fur, lucha libre masks—then, af-ter it dries, you add a solution that rusts it. It's pretty nifty, but very unpredictable. Sometimes it rusts bright orange, sometimes a deep red. One thing I have found is that the area where the solution pools up is where it is the most vibrant in color. In this case I don't really care if it's vibrant or not; I just want to dingy the piece up a bit. When using this product, I often find myself using a bit of paint to bring out highlights or color changes where the rusting solution didn't quite hit my expecta-tions. Ultimately, I'm a bit of a control freak when it comes to making things seem random and decayed. Ironic, isn't it?

One of the last things I do to my piece is paint little designs on it. Scales is what they look like, and when I finish, I decide that this rudo is perhaps something from the TV show *Land of the Lost*; you know, Marshal, Will and Holly? My mask is somewhat like a Sleestack—one of the hissing, big-eyed dudes. Hey, that's a great idea for a movie: *El Charro vs. the Sleestacks*. Maybe they could throw in a T. rex for extra excitement. If you're a movie producer looking for a costume designer for such a film, I'm your guy. Just have your people get in touch with my people.

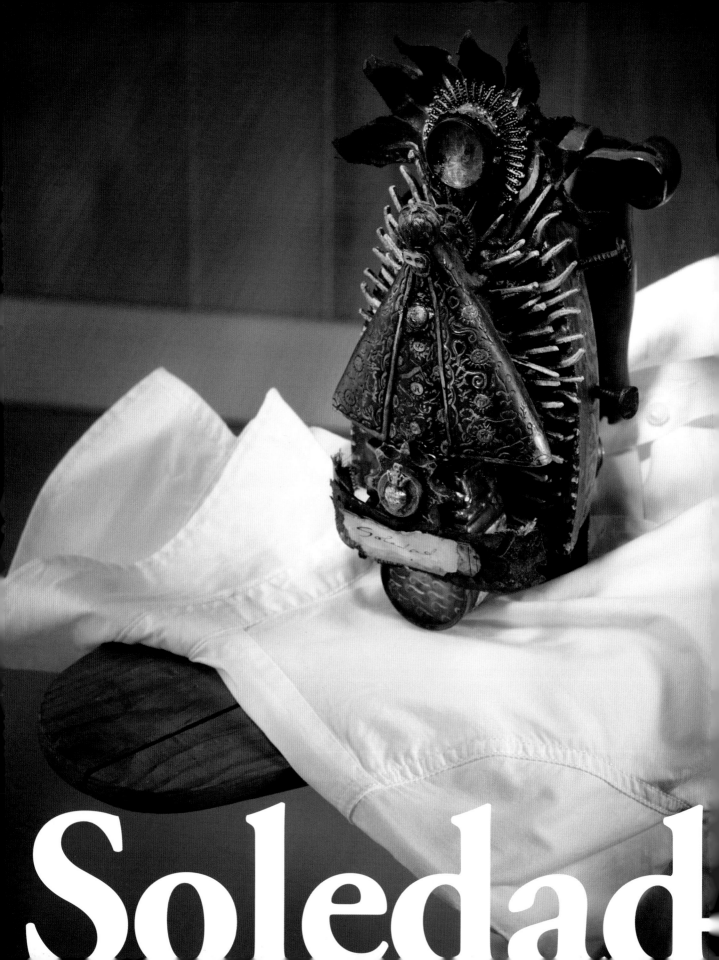

Soledad

Oaxaca's patron saint is the Virgin of Soledad

(solitude). Her ensemble is distinguishable—black dress with gold design details and a prominent triangular shape. The relationship between the city of Oaxaca and this unusual version of the Virgin goes back to the seventeenth century.

A mule train was camped outside the city, and the drivers noticed an extra mule. No one seemed to know where the mule came from, and, when prodded, it keeled over and died. (That part makes me sad.) The dead mule's pack was examined and inside was the statue of the Virgin of Soledad, dressed in black velvet, gold, pearls and a crown. Believing this to be a miracle, a basilica was built on the exact location where the statue was revealed. It is a beautiful structure.

Finding the Virgin

Representations of this equilateral Virgin are everywhere in Oaxaca, but interestingly, I found the main components of my Soledad shrine in Puebla, not Oaxaca. Not only did I find a statue of her there, but also the old iron that she ended up being mounted on. I wish I could say I found my little figure in the pack of a dead mule (well maybe not), but I did have a very enjoyable day, the day that I discovered her.

Puebla is a few hours out of Mexico City, and it reminds me of a smaller, more manageable version of its sprawling neighbor. It is renowned for its beautiful Talavera pottery—typically in blue, white and yellow. There is no shortage of this tile work in that town. My first trip there was with four friends and we arrived in a Volkswagen taxi. (That's right, five of us, with lots of bags.) I seem to recall someone was sitting on someone's lap. Sure it wasn't safe, but I must admit that it reminded me of my high-school years and cramming as many bodies into a space as we could. I didn't seem to mind the discomfort back then—it was fun, and this journey to Puebla was the same.

First stop was a drink at la Pasita (the raisin)—a great little bar that had a great back bar filled with all sorts of vintage toys. They specialized in bizarre little shots, using different flavored liqueurs. The menu was huge. I had a shot of something that had coconut and a few other things, and came in a little shot glass with a peanut floating in it. They also have a good sense of humor—one liqueur was Pepto-Bismol pink, and they poured it out of a laundry detergent bottle. The signature drink was the Pasita—a raisin liqueur that they made themselves and served with a skewered piece of cheese in the shot. I was also informed that the local nuns make an eggnog drink that they serve called Rompope. Remembering all this talk makes me want to wander down that way right now.

Now, drinking was not the only reason we ventured to this part of Puebla. The main attraction was the Callejon de los Sapos—alley of the frogs. There were no amphibians there, only antiques. It was a long corridor of antique stores, and on Sundays, a flea market was typically held in the area. Unfortunately, when I was there, it was the middle of the week, but the stores are plentiful so definitely worth it. I ended up buying some nifty old frames, a Soledad statue (that wasn't old but it was only a few bucks) and an old iron (also only a few bucks).

As with most cluttered antique stores and bookstores, you have to dig. You have to remember that there are usually lots of goodies that have been hidden away for centuries. If you're willing to get a bit dusty, you'll retrieve items long-forgotten and passed over by the everyday shopper. Some of these stores will have prices, some will not. If they don't, it can be a good opportunity to barter.

When I purchased my little Soledad, I got a bit of a bargain, due to the fact that I was purchasing so many other goodies, plus my friend Steve was also purchasing various oddities—that helped. I left the alley of frogs with my little Soledad, packed her on a mule and took off. (Actually, it was a VW taxi but by the looks of it, I can say in good confidence that it had a very real possibility of keeling over dead.)

Bartering

1. No price tag means it's OK to barter. (In my experience, most vendors seem insulted if you try to barter when the object in question is already priced.)

2. Be blasé. You've got to have a poker face. The more you seem to want something, the more the seller knows they've gotcha. Stay seemingly uninterested, shrug your shoulders, yawn, talk on your cell phone. If you have friends with you, make sure they are on the same page, point at other vendors as you pretend to discuss.

3. Walk away. Don't hesitate to keep wandering. Most of the time the object will still be there when you come back by (unless you are with friends who are non-barterers and are looking for the same thing).

4. One-half to one-third of the initial price is a good starting point. Don't devalue the object too much; if you insult the vendor, they may not sell or the price will stop moving down in the bartering process.

5. Buy multiples. Try the bulk-discount routine. Almost always, sellers will reduce the price if you're buying more than one item. "How much if I buy ten?" Although, I've done this, and some sellers look at me in bewilderment as if I couldn't multiply.

6. Remember the amount you're haggling over. Sometimes you get so wrapped up in the process that you forget that you may be haggling over fifty cents.

7. Don't be greedy. Remember that Mexico is a poor country and many of the vendors are struggling financially. This is one of the reasons I'm not a hardcore haggler. I enjoy the process, but if I can save ten to fifteen percent I'm content.

8. You don't have to barter. Bartering isn't for everyone. If it's not your bag and you're perfectly happy with the price, then by all means, pay the asked price. You'll be happy and the seller will be happy.

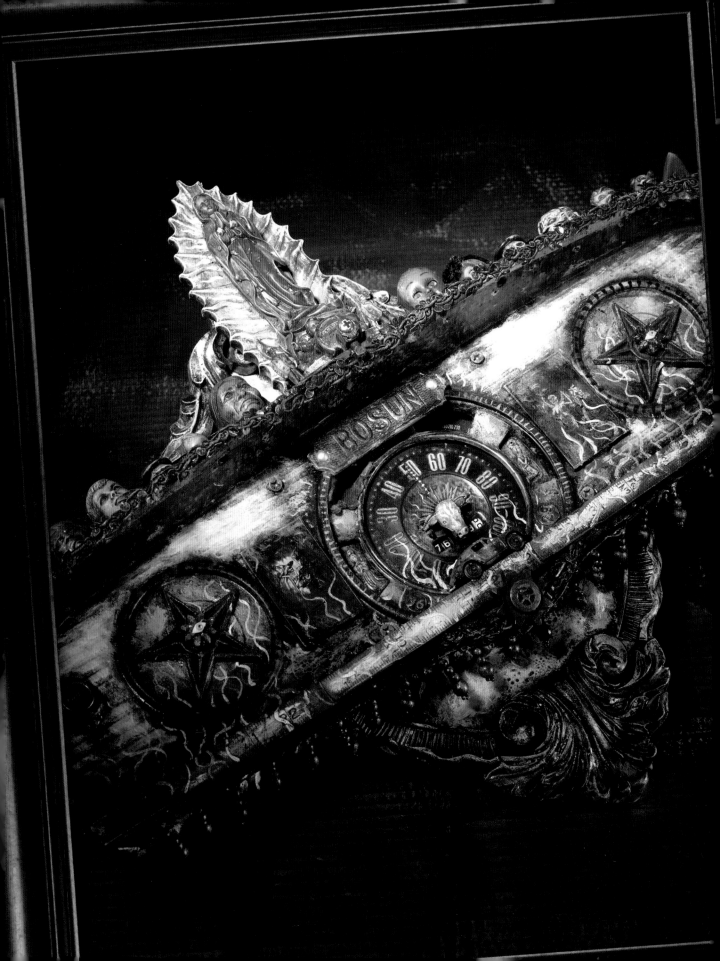

Taxicab Shrine

I was a bit disappointed on my last trip to Mexico when it came to my taxicab experiences. It's not the cab drivers I had a problem with; I actually had some very pleasant, albeit linguistically-stunted conversations. My disappointment stemmed from an aesthetic point of view. In years past it seemed like you couldn't help popping into a Volkswagen bug without being overwhelmed with an amazing display of kitsch and religiosity. On my most recent trip, I had my camera ready at all times to get some great photos of the ornate dashboard creations that I had remembered from years past. I recall being in cabs that were quite extraordinary in their over-the-topness. But during this last trip, cab after cab, it was the same: pretty straightforward, maybe a rosary or a saint but not the kitschy quality I remembered. I started to question my recollection. Perhaps I was thinking of Southeast Asia; I know I saw some wild things there No, I was certain that I had come across some wildly-decorated cabs here in Mexico.

I am reminded of a time when I rolled into the Mexico City airport late one night and needed a cab. I did what you should never do; I hired a cab that was not authorized by the airport authority. I wasn't really thinking straight. I was tired, I just got through customs, I didn't want to wait in a long line, and in front of me was a man in a suit asking if I needed a cab. I did. So I went with him. Of course, I had heard all the tales of kidnapping and such, usually from my father (prior to every trip I take to Mexico), but I figured, what are the odds? First, I'm not an oil tycoon or a politician, I'm just an artist. Who in their right mind would kidnap an artist? So suit-man grabs hold of my bags, and we start wheeling out the door. Next thing I know we are outside jaywalking across a busy four-lane street. At this point I'm starting to get nervous, but do I retreat? Hell no. I was aware that this was not the brightest thing to be doing; but once again, I'm an artist. But now I see that we are headed to a really dark parking lot—really dark. Okay, okay, now I'm getting a bit sketched out and I think to myself, "This might super-suck." But once again, no retreat! If I flee, I lose one bag—it had many tools and paints . . . they are expensive. So we get to a car, not a cab, but a 1980s-era sedan, with maroon velvet seats. Stylin'. Meanwhile, I'm scoping the parking lot for dark foreboding characters. The driver got out. I was waiting for a gun. No gun, just a hanky. He was a short man with a really bad cold. My bags were placed in the trunk (no shovel and plastic bag—yes, I looked) and the front passenger door was opened for me. I sat. The door closed. I watched the two men in the side mirror to make sure my bags weren't being removed from the trunk. Nope, the suit-man just walked away, and the driver hopped in.

So far so good—but still, who knew where I'd be taken? It was like being on a plane; once the plane takes off, what are you really going to do? I sat back and enjoyed the ride. Once I relaxed a bit, I noticed that the driver's dashboard was pretty amazing. Let me amend that—flippin' unbelievable. This driver had what seemed to be every Mexican lucha libre wrestling action figure under the sun and had them sitting on the dashboard. They formed a jumbled mass, to the extent that the individual

wrestlers were no longer distinguishable in the mass of intertwined plastic flesh. What was really cool was that in the center of this amorphous pile of lucha libre stood a plastic statue of the Virgin Mary and some rosary beads. What a great visual contrast: seething humanity and then an island of serenity in the form of a figure standing above it all.

As we drove, I asked the cab driver about the wrestlers. He said that he started buying the wrestlers so his boys had something to play with when they came with him in the car, and the collection just grew and grew. He then said that the Virgin was his. We laughed.

It was at this point that my cab driver turned to me and said, "Mucho prostituto." I looked at him with a bewildered look. Then, I looked outside the car. Indeed, the streets were lined with an assortment of working girls in some rather stunning ensembles—mostly consisting of sequins, pumps and fringe. A

fabric or textile artist would have been in visual awe. I kind of got the idea that he thought I might want him to make a pit stop. And no, we didn't stop.

The rest of the journey was a nice little dialogue between me and the driver—part in my broken Spanish, part in his broken English. I learned that he moved here from Peru with his family and was trying to make a living as best he could. We arrived at my hotel. There had been no guns, no machetes, no ski masks, no theme music playing from *The Good, The Bad and The Ugly*, as bullets riddled the car in slow motion—only a pleasant little journey consisting of a Peruvian with a runny nose, and one of the most amazing dashboard shrines I've ever seen. Was it worth the risk? Maybe. But I have gone back to using the authorized taxis. I'm telling you, that parking lot was really dark.

Taxicab Shrine

When I told my editor that I was going to make a dashboard shrine for this book, there was silence on the other end of the phone. "Uh . . . OK . . ." which translated as, "You're really going to ship me a entire car dashboard? That will definitely not fit in my cubicle." I jumped in and said that she was more than welcome to hang it in her home while waiting on the photo shoot. This seemed to alleviate the stress. I did have hopes of tracking down an old Corvair dash, which would be a bit smaller, but fate jumped in and gave me a different option.

Scottsdale, Arizona. Temperature: 20 million degrees. I teach here every year, in August. I like this part of the country but I am not a heat person. When I come down here I find myself jumping from air-conditioned building to air-conditioned building.

On some of my trips I hit a particular salvage yard called Apache Reclaimation. Once upon a time it was a great little salvage secret. Now it seems to have been discovered, so I started hunting elsewhere. My most recent trip yielded a new find. My friend Terry Lazin, who does some stupendous shrines, told me of her source for goodies. I could tell you, but Terry would take me down if I gave it up. So one day, I wandered to her secret site, a nice junkyard with tetanus everywhere—perfect. One problem though: it was Arizona, it was August and I was surrounded by hot metal. Oh well, at least it was a dry heat . . . riiiiight. The place seemed deserted. After all, who in their right mind would be wandering around in 115°? I found plenty of scraps, but I was really looking for a dashboard. Now, I hadn't really thought too much about shipping it; I would worry about that if I found something.

I decided to check with the office and see if they had seen such a thing lying about. The attendee didn't know, but it could be that I was less important than the *Dr. Phil* show, whose volume was super high to drown out the noisy oscillating fan. I went back to my hunting, sweating like a pig-dog from hell. I wandered down an alley made of, well, everything and nothing in particular. There was no way out so I looked around, turned and walked back out. Suddenly I heard, "Whatcha lookin' for?" The voice came from the dead end that I just came from. I turned and I saw a little grungy man. Where in the world did he come from? He wasn't there a second ago. I did a quick survey and tried to find the hole he crawled out of but couldn't see a porthole. Thus, I secretly dubbed him the Junkyard Troll. I am bewildered to this day. I did tell him about my quest and, sure enough, in seconds we were wandering down past the weird innards of radiators to a pile of rusty things. He moved a few pieces and lo' and behold, a dashboard. Well, not an entire dashboard but the section with the speedometer and gauges. Best yet, it was light and thin. Amazingly, in this entire heap, the troll was able to isolate the one thing I was looking for. Of course I can relate. My studio is a smaller version of this junkyard and many of my found objects are catalogued by what they are underneath. For instance, I know that the old camera is beneath the pile of rusted rakes. It's when I "organize" that things get lost. So I guess that in my own way, I am a troll, though I like to keep my surroundings at a more reasonable temperature.

The Process

When I started the dashboard, I knew, given the source of its inspiration, that I wanted it to have a bit of Mexican kitsch, and I also knew that I wanted to combine toy images with that of a central saint or Madonna. The first thing I did when I got to the studio to attack this project was to pick out an appropriate figurine, which turned out to be a Guadalupe that I picked up when I was visiting the Bascilica in Mexico City. I bought it in a booth that might as well have read "Everything Guadalupe" because there were a jillion styles and sizes. Not far from the booth were a couple of fake donkeys where you could get a photo taken wearing a sombrero—the image of the Virgin in the background.

Initially, I had envisioned the piece to have tons of wrestlers similar to that of my driver in Mexico City, but I decided that I would take a slightly more subtle approach. I found a variety of doll and figurine heads of various shapes and sizes and lined them across the top. Along with the various baby heads and action-figure heads, I finally found a use for these horrible clown-head decorations I'd been hoarding. I found them at a garage sale, and they were just so bizarre that I had to buy them. (I should also mention that I am a bit freaked out by clowns, so this was a way of getting rid of a couple of them.)

I also added a steer head from a swizzle stick as a decoration for the speedometer, which gave me an idea to give this sort of a Ranchero feel. Thus, a couple of rusty stars prominently placed on the console seemed to be appropriate.

When I was in art school I recall working in my studio on a rather large painting and, throughout the day, my painting professor walked through, peeking in without saying a word. At the end of the day he said, "You know, Michael, you've had three or four really good paintings there." And then he left. I mention this because that is what I felt with this piece. I just couldn't seem to decide where I wanted to take it and kept changing my mind midstream. For instance, after most of the goodies were attached, I thought that I would paint it bright pink. I didn't like that and did a turquoise blue, then a red, then a muted gray, then finally back to a blue but more subtle. For me, this is the most frustrating part of making art—making a commitment. I think my curse is that I very seldom have a definitive end in mind, so this means that I rock back and forth between poles before a final solution is resolved. I say that it is a curse because it is not pleasant to experience. I liken this process to a pendulum that goes back and forth but each swing shortens a bit with each pass. Eventually, the vacillations get centered and resolved, but until then, each swing makes me want to throw that piece of art right out the window.

One thing I tell my students is that when you're at a really frustrating point with a piece or art, and everything about it seems like a piece of poo, that is when it's time to walk away. It's time to get a coffee, or watch an episode of *Seinfeld*, or find a friend on Facebook. Whatever it is you do to clear your head, this is the time to do it. The reason is that if you don't the entire piece will be destroyed or thrown away. But if you take a little time away, typically what happens is that no longer is the entire work a piece of poo, but only parts of it. Usually, a break allows you to hone in on the problems and fix them. The other way is like fighting a riptide; the more you fight, the more you're likely to drown.

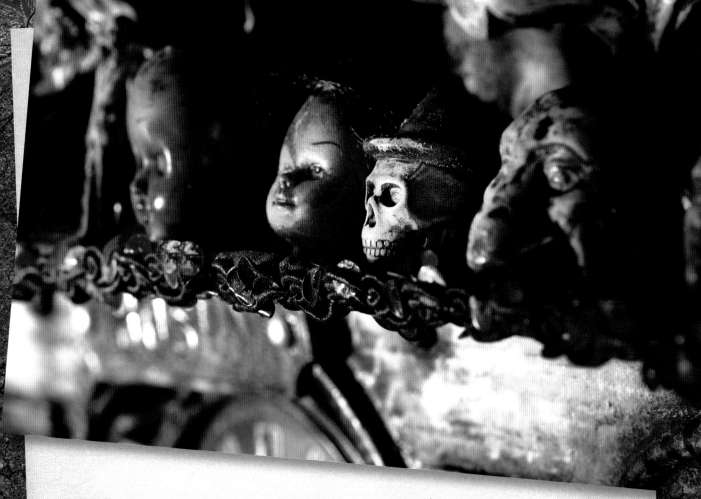

Zen-ify Yourself—That's the Solution

This is what I should have done with the dashboard, but I was fighting the riptide the whole time. I should have taken a few more breaks, but nope, I was determined to duke it out; and because of that, it kicked my butt. I nearly did throw it out the window (or rather take a torch to it and burn everything off that I had added). Instead, I finally got to a point where the work was OK (and when I say OK, I mean not great but just OK), and I set it aside and started work on something else. All the while, I kept looking peripherally at the dash, and, like magic, I had solutions.

I have to let a piece of art get under my skin sometimes, and really know its flaws before I can fix it. I find when I take a breather from a piece of art, it's not like I am not thinking about it, but it takes me away from a situation where I can make it worse. In my head I can safely conceive of solutions to attempt. It may seem like you're just drinking a macchiato and people-watching, but really the mind is subconsciously still chugging away. You don't have to be making art to be making art.

In this particular case, my final decisions on color came in a dream, or at least in a semi-sleep state. I woke up, went out to the studio and knew exactly what needed to be done. I have been told that one is most creative when closer in proximity to a dream state. I don't know if that is true, but it does seem that I have the least problems if I go out to the studio very early in the morning as opposed to very late in the day or evening. To sleep perchance to dream?

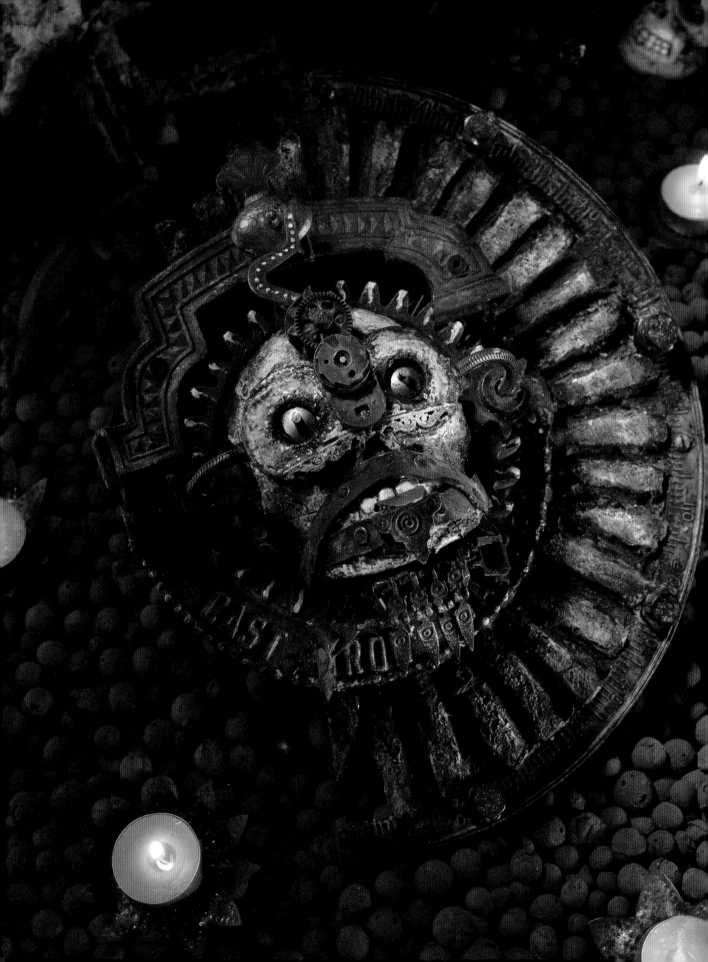

Solar Disk

Could you imagine the Venus de Milo with arms, the Liberty Bell without a crack or the Sphinx with a nose? Here's the thing: It's because they are busted that they are memorable. Their flaws become their attributes, or at least a point of connection. The other thing that happens is that those signs of decay humanize these works of art. Suddenly, they are more relatable because they fall prey to the same rules of temporariness that mere mortals must: Even art isn't forever, as much as we wish it were.

I mention this because Mexico is filled with pre-colonial sculptures, architecture and carvings that have deteriorated due to nature or conquest. Outside Mexico City there are the remnants of an ancient metropolis that was called Teotihuacán. It was inhabited long before the Aztecs rolled into town (its heyday being from about 200 B.C. to A.D 700). This place and the structures were named post mortem, by the Aztecs. They were so mysterious to the Aztecs that they decided that this must be the birthplace of the gods.

If you visit Teotihuacán and you follow the Avenue of the Dead you will run into the Temple of the Sun. One of my favorite Mesoamerican carvings came from the façade of this structure. It is now housed in the National Museum of Archeology. It is a stone carving of a radiating solar disk, and in the center is a skull with its tongue hanging out. It is very similar, though less ornate, to the Aztec calendar (also known as the sun stone), and in the center of the Aztec version is a carving of the sun god Tonatiuh, who also has his tongue hanging out. So what's the deal with this gesture? I used to think that it was a mockery of death, but a bit of research informed me otherwise. To use a pop culture reference: "Feed me, Seymore." In other words, this image was used to remind you to keep up with your human sacrifices. The sun god is starving and, if you want to ensure good crop growth, you best keep him well fed. Hopefully, when your children use these gestures, they don't mean the same thing.

Now the cool thing about the solar disk skull with a carving is that only part of the disk remains intact. Half of it has crumbled away. The deterioration adds to the mystery associated with the events that this carved skull must have seen generation after generation. Unfortunately, dead men tell no tales.

The Process

I'm no stonemason. So when I approached making this piece I needed to address it a bit differently than the original sculptors might have. I decided to more or less replicate it using found objects but no stone. Not that I have anything against stone; it's just so flippin' heavy, and I have found that it is a bit less than ideal when it comes to mixing media. I seriously thought about casting cement, but I came to my senses and realized that I could replicate the mineralesqe nature using space-age materials.

I started by cutting a wooden form into the silhouette of the disk. I then found a ceramic skull that I sliced down with my handy-dandy Dremel fitted with a ceramic cutoff wheel. I did a bit of surgery and lopped off the back half of his head—not out of any sort of masochism but merely so that it would nestle into the disc a bit more. From there I started taking bits of balsa wood and laying them around the skull. These would all be treated with other goodies later, but I needed to rough them up a bit. I took my sanding drum attachment, and with the Dremel I carved them in a way that resembled stone carving. Once these basic forms were in place, it was time to texturize. I coated the whole tamale with hard molding paste and then proceeded to rough it up a bit. I did this by merely patting the surface with my hands. This made some nice bits of texture—very important if you intend to paint—which, of course, I did.

Thingy-ma-jobbies came next. I knew the original was a basic stone carving, but come on, there is no way I could possibly get through the creation of a piece without finding some interesting and odd items to adorn it with. The original was beautiful in its stone simplicity, but, well . . . I guess I'm just more of a maximalist as opposed to a minimalist.

I had a number of old globes lying about. Now I have to admit that I had yet to really find much use for the orbs, but I had always found the metal meridian piece interesting. I actually decided on the size of this piece based on a meridian I had lying about. I thought it would add an interesting juxtaposition to the stone quality. Also, it is a symbolic juxtaposition to the ancient era and the age of conquest. Other little adornments were added as well. One of the more interesting adornments, which I used in the skull's chin, came from a garage sale. These little ornate strips came from a tiny metal pouch. Apparently, the pouch is Turkish and was used to hold gunpowder. This was a humongous dilemma: To dissect or not dissect? That was the question. I dissected. If I spent more than ten dollars on it, I might have hesitated, but probably not. Once my doodads were added, I started my washes of color. I started by painting the textured area white, then, after it dried, I made washes of the "uszhhh." The wash flowed from the higher texture to the nooks and crannies, making the piece look rock-like. In other words, it rocked. (See pages 22–25 for more on Uszhhh and other color combinations.)

Post-Studio Analysis

When I was at the National Museum of Archeology I stood looking at the actual solar disk, which was bookmarked by two stone, skull profiles. Not far from this were more remnants from Teotihuacan. Stone has such weight—not just in terms of weight but in terms of reference. It implies time gone by. When in the presence of ancient stone artifacts you are left with a sense of mystery. I am left staring and wondering who, and under what circumstances, looked upon the same artifacts? What artist created this? What did the Aztec who discovered this feel? Did Cortés or Montezuma cast their gaze on these very same stones? Things like this make the past so complex and wonderful. The future may seem infinite, but artifacts such as these stone relics can make the past seem equally as infinite.

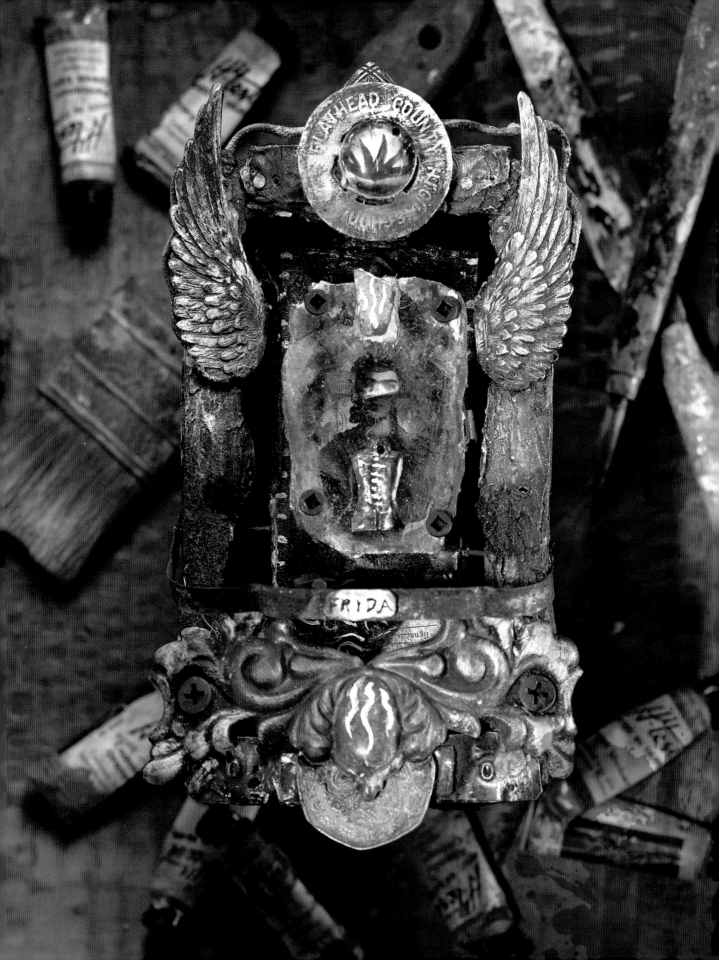

Frida

I always get a bit anxious going through customs when I travel. I suppose this is normal. It is a process designed to intimidate. I get nervous because often I am hauling around art supplies and power tools—the types of things that make screeners a little extra curious. Once I was waiting in line at the Mexico City airport and a customs guy calls me over to inspect my bag. "Oh great," I thought, "now I will have the ordeal of trying to explain paint and such." My expectations were based on experiences in the U.S. and being asked, "What do you do for a living?" I can't tell you how many times I get "the look." The look that says, "An artist . . . Oh. You're one of . . . them." With this in mind, why would it be any different on the Mexican side of the border, except with a little extra bureaucracy, in a language I don't understand very well? So the Mexican official opened my bag and started going through it. First thing he finds is a case of paintbrushes, and says: "Pintor (painter)?" I reply, "Sí. artista." A radiant glow came across the man's face and smiling he put his hand on his heart and said, "Bueno (good)." He continued examining my bag, saying a few things that I didn't quite understand, and then he pulled out a piece that I had been working on. It had my usual found-object items sticking out all over the place. At this point, I figured the gig is up, because I imagined him saying, "So you call this art?" (In Spanish, of course.) Instead, he looked at the tiny shrine made out of an old camera and seemed fascinated. It is a good thing that I got to the airport early because he genuinely seemed fascinated with the pieces of art I had made. He was detaining me, but not because I was a security risk, but because he wanted to see what I created.

When he was finished, he zipped up my bag, grinned and said, in English, "Thank you." I took this not in the general courteous sense, but the way he said it was so heartfelt, that it felt more like he said, "Thank you for being an artist."

I will never forget this exchange, because it is probably when I fell in love with Mexico. Prior to this, I liked it, but suddenly, I recognized I was drawn to this place because here was a place that loved art and valued it as a part of the life experience. The Mexicans have national pride in their artists. Diego Rivera is a biggy, there's also Orozco, Posada, and of course, the matriarch, Frida Kahlo.

Before I visited Mexico, I was lukewarm on Kahlo's art, but the more I visited the more I felt that it seemed to encapsulate a Mexican proverb I had heard: "La esperanza muere al ultimo (The last thing to die is hope)." Most people know the various tragedies that Frida experienced, from her physically disabling trolley accident to the emotional turmoil in her relationship with Diego Rivera, but despite these difficulties, she created and moved forward. To be sure, her art is painful, but it is also beautiful, a perfect metaphor for the culture she came from.

La Casa Azul (the blue house), Frida's residence, is in a pretty suburb of Mexico City. It is a wonderful place filled with light and color and flowers. In contrast, a few blocks away is the house of her friend, lover and Russian revolutionary, Leon Trotsky. It is dour, Soviet-grey, utilitarian—a beautiful property, but a downer. It has always seemed to me that Frida's solution to the troubling world seemed like a good one: when life is hard, paint your house blue.

Frida Shrine

Old habits are hard to break. When I first approached this piece, I thought that it might turn out rather colorful. I just couldn't pull it off. After I had constructed my little box and added wings and various other items, I started adding a bright blue—like Frida's house—but it just wasn't sitting right with me. It ended up a verdigris—no surprise. It does bring up an interesting point though. I think that in each artist's mind, lurking around, is the perfect aesthetic for each particular piece. Obviously, this varies artist-to-artist, artistic-phase-to-artistic-phase, but each piece requires some unique pampering to get it right. It's funny how I can do the exact same process on a current piece of art that worked swimmingly on another earlier work, and then see, "No way, José." So I toil and toil until I find that "magic moment" when a piece clicks. Sometimes it happens right away, other times it takes weeks, months or never.

Back to Frida Blue. As I said, I tried to make the blue work but it wasn't jiving. Let me say this: I know that if I started working with that color a bit and it became second nature, I could probably get it to work, but currently it's not in my hard drive. Much of art is intuition, and right now I have a particular color scheme that registers as "correct." In the past I used bright reds and bright yellows (yes, it's true), and in another phase I was using periwinkle. Right now those old solutions are not what I equate with resolutions now. It's the natural ebb and flow of artistic process. Resolution for this year: Work on being comfortable with Frida Blue.

The Process

The very first thing I started with on this piece was the Frida image. I found some Frida photos that I could play with and printed them on transparencies. These are great to work with because, if treated properly, they can create some pretty dynamic effects.

The best transparencies to work with are from laser printers. I actually have an inkjet printer that works OK, but it requires an extra step. One problem with inkjet is that the ink can smear, especially if you are adding paint or paint washes on or around it. This is not a problem with laser prints or photocopies, but with inkjet you can lose an image in no time. So the extra step I have to go through is spaying a gloss fixative over the ink-side of the transparency, and then I can add as much paint as I like. I should also mention that gloss is important, otherwise what is behind the transparency can become foggy (which may be an effect you want, in which case go for the matte fixative).

The problem with transparencies is that they can look like cheapo plastic, which, after all, they are. I tend to try to make them look a bit more interesting. One thing that you can do is take a soldering iron and use it to cut the image out. What this does is make a nice rough, blackened edge that doesn't look like you took a pair of scissors to it.

My favorite technique is done with a candle, which is what I did in this piece. I cut out my Frida image and with the candle, burnt the edges. This made the edges rough like the soldering iron but it also made the transparency bow, and, oddly enough, made it look like glass. One thing that I try to do is to hold the transparency in a way that controls the direction of the bowing—otherwise, the plastic might bow in a variety of different ways. Maintaining a curve in the transparency while you burn it will allow you to create the impression that the transparency is thick—like blown glass.

Another thing that is nifty about transparencies is that they are, well, transparent. This is great for a few reasons: You can use them in multiple layers to create a ghostly effect, or you can place objects or ephemera behind them. Painting on the back of the transparency can result in some cool effects. It is amazing how much detail you notice if you throw some white paint down. Painterly artists can go crazy and be very elaborate with painting. On this piece I used a bit of gold metallic paint, which gave the piece a subtle tintype quality. Interference colors, by Golden paints, also result in similar effects.

Mica—that bizarre, layered, glittering mineral—is another great transparent surface to work with. Mica is nice because it comes in layered sheets that can be separated. The more mica layers, the more obscured the object or image behind it. I thin it down so it is fairly transparent; my images are a bit dark so if I leave the mica too dense, I'd lose detail.

After I decide on the thickness, I need to decide the length and width. For my situation here, I don't cut my mica, but rather, I tear it. This roughs up the edge to bring out the crystalline halo along the mica's edge. Mica can be drilled, so in this case I drill some holes and set it over my Frida with some bolts. This worked well for this particular piece because it gave the sense that my little Frida was encased in ice—an effect that I refer to as The Mysterious Frozen Caveman Trick.

One thing that I like about the finished piece is the dream-like effect of the interior, in contrast with the tactile reliquary that houses the Frida image. For some reason it reminded me of a quote by Octavio Paz, which ultimately becomes the title of my little shrine: "Deserve your dream."

Don't Get Burned

- Fire, bad—Make sure you blow out the candle when done.

- Burning plastic fumes, bad—Do this in a well-ventilated area, preferably outside.

- Holding a piece of burning plastic while it melts, potentially bad—So wear a pair of non-flammable work gloves if you're afraid or use a pair of pliers to hold the edges of the transparency.

- Transparency burning out of control, bad—Make sure you're ready to blow out the flame. Also, I have a bowl of water nearby, just in case things get really crazy.

Burning Transparencies

Needless to say, I'm not happy with something that looks like it just came out of the printer; hence . . . yet another burning method. Some cool distortion often goes on here too.

Stuff You Need

- image printed on transparency
- soldering iron or wood-burning tool (or scissors if you don't want to get carried away burning things)
- crème brûlée torch
- fire-retardant surface
- white acrylic paint
- paintbrush

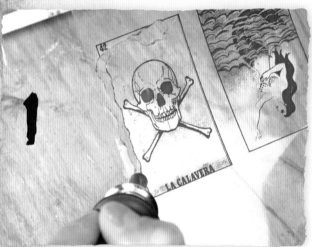

Print an image out on transparency film. Using a soldering iron or a wood-burning tool, "cut" the image out.

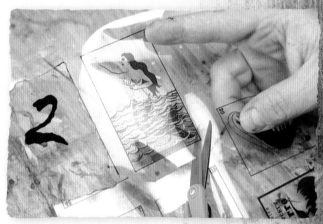

Alternatively, you can cut the image out with scissors.

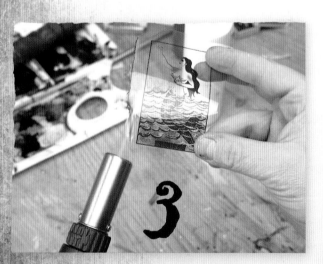

Then, carefully torch the edges.

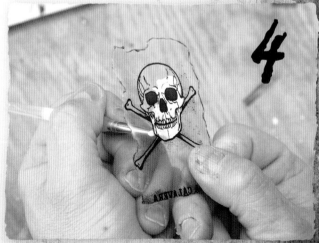

I like to then add depth and highlights by brushing white onto the back in places.

Mysterious Frozen Caveman Trick

So named for the "cool" look of a prehistoric dude discovered cased in ice, this tricky window front is actually quite easy to churn out.

Stuff You Need

- mica
- something like your thumbnail or the head of a screw
- acrylic paint of your choice
- paintbrush/water
- heat gun

Cut your mica window to size and begin by roughing up the edges a bit using your thumbnail.

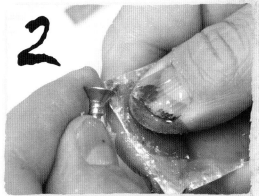

Or something like a screw.

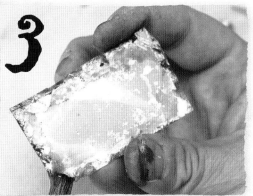

Apply a soupy color wash around the roughed-up edges.

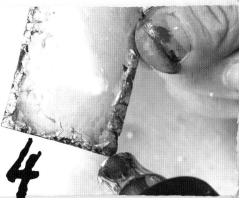

Heat the edges of the mica with a heat gun and watch as the paint is pulled inward, between the layers.

Ooooo—magic!

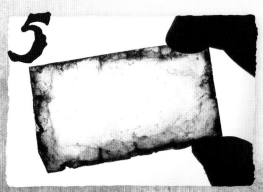

DONAJI

In my last book I wrote at length about the legend of Donaji, so I won't bore repeat readers with all the gory details. But, to briefly recap, the story is about a Zapotec princess, Donaji, who falls in love with a political rival, a Mixtec prince. She lives with him and ultimately betrays him to benefit her people. The Mixtec prince finds out and Donaji is killed. Several months later, along the riverbanks that flow through the Oaxaca valley, her severed head was discovered as if it was still living, with a lily growing out of her ear. Okay, everyone is up to speed, in a "Cliff Notes" sort of way. (I could hardly do a book on Mexico without talking a bit about Donaji.)

In the state of Oaxaca she is a regional favorite, as far as legends go. She is a local symbol of the eras before Spanish conquest, so much, in fact, that representations of her severed head can be found carved in stone on theaters and government buildings, as well as printed on shoeshine stalls and ambulances. I know it sounds kind of gross, but really, the image is surprisingly sweet. It is delicate. It is beautiful. It is sad.

The odd thing is that many things in Mexico seem to be simultaneously beautiful and sad. Another strange thing is that Donaji is like the positive version of the sad spirit, la Lloróna. Both are about lost love, and both are about sacrificing one love at the expense of another. They are like two antithetical sisters, both bound to the waterways of Mexico, but Donaji is a woman of sacrifice, who gave her life out of obligation, while la Lloróna—a woman of dementia and melancholy—gave her life out of regret.

There is something unsettling about a head without a body. I'm sure this statement seems a bit obvious, but it seems like the ultimate violation to the living body. It is a point of no return. One can lose an arm or a leg and still live, but a head is definitive. The Headless Horseman, the severed head of Medusa, the guillotine—all sources of childhood fears and fascination—are both compelling and repulsive. Many years later, as an adult, it was odd to experience that strange sensation I had as a child.

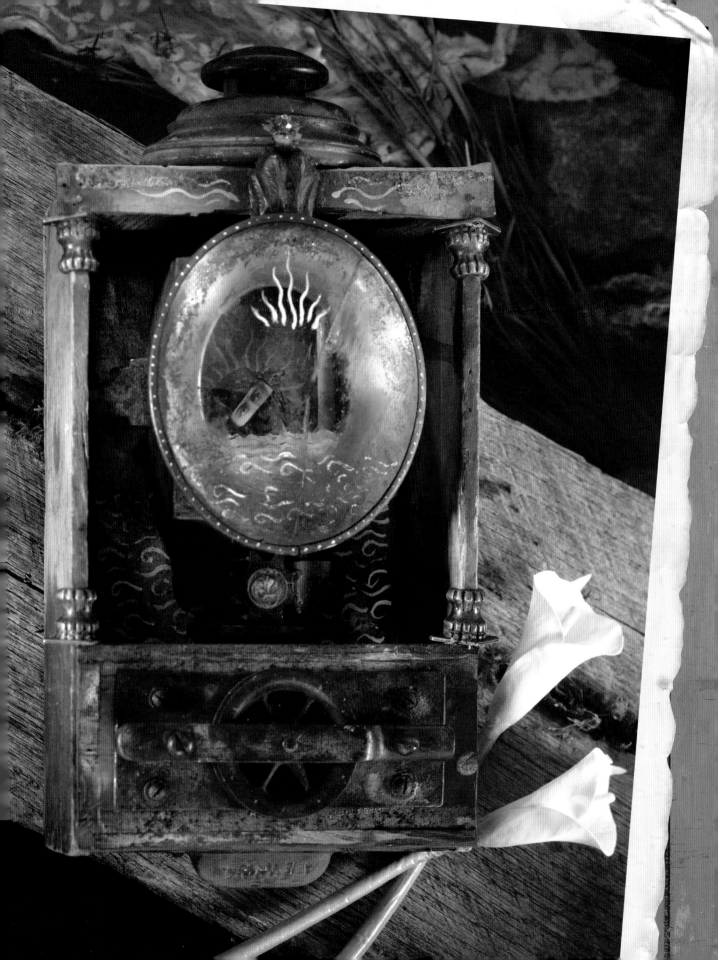

This piece began with a small doll head given to me by my Oaxaca workshop organizer, Colleen. She gave it to me during class one day, wrapped in paper towels. I opened it and said, "Donaji." Colleen replied, "Exactly." She knew my attraction to this story from my previous book and felt that I must have this.

For a year, that little doll's head sat comfortably in a printer's tray nook. I knew that I could only use it for a Donaji piece; anything else would seem like a betrayal to both Colleen and the Zapotec princess. So when I decided to do another interpretation of this legend, this was my springboard.

Of course, my first step was to find something to place her in. In an odd coincidence, Donaji and la Lloróna were united once again. What I ended up choosing to be my housing for this bodiless doll was a carriage lantern that I purchased at the same time as the flashlight used in the la Lloróna piece. It evoked a bit of the Beaux Arts style that is on El teatro Macedonio Alcalá—a vintage theater in Oaxaca City that prominently displays an image of Donaji carved on the keystone. Granted, the princess is from an era much further back than the 1890s, but the most common renderings of her seem to come from this era. Thus, I go with the flow.

I decided I wanted to create the effect of water, but in a manner that might befit a vintage theater. So I took some matboard and cut out a few wave shapes. From there, I painted them with wave designs on the paper. This is a pattern I call the "Swirly Flow." It is a repetitive pattern I have used for at least fifteen years and can't seem to get enough of. Basically, it is just a water-inspired design. It starts with some basic wave marks going across a page, then a line of spirally wave shapes, then repeat. I do this typically in white or black, then lay a wash over the design pattern of whatever color seems most appropriate.

Behind the lens, I layered the paper waves from the back to the center. Then it was time to add the Zapotec princess. I placed her head just behind the last wave. I started off with it

upright, but this seemed horribly wrong. Upright didn't seem to imply the idea of severed, and besides, the standard image around Oaxaca has her head lying sideways. It took a bit of adjusting, but I finally got the angle right. It's amazing how something as simple as a subtle gesture can be so laborious. I think this is a part of art-making that can be innocently overlooked; I think that often the time an artist spends changing his/her mind is seldom accounted for. I literally spent an hour playing with that head, getting the angle just right. Of course, as would be the case, I got it situated just-so and then decided I didn't like the eyes of the doll. I wanted to add photographic eyes. Glue was setting, and I really didn't want to tear the head off to put the eyes on. It was time for a little invasive surgery. I got out my long bent-nose pliers, added a bit of E-6000 to the back of the thin piece of wood that I pasted the eyes photo on and maneuvered it into place. My fear was getting E-6000 all over the place. I needed to plunk it right on the spot or shiny strings of glue would be everywhere. First try—right on the nose—literally and figuratively. I let it sit for a spell in position so that the eyes didn't drift down to the mouth.

When I came back to the piece an hour later, I immediately stopped myself before going overboard. I decided this piece was to be simple and rustic. I left the painted stuff for inside the lantern lens, but the exterior would be more or less natural. An old wooden box would house the lantern and, more or less, I left it at that. A few simple touches: a basic pulley to add to the rustic feel and a tiny glass lily to complete the legend.

When I finished, I set it next to the la Lloróna piece. Different as different could be. Not just in style or mood but in storytelling. Lloróna seemed to be more complex in trying to convey a story, while the Donaji piece seemed simpler. This piece is less about the story's details, and more about the tragic mood. If only Shakespeare had been familiar with this story. No doubt he would have written a humdinger.

SWIRLY FLOW

If riverbanks or the salty sea play a part in the story of your own piece, it's easy to suggest a flowing current with a few simple strokes. For the detail basics, see page 37, and here are some tips to highlight the look further.

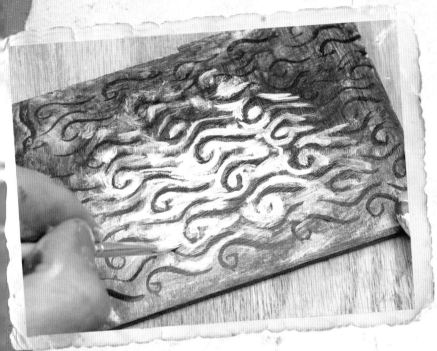

1 You can also add highlights to a piece by painting design details with white and a detail brush.

2 Then, to knock down the white, wash over the piece with a color that complements the background color. Here, purple and cool tones made up the background, so I used a wash of Uszhhh.

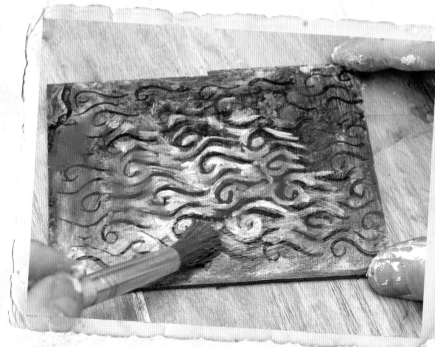

79

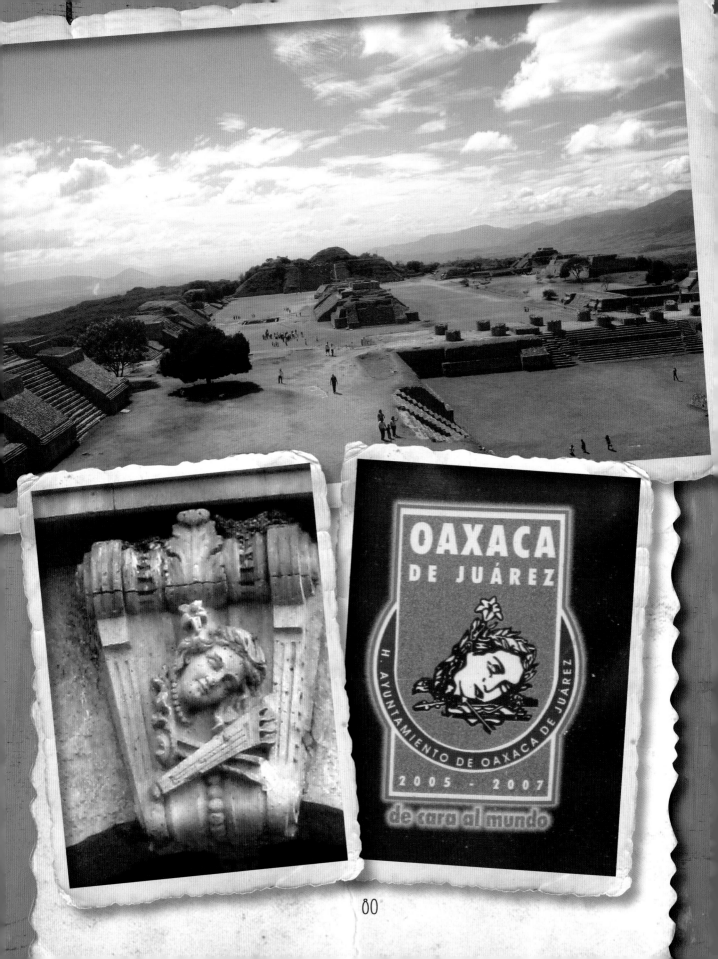

OAXACA
DE JUÁREZ

H. AYUNTAMIENTO DE OAXACA DE JUÁREZ

2005 - 2007

de cara al mundo

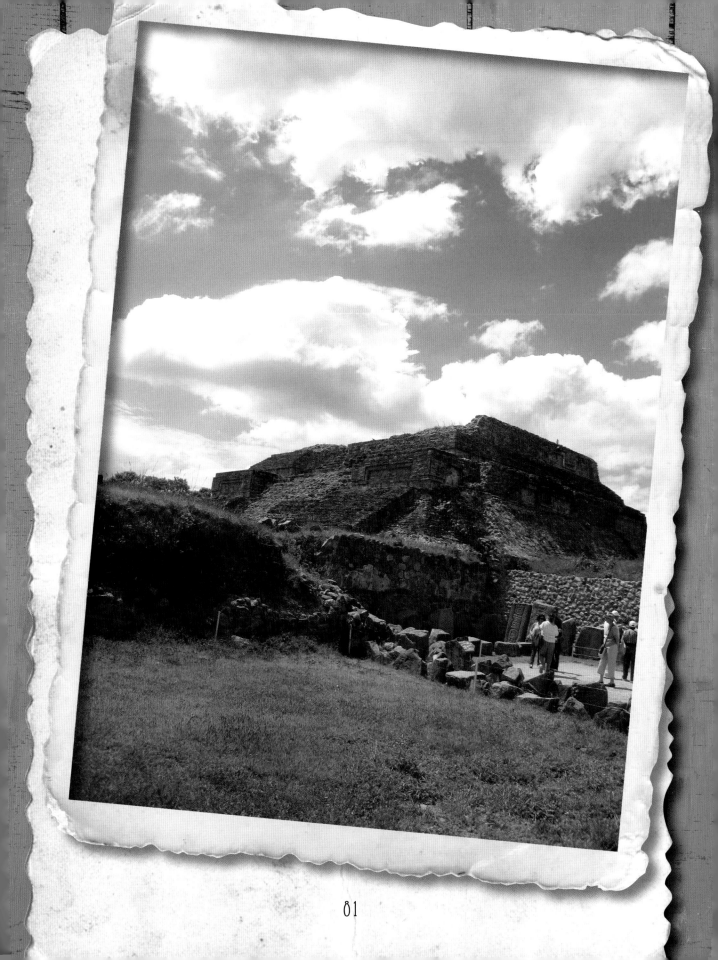

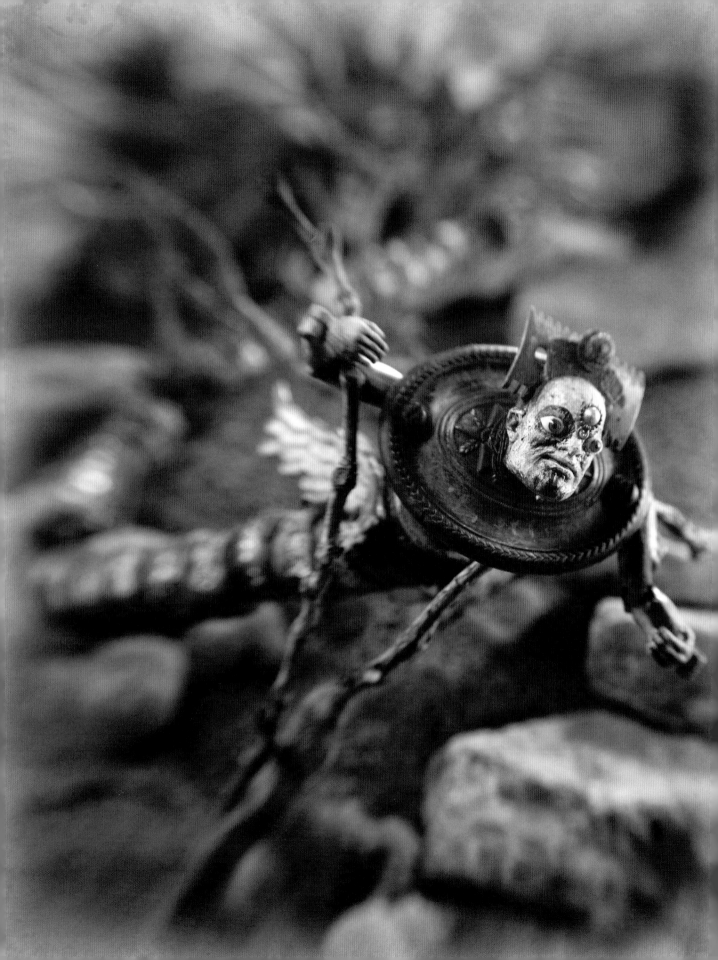

Quetzacoatl

If you visit Mexico, you'll notice ancient deities are lurking everywhere. When the Conquistadors conquered the region, they replaced the old gods with new ones, but they were not one hundred percent thorough. The past runs deep in this neck of the woods.

I'm into myths big time, but I have to admit that it took me a while to get into the Mesoamerican deities. The names are so darn intimidating when you see all those multisyllabic ramblings. Quetzalcoatl is one of those deities whose name gave me problems, but this guy is a biggy, and if you're gonna learn Mexican deities, he is a must. A fair-skinned, bearded god, he was symbolized by a plumed serpent—a snake with feathers. One of his best-known exploits involves his daring entry into the land of the dead to gather human bones from previous eras. He then gave the bones life by sprinkling his blood onto them and thus created the fifth world.

Another myth that had somewhat dire consequences for the Aztec culture had to do with his rival, Tezcatlipoca, a mysterious, dark and deceptive fella who carried a black obsidian mirror. The story goes that Tezzy (as his friends used to call him—of which he had none—so I guess no one called him that) got Quetzalcoatl drunk and then pulled out his magic mirror and made him look into the reflective black surface. Quetzalcoatl was horrified to see that his reflection was fierce, bitter and ugly; unbeknownst to the Plumed Serpent it was actually the reflection of Tezcatlipoca. Depressed by the vision, Quetzalcoatl left in a raft made of serpents and said, in his best Arnold Schwarzenegger impersonation, "I'll be back." Well, unfortunately for the Aztecs, there was a bit of mistaken identity when Conquistadors rolled into town with the fair-skinned and bearded Hernando Cortés, in 1519. The Aztec king Montezuma believed Cortés was, in fact, the returning Quetzalcoatl. Needless to say, Cortés didn't argue with this mistaken identity. This was a costly and bloody mistake for Montezuma and the Aztec culture. The rest is history, as they say.

Once I learned about the exploits of Quetzalcoatl, I started seeing him everywhere, especially in his metaphoric, plumed-serpent aspect. Everywhere I turned—snakes and birds. For instance, I went to visit a Diego Rivera mural entitled *Dream of a Sunday Afternoon* in Alameda Park, and there he is, front and center, wrapped around the neck of the fancifully-dressed, lampshade-hatted skeleton named Catrina. It was a feather boa, but with a snake head and tail—Quetzalcoatl. From there I wandered to the Belles

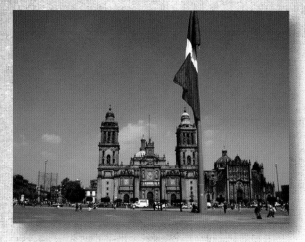

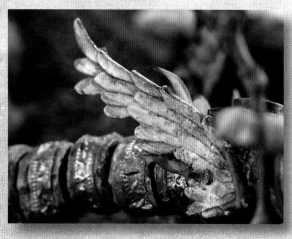

Artes Opera house, and what did I see at one of the entryways? Two slithering marble snakes forming the two opposing sides of an arch, with their fanged heads meeting at the keystone, which was a man wearing a large bird helmet. It was at this point that it dawned on me: the Mexican flag has the image of an eagle on a cactus clutching a serpent. Was Quetzalcoatl the omen that led the Aztecs to settle in the Mexico City area? For me, the answer seemed obvious and from that point on, I was hypersensitive to the snake-bird thing. It got to be a bit ludicrous, really. "Hey, what's with this zigzaggy street? It must be a metaphor for the plumed serpent." "What about those snakey-looking shoelaces?" I did have one sighting of the Mexican god that I will stand by though.

I had a view from my Mexico City hotel room that overlooked the Zocalo (square) and the Presidential Palace. In the center of the square was a giganto Mexican flag (this sucker was 15 meters by 25 meters on a 50-meter flagpole and was part of the Banderas Monumentales program that basically put up big ol' flags).

One evening at sunset, I heard a military band playing outside my window. I looked out and saw a large bit of pomp and circumstance as a military unit lowered the main flag. Remember, this is a *big* flag. So I was expecting them to fold it up and haul it away, but instead, they rolled it up like a big carpet. So here they were, marching out of the square with this long—dare I say—snake? Okay, so as I said, I was a little Quetzalcrazed at this point, but I swear they marched out of the square using a subtly serpentineish maneuver. Maybe I was reading into things . . . I think not.

The Process

The roving street vendors in Oaxaca have started selling movable wooden snakes and reptile toys. I'm sure you've seen the type I'm talking about. They seem lifelike because they appear to slither as you wave them back and forth, but they are actually made of wood—basically a series of pieces strung along a flexible leather spine, allowing the movement.

Well, I decided that I should use this concept to create a Quetzalcoatl piece. It would then become interactive—cool! An action figure, if you will. So, to go along with this concept, I started prowling the local secondhand shops. Store after store I would walk in and say, in a caveman voice, "I need some man-heads." Usually, I would get a bewildered look and a response like, "Good luck with that one." Store after store I wandered with no luck until a garage sale yielded a score: a bag of goodies—broken man-dolls! Included were GI Joes, Star Wars figures, and a bunch of karate action figures with really bad 1970s haircuts (remember the haircuts of Starbuck and Apollo on the original *Battlestar Galactica*?). All of these little hombres were missing various limbs. (I wondered if they went through the same trials and tribulations that I put my Six Million Dollar Man Doll through . . . after all, we can rebuild him.) So I found an appropriate head for Quetzalcoatl and some arms with kung fu grip, and started on my merry way.

I should say that while I knew the basic concept—a bunch of wood slices held together by a central flexible spine—I'd never tried to make one of those snaky devices before. Should be easy enough, right? Step one is to slice a piece of wood—in my case, a long dowel, about 1" (3.5cm) in diameter. This was a breeze—chop, chop, chop. (I should qualify; this is a breeze assuming you're not a power-tool-o-phobe. There are reasons they invented power tools. If I had to do this stuff the old fashioned way? Forget it; I would still be painting on canvases [not that there'd be anything wrong with that].) So as I was saying, "Chop, chop, chop on the chop saw." Like slicing bread, and no fingers lost—bonus!

So I admit I'm a bit lazy (not Big Lebowski-Dude lazy, but still). There are artists who look for the exact right thing for each piece they are working on, and you know who you are. I tend to use what is available. In this case, I scoured the studio and could find not one bit of leather to make the spine with. Next thing I did was to look down at the belt I was wearing. I was this close. Fortunately, I liked that particular belt and looked for other options. What I did have that was handy was a piece of metal strapping that had been used to hold crates together. Seemed like a good choice. The next step required making a little slice in the bottom of each piece of wood. With a little forethought (something often missing from the organic, creative process), an easy way to do this would have been to take the uncut dowel and using a table saw, adjust it so that the blade only came halfway through the diameter of the dowel. Then I could have just run a cut lengthwise down the dowel and sliced it like bread with the chop saw. Live and learn. So instead, I was doomed to taking my handy-dandy Dremel—fitted with the wood-cutting blade—and making individual slices in each piece after securing them, one by one, into the vise. Thirty of them—one by one.

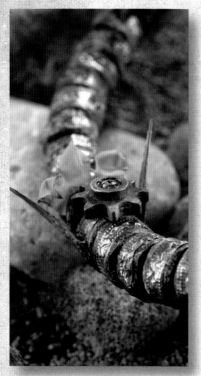

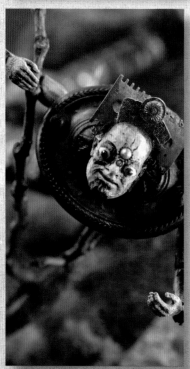

Before I assembled them into a long 'ole spine, I decided to do a bit of carving. For this, I actually used the sanding drum for the Dremel. I softened the edges and created a nice little valley that rings around each little piece. This was going to be used to inlay some embossed copper—fancy, huh? So once my high-tech/Andy Griffith-whittling was done, I took my metal strap and glued the dowel pieces onto it by squeezing some E-6000 into each of the slices' notches. E-6000 is strong, but also super messy. That's OK—what I can't wipe off, I can disguise. Once all the little tinker toy-looking things were added to the strap, I did a bit of repoussée work on long strips of copper that could be wrapped around each dowel and would both help hold the strap in place and cover the notched part.

OK, the basic structure was done. Next came the hard part—making that thing a piece of art. This is the part I long for and the part I simultaneously dread. Typically, making art isn't easy for me; it's a bloody battle. As for the idea of going into the studio and it being a joyous experience of pixie dust and daffodils—I ain't never seen that before. I've felt that way when I've finished a piece, but not before.

With Quetzalcoatl's body made, I immediately added one of my action-figure heads. I chose a Yul-Brenner-looking dude. He had a bit of a snarl that I liked. From there, I decided to add some eyes from my glass-eye collection from La Niña de las Posadas (more on this collection later). You would not believe how long adding the new eyes took. I started by carving out little orbits to set them into, but I went too deep with the Dremel and created holes in the head. I dropped a few inside the head that were not retrievable. Then, I spent hours—literally hours—deciding on eye size, color and shape. When coupled with this dude's bald head, the blue ones made him look like the vampire from Nosferatu. So I opted for brown ones.

At that point, he looked like the guy from the 1973 movie *Sssss*, with Dirk Benedict playing the poor sap turned into a snake man. I decided GI Joe arms might help. Sure enough, snake man became much more Quetzalcoatl-ed. The painting part of the process included some nice verdigris colors to really enhance the embossed copper.

As a final touch, I added a few silk leaves. I planned on attaching more colorful flower petals but it turned the piece too cutesy for my likes. The green was toned down enough that it didn't overshadow the rest of the piece.

Ta-da—Quetzalcoatl returns. And he's fun. And he has kung fu grip . . . now that's what I call a god.

The Quetzalcoatl Action Figure

Needless to say, there are countless ways you could dress up your own version of Quetzalcoatl, so I don't need to tell you which type of doll to use, but here is the process for creating the slithering body.

Stuff You Need

wood dowel (the one I used was about 1" [3.5cm] in diameter)

Dremel tool with cutting blade and sanding drum

"man doll" head and arms

chop saw

epoxy (E-6000)

strapping wire

copper sheet (22- or 24-gauge)

embossing tools

torch

scissors

paintbrush and water

acrylic paints:

 white

 Phthalo Green

 Dioxazine Purple (Golden)

 Mars Black (Golden)

 Quinacridone Gold (Golden)

 Van Dyke Brown (Golden)

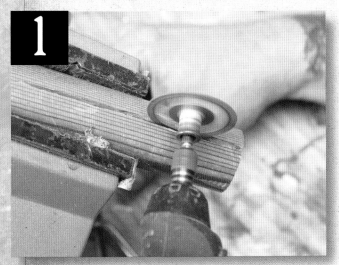

1

Start with a large-diameter dowel (1" [3cm] or so), and using a Dremel, carve out a notch about ½" (13mm) deep that runs the length of the dowel.

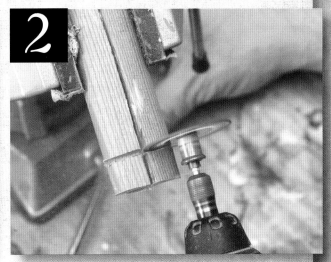

2

Next, cut the length into twenty to thirty 1" (3cm) sections.

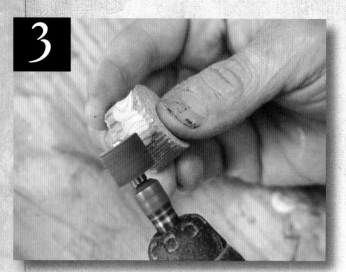

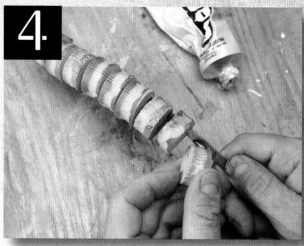

3 Sand each piece to smooth the rough edges. Then sand out a slight groove around the perimeter of each piece.

4. Cut a length of strapping wire to accommodate the length of your snake. Using epoxy, glue the pieces to the wire, inserting the wire into the notch, leaving about a ¹⁄₁₆" (2mm) gap between pieces.

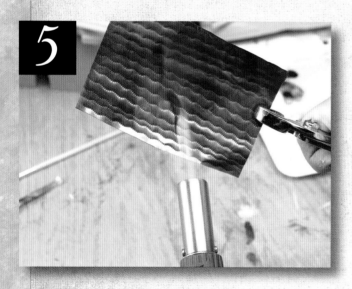

5 While the glue cures, prepare some metal strips for each piece. Start by embossing some copper, however you see fit. Then torch the piece to give it a patina.

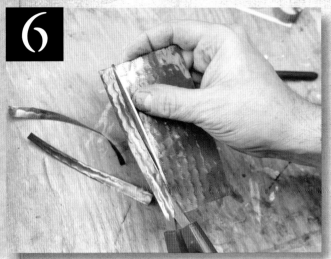

6

When cool, cut the metal into strips, about ¼"
(6mm) or so wide.

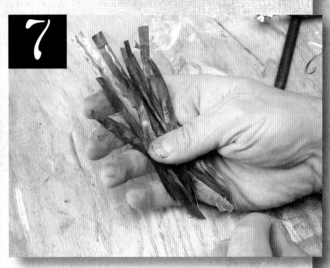

7

The irregularities of the copper pieces
will vary widely. This is a good thing.

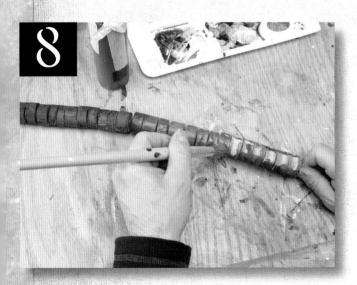

8

When the epoxy has cured,
paint the wood with a wash
of a dark color.

9

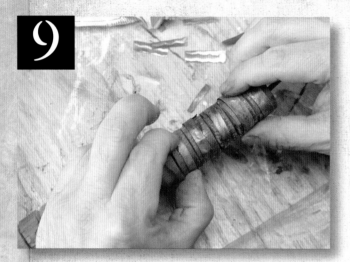

Glue one metal strip to each piece of wood, around the indented portion. You may wish to secure each piece with a nail, tape or rubber band while the glue cures.

10

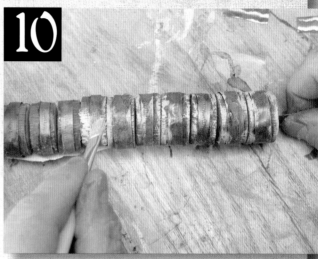

Drybrush a mix of Verdigris (see page 91) over the entire snake, including the copper bands.

11

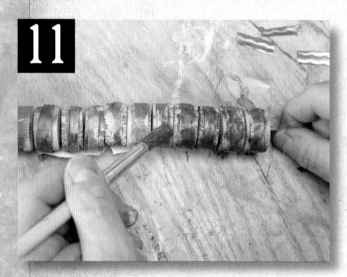

Now wash over everything with a wash of Uszhhh (see page 23). Add a head or any other appendages as you see fit.

Verdigris

The process of getting a nice patina on Quetzacoatl was easy because I was using copper—a material that naturally achieves this look and achieves it even more quickly with the supernatural addition of manufactured patina solutions! But for times when actual copper is not part of the deal-io, paint washes will easily do the trick.

Stuff You Need

paintbrush and water

acrylic paints:

- white
- Phthalo Green
- Dioxazine Purple (Golden)
- Mars Black (Golden)
- Quinacridone Gold (Golden)
- Van Dyke Brown (Golden)

1

This technique works best over something dark, in this case, black. Mix white, a tiny bit of Phthalo Green, and an even tinier bit of Diox Purple. Load a dry brush with the mixture and work excess paint out of the brush on a paper towel. Run the dry brush over the dark surface, allowing the paint to just skim the surface of the textures.

2

When the first layer is dry, brush a wash of Uszhhh (see page 23) over the piece.

La Niña de las Posadas

I teach a class in Oaxaca every year and one of the best parts of doing that class is some of the junking and supply-gathering we get to do. It can be a different sort of experience in Mexico. For instance, when you go to a hardware store, it's no Home Depot. Typically, their hardware stores are very small spaces that have prototypes of the merchandise displayed in various locations about the store. So if your Spanish is somewhat lacking, like mine, shopping is a process of looking and pointing. The clerk then retrieves your items. It's a little intimidating at first, but once you get the knack it's kind of fun, mostly because it encourages human interaction. Now having said that, I will say that I am often put in the position of Shopper Liaison for a large group of students. "We'll take seventeen of these nails, here, and three mousetraps." "Seventeen more nails but smaller. Oh . . . Wait . . . Those aren't the right nails. Are there any in brass?" This can get a bit overwhelming when you "hablo un poco." (My most popular saying.)

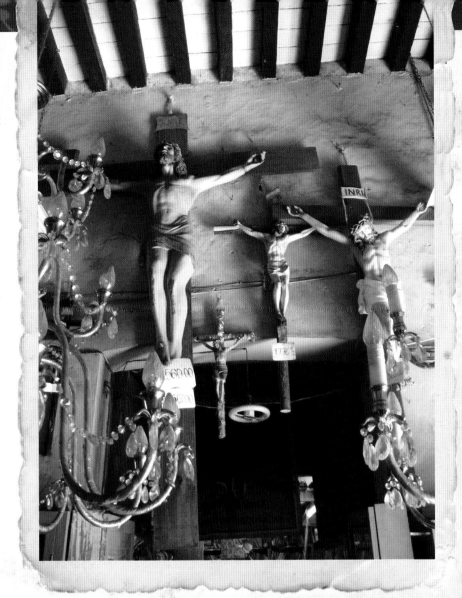

There is another place I like to send students to that is a shrine-makers paradise: La Niña de las Posadas. This is a religious supply store. This place is wild. When you walk in you are overwhelmed with life-sized replicas of Christ on the Cross. Then comes the room of Every Saint Under the Sun. If they don't have the saint you're looking for then you're not looking very hard. Guadalupes, Soledads, San Franciscos, on and on, lined up in rows. In fact, when I first walked into this room, I couldn't help feeling like I was a comedian on stage, surrounded by a really tough crowd.

As you meander through the store, you find a variety of rooms filled with other sorts of goodies. One room is filled with Milagros and metal charms for various saints. Another is filled with ornate frames, nichos and holy water holders. Another room is candles and crowns. My favorite is the halo and eye section. It is here that they sell glass eyes of various sizes, I assume, to repair eyes of the various statues you may own. This was also very popular with my class. Hordes of marauding art students descended on this counter. Madness, I tell you. I stood back and watched with amusement, but then I

saw the frustration that was in the staff's eyes. One pretty young attendant named Dulce (sweet), knowing that I was behind this insane group of gringas and gringos, jokingly gave me the evil eye. She kept saying to the group, "lento" (slow down).

Now what is really crazy about this place is that when you go to the various locations and order your goods, you do it in the same way as you would at the hardware store. The difference is that for every type of item you select you get a receipt—not the item. So you order ten heart Milagros—you get a receipt; you order twenty eyes—you get a receipt; fifteen frames—a receipt. You then take your stack of receipts to a line for the cashier. Here you pay, your receipts are stamped and you move to the next line—the line where you pick up your stuff.

This is the somewhat surreal part: there are piles of all the things everyone in the store has ordered. Stacks of wings, piles of eyes of different colors and sizes, Milagros here, there and everywhere, etc. You hand over your receipts and the lunacy begins. The clerks go through every item on the receipt and try to locate the items. Some-

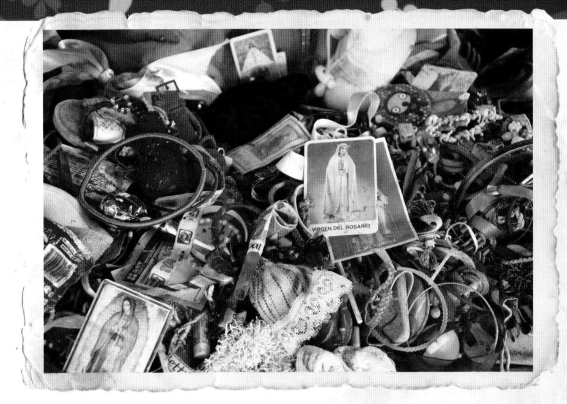

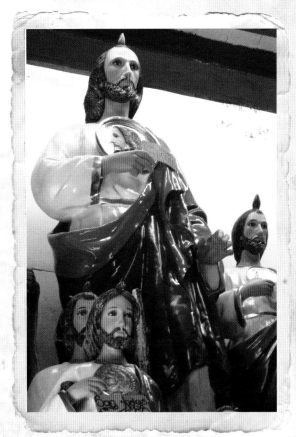

times they can't be located, and so the clerk disappears for a while to try and find them behind various counters. Eventually, you do get out of there, and with luck you will get out of there with most of the items you paid for. Often you find a few bits that weren't yours. I love this place, but be warned, your zen levels better be on overdrive. Of course, in general, I think that when in Mexico, best to zen-ify; otherwise, if you're wound tight, your brain will explode all over the place, and that makes for one ugly American tourist.

Tigre

Jaguars are a popular subject matter in Mesoamerican art. The ancient Olmecs were in awe of these large cats, and the shaman would closely associate himself with these critters. They were considered guardian spirits, because they had the capability to move between the living and the spirit worlds and would be able to protect the shaman from evil spirits if he, too, ventured into such realms. Jaguars lived in trees yet could be in water; prowled both at night and during the day; wandered the land but also the caves where the ancestors dwelled. Another interesting thing is that in art, the Olmecs created representations of what now are called "were-jaguars" (yep, just like werewolves). These carvings are representations of people that are somewhat jaguar-ish. Of course, I am reminded of the film *Cat People* with Natasha Kinski. The Olmec figures aren't quite as sexy—and never posed with a boa constrictor (then again, maybe they did).

The Aztecs had soldiers associated with the jaguar, who dressed in skins from the animal, and the Mayans considered this jungle cat to be the most important creature in the cosmos. In fact, I recently discovered that someone replicated an old Mayan instrument from A.D 600-900. This instrument was considered to be the very first stringed instrument in the Americas before the Europeans rolled into town. It consists of a drum, a string attached to the drum membrane, the string then attached to a long stick (it looks like someone fishing out of a drum), then a second rhasped stick is used to scrape across the long stick. The sound travels down the string into the drum, where it is amplified. It's amazing because it sounds exactly like a jaguar growling. I'm not talking sort of—I mean exactly! It's astounding. (A sound sample can be found at the Princeton Art Museum website if you're interested.)

Jaguar costumes and masks are used in various rituals and dances, dating back to the pre-Columbian era. One such ritual is Tigre (which translates to tiger, but is a colloquial term for jaguar) rope fighting, in Zitlala, in which two participants wear large, brightly-painted jaguar masks and go to town on each other with stiffened rope clubs. They whip each other until one is the apparent winner. Usually blood is spilt at the events, but that is the point. These are rituals to help the harvest. Many in the community believe that the blood of the fighters will help next year's crops. They are appeasing the rain god. For Central Mexico the rain god is Tlaloc, and, interestingly, he has fangs and goggled eyes, which is not that dissimilar from the jaguar costumes of the fighters. Don't let anyone fool you; the ancient gods are still very much alive in Mexican culture.

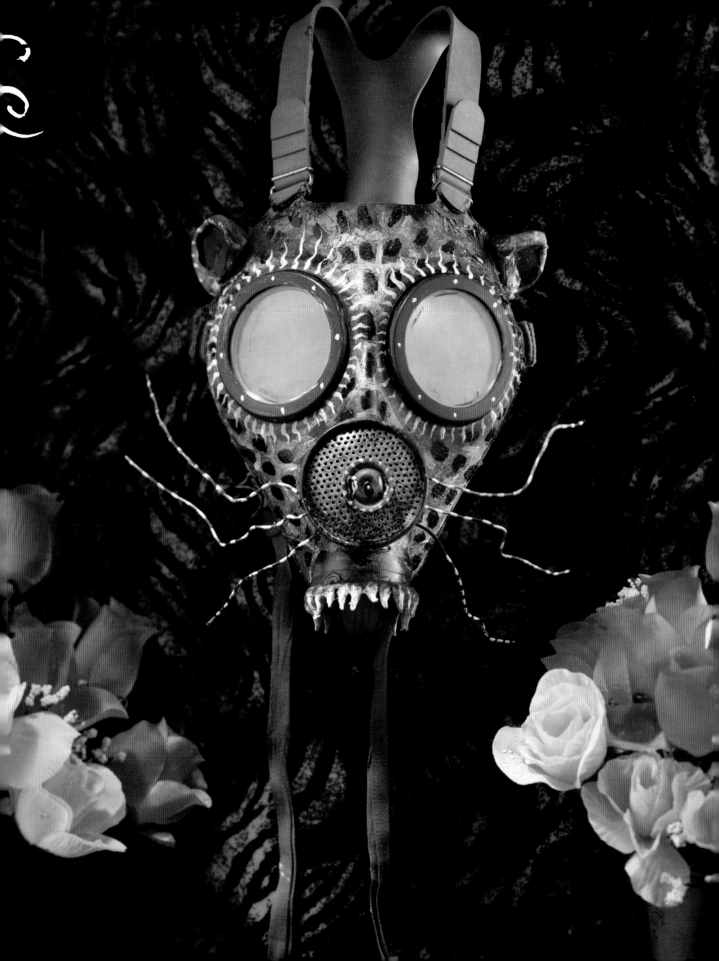

Process

The jaguar masks from the Tigre fights are more like a helmet, but they have big round, often mirrored eyes, and a large fang-filled mouth. When I approached this project, I decided I wanted to give a sense of the traditional source. In other words, I wanted to experiment and see what would happen if I put on the brakes with my particular aesthetics and attempted to let the regional style be more apparent.

Of course, at first, I had to use some of my assemblage techniques; after all, I still wanted to use found objects. In particular, I wanted to use a Russian military gas mask I had lying about. I thought this might be an interesting item because it, too, was designed for combat, and I thought that might make an interesting parallel. Another reason I gravitated to the gas-mask idea was the goggle-like eyes that were so reminiscent of the mirrored eyes of the Tigre masks—very round and very prominent.

The first thing was to de-mole-ify the mask. In other words, make it not look like an under-ground dwelling mammal (nor a strange growth on the body either). Of course, most gas masks seem to have that subterranean animal motif (except for the big eyes, as moles are blind). So, to transform the mole-man mask, I immediately added feline ears and teeth that I formed out of Apoxie Clay. Once formed, I let them dry for two hours and then attached them. For the teeth I used E-6000, since they were light. The ears required a tiny bit more construction, but a couple of screws from the inside of the mask to the clay forms did the trick.

One thing that you see in many of these traditional masks is hair. Not everywhere, just in various spots around the face, sometimes used as whiskers. I didn't really want to use animal hair but I did want whiskers. I first drilled some holes in the area where the nose would be and

then inserted some rebar tie wire into the holes. Nice thing about the tie wire is that it is very bendy and holds its form.

OK, time to paint. I had a photo of an actual Tigre mask taped to my studio wall. Bright yellow. Spots. Red eyes. White teeth.

Then the challenge: to create something without my usual painting style—in other words, no Uszhhh. It had been years since I copied from another source so directly. Here's the amazing thing. It was flippin' easy. I looked, I duplicated. I am used to agonizing over decisions and directions. In this situation the traditional jaguar mask already established the direction. I don't think I have ever finished a work of art so quickly in my life, except for my abstract expressionist phase where I was very messy and very fast. (Yes, I know . . . I'm still very messy.)

Conclusion.

I have decided that replication is much easier than blind creation. To create something without a preconceived notion is a battle; this is how I usually work. One might surmise that because of this experiment and the ease at which I finished the piece, perhaps I would start to work that way more frequently. Here's the rub: As much of a battle as it is to conceive of something unique, it is still worth all the grief necessary for its inception. I remember my mother saying that she would never give up the pain she felt giving birth to my sister or me. Being male, I can't entirely relate, but it makes sense; the greater the sacrifice, the bigger the reward. It is not unlike those Tigre rope fight-ers; they are fighting and suffering in the hopes that their pain will reap great bounty in the fields. In my studio I'm trying to summon my own rain gods—preferably with less scar tissue. Then again, I do work with power tools

98

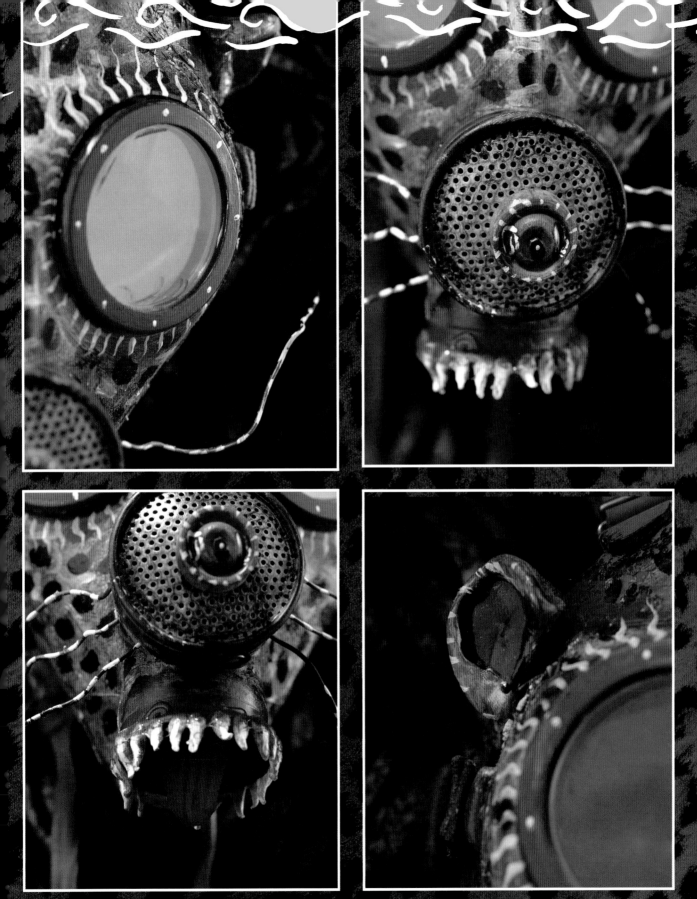

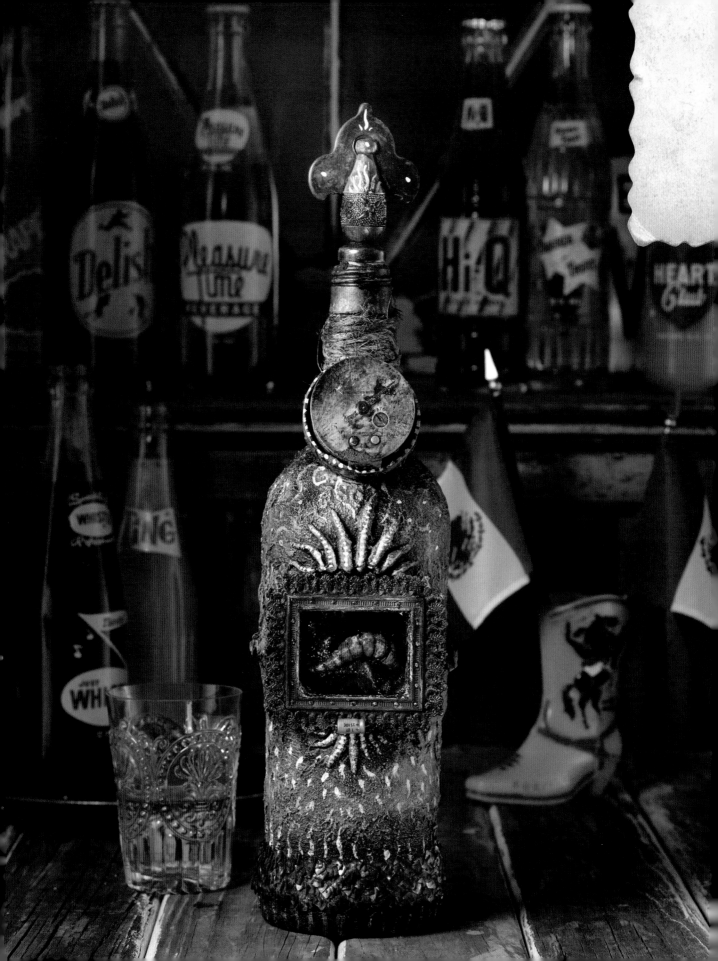

Mezcal

As the saying goes, "Para todo mal, mezcal, y para todo bien, también." (For everything bad, mezcal, and for everything good, as well.) This is the smoky-flavored magical elixir of Mexico, usually associated with the southern state of Oaxaca. Similar to its cousin, tequila, both are made from agave (maguey) plants—tequila specifically from blue agave, while mezcal can be made from a variety of agave types. To many, the biggest difference is that sometimes mezcal will have a worm—actually a caterpillar—in the bottom of the bottle. While it is actually against the law to put worms in tequila, I'm sure some people think that it should be illegal to put worms in any booze, but I'll address that later.

I can vividly remember my first Mexican mezcal experience. It was my first trip to Oaxaca and I was solo. One of the most wonderful aspects of Oaxaca is the people-watching opportunities available at the various outdoor restaurants scattered around the Zócalo (city square). I was wandering around looking for a place to eat and a waiter hailed me and pointed to a table. It looked as good as any, and it had a nice view of the musicians, locals and tourists, so I accepted the invitation. I was enjoying a nice chicken mole (chocolate/chili sauce from this region), and I noticed that another customer a few tables down had two shot glasses in front of him, one with a golden liquor and another with something that looked like tomato juice with a salted rim. I called over Alberto, my waiter, and

Mezcal con Sangrita

2 cups tomato juice

1 cup orange juice

¼ cup lime juice

2 teaspoons Tabasco Hot Sauce

2 teaspoons minced onion

2 teaspoons Worcestershire Sauce

cracked pepper

celery salt

seasoned salt

mezcal (you decide how much)

asked him what the man was drinking. He said, "Mezcal con sangrita" (Mezcal with little blood). How could I resist this? Basically, you take a sip of mezcal and a sip of sangrita. Now, sangrita is basically a Mexican Bloody Mary mix, and it's amazing how it cuts the bite of the mezcal. In fact it makes the mezcal more flavorful. There are tons of different recipes for sangrita. I've even seen Fanta soda used (which was actually pretty good), but above is a recipe that I use at home to bring back the feeling of Oaxaca on a warm fall day.

So, let's talk worms, or, more correctly, caterpillars. When you do find a worm in a bottle of mezcal it is usually a "gusano rojo," a red worm that hangs out in the maguey plant. Have no fear—if you end up eating or drinking this little guy out of a bottle, the alcohol most definitely has killed anything that will harm you. I've eaten my share of pickled caterpillars, but one thing that I have yet to do is partake of the live ones. Yikes. It is not uncommon to see women in traditional indigenous clothing carrying baskets on their heads filled with worms. Mezcal drinkers will plunk a few pesos down to garnish their drink with these squirming little dudes. Roasted, okay, I could handle that; after all, the orange-colored salt around the rim of my sangrita glass is usually sal de gusano—a salt, pepper and ground-roasted-worm combo. It's actually delish—trust me.

The premium mezcal is great, the medium-range stuff is really good, but . . . the bad stuff is really bad. Perhaps lighter fluid may be a better way to describe it. So if you have a choice

One of the reasons I'm going on so about mezcal is that, for me, if I need to be recharged creatively, I go to Oaxaca. There is an energy here that is life affirming. Art from the various villages flow through the city like a colorful river. Sitting on the square you can watch the families, the festival processions, the street vendors—the heart of a beautiful place. Sitting, watching, usually sketching with a mezcal con sangrita is the most relaxing thing in the world to me. Ideas flow through me—and certainly the mezcal helps, but not just because of the alcohol; it is a smoky earth flavor that reminds me of the dusty ancient culture that rests beneath my feet.

The Process

How could I write a book about my Mexican inspirations and not include mezcal? It is no frivolous drink; it is something cultural. It is a cultural symbol, but it is also a personal symbol for my various adventures down south. A few years back, I was given a gift from an art teacher, James Todd. He stopped by with an empty bottle of Gusano Rojo, a brand of mezcal he picked up on one of his excursions. Now ordinarily, I would consider an empty bottle to be an insult, but he brought it to me because he thought I might get a kick out of the label. It's like something out of a 1930s comic strip, depicting a red female worm walking past a field of agave plants, carrying a jug on her head.

It is a bottle that I have kept prominently displayed with my collection of Day of the Dead toys. When it came to making a mezcal shrine, I was inches away from transforming this actual bottle. I couldn't do it, though. It's not that I couldn't buy another bottle of this stuff with the same label; it is because an art teacher that I held in such high regard offered it to me as a gift. So, transforming the actual bottle was out of the question. Instead, I found an old rum bottle that would work. I intended to do so much altering that not much would remain to even identify what it originally housed anyway. I wanted to cut an opening into the side of the bottle to create a little nook for a gusano rojo. That meant it was time for the Dremel and the diamond cutoff wheel. For this, I needed to firmly hold my bottle in place, in a vise; I didn't want to be holding the bottle in my hand if the wheel decided to go rolling. (I've found that a

cutoff wheel doesn't recognize the difference between flesh and non-flesh. Best to keep my fingers away.) Next, I needed to have a spray bottle handy since you need to keep glass wet when working with diamond bits or a diamond wheel. Slowly, I cut a rectangle out of the center of the bottle. One hand managed the Dremel, the other kept busy atomizing water (which is just a fancy way of saying spritzing). In no time I had a small nook in my bottle. I sized it to match a little ornate frame I had bought from an antique market in Mexico City. Since the bottle had a curved edge and the frame was straight, there were spaces on the sides of the frame where the bottle and frame didn't connect. They would need to be filled in. I had just the stuff

One of my recent discoveries is a product called Aves Apoxie Clay. This stuff rocks! I discovered it when I started playing with broken toys (no, not when I was a child—as an adult). I found that it was a great way to connect objects that don't belong to each other. The nice thing about this stuff is that it is a two-part clay that air cures after it's mixed. It dries pretty quickly with a working time of two to three hours. When it cures, it cures hard—real hard. There are epoxy putties that have a quicker drying time, but I have found that for the most part they don't have the strength or durability that the Aves product has. The other reason I like it is that water can be used to smooth it out within the working time. I use this stuff for tons of different applications. Have a bolt without a nut? *Voilá!* Or if you need to build up a surface or close off a gap between, say, a bottle

and the edge of a frame, it is perfect.

Around the opening I had cut in the bottle, I took some Apoxie Clay and I built a nice little form for my tiny frame to rest in, and I smoothed the clay with a bit of water. I had a little extra clay so, instead of wasting it, I took it and sculpted some agave leaf forms that I applied to the area above and below the frame. I still had more clay and I decided what to put inside the nook—a gusano rojo (a little red worm). I started off with a comical worm like on the mezcal label. Rapidly, I decided that it needed to be more naturalistic and larger. The legs were the hardest part. I couldn't make them small enough, so what I did was press the side of a wood screw along the bottom of the worm. This created a nice zigzaggy pattern that left the impression of little insect legs.

The plan was to seemingly float my little friend inside the nook. To do this, I took a screw and ran it through a small piece of wood. I set the wood inside the bottle so that the tip of the screw came through the center of the frame. Eventually, I would set the worm onto this screw. In the meantime, the wood needed to be set into place. I thought that foam insulation would hold the block of wood in position as well as create a nice little cave-ish look. I took some Great Stuff foam insulation and filled the bottle after centering the wood.

One day later, the foam had set and luckily, as a precaution, I had masked off the frame with plastic, in the event that the foam spilled over—which it did. I peeled off the plastic and started digging into the foam to find the screw and to carve out my little cave.

Before I added my worm, I needed to add some texture to the exterior of the bottle. I had some Extra Coarse Pumice Gel by Golden that would work nicely, because it would leave lots of little nooks and crannies that would add texture and dimension when I painted over it with washes. The more texture, the more interestingly the surface reacts to the layers of watery paint. I opted for a nice greenish hue, since I intended to paint my worm the complementary color of red; this color combo would call attention to the worm.

After I got the colors right, I added a few other items such as a gauge—perhaps to measure alcohol content—and as the top for the bottle, I added a little steeple-like form. Finally, the last thing to do was add Gus, the gusano rojo. To do this, I carefully predrilled a tiny hole into Gus that was the same in diameter as the screw. I added a little E-6000 to the screw and set him onto it. After the glue cured, I took a tiny bit of Apoxie Clay and added some to the back where Gus and the screw met. This was for a bit of extra insurance. Never hurts.

A bit of painting here, a doodad there, and by the end I was pleased, although I had one disappointment: the bottle couldn't actually be used. This would have been a pretty item to serve up mezcal. Well, maybe next time I'll befriend a glassblower to create a bottle with a nook built into it. Yes, next time . . . let me ponder it over a Mezcal con Sangrita . . . and yes, perhaps a worm.

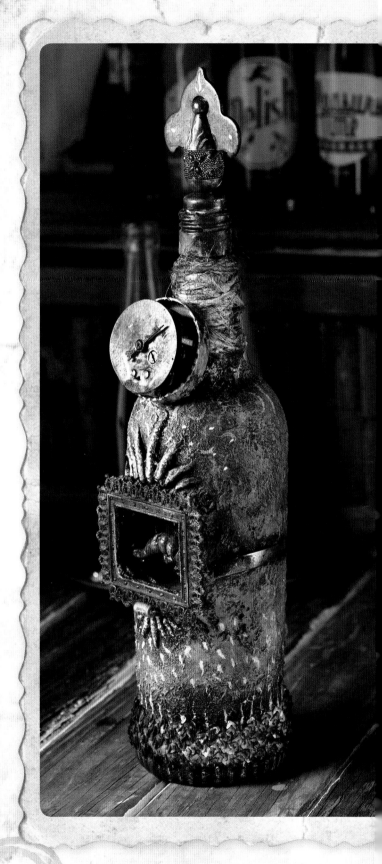

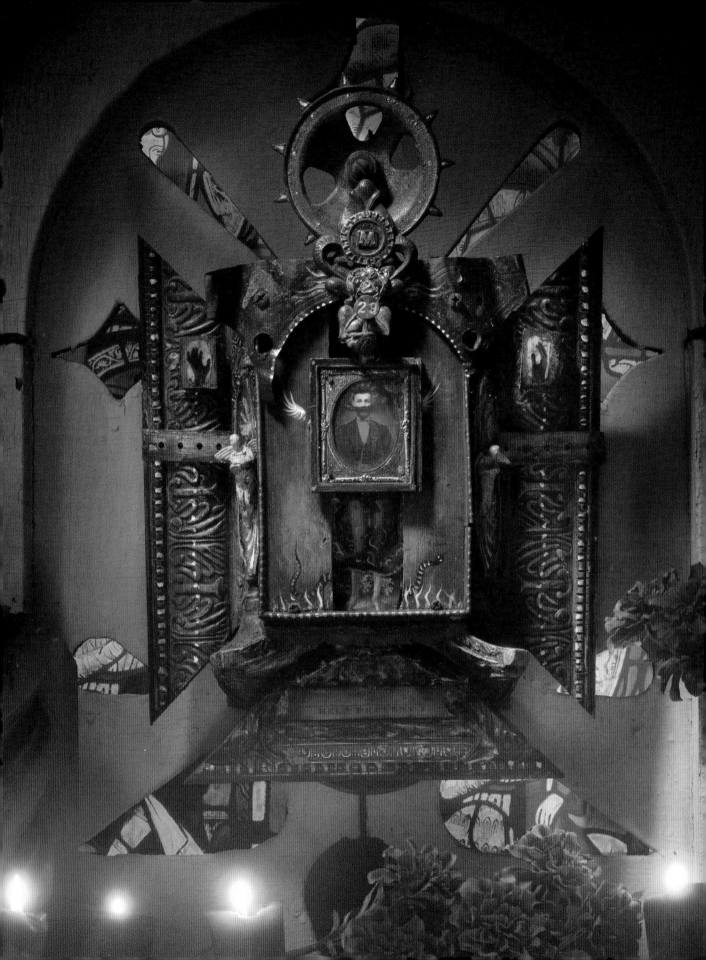

San Miguel

"San Miguel vs. el Diablo" sounds like a great Mexican horror/wrestling movie, but it's actually a classic match-up between rivals. A common image of San Miguel (Saint Michael) is with wings outstretched, sword unsheathed, and a devil or serpent beneath his feet. Now that's what I call a matchup.

I had a strange sighting of ole San Miguel (well, sort of). A couple of years back, I was doing my annual Oaxaca Dia de los Muertos workshop, and all week I had been seeking out a retablo—a piece of work representing the archangel Michael. I was his namesake after all and, though I'm not Catholic, I am a sucker for good vs. evil themes in art. I looked in various shops for vintage retablos or nichos, but nothing of Saint Michael. I found a few ceramic things, but I was really hoping for something more antique-ish.

Well, one day on a field trip, my class and I headed to the village of Ocotlan to visit a Dia del los Muertos celebration, so we packed up the van and headed down the road. Funny thing about filling a van up with folks who have the same affinity to old junk as me: Every pile of iron oxide becomes an attraction. Every few minutes you would hear the sound of someone go, "Ooooh" Usually this meant that outside the window was a big pile of rusty things. Then the cameras would start snapping. The driver, bewildered, didn't quite know what to think. He kept looking out the window to see what everyone was photographing. He then looked back through the rearview mirror implying the question "Should I stop?" We motored on. We had places to be, but any other time, definitely.

Ocotlan is a little village that was the home of the famed painter Rodolfo Morales. After achieving notoriety, he created a foundation that helped restore the village of Ocotlan as well as other Oaxacan historic structures, and much of the funding came from his own pocket. He would create a collage each day. Funds generated from selling the works of art would go to fund his various restoration projects. He died in 2001 but, needless to say, he remains a local hero in the Oaxaca area.

We pulled up to a cemetery, and people were everywhere, as were various vendors—especially folks selling flowers. The class was in awe. They had seen a nighttime celebration, which is amazing because of the candlelight, but a daytime celebration is so rich in color, especially the golden glow of marigolds (whose brightness helps create a path for the dead to follow).

We wandered past the beautiful graves and the beautiful people celebrating, sometimes interacting with the locals, sometimes just taking the experience in. I came across a grave with a crucifix painted black and then decorated with patterns and writing in white paint. I hadn't really noticed any graves like this and was drawn to the uniqueness. A family sat nearby chatting as I admired their painted cross. It was then that I noticed something lying in the dirt. I assumed it was a little Guadalupe or skeleton toy. I alerted the matriarch of the bunch. She thanked me, reached down, picked it up and placed it on top of the cross. And there it was: San Miguel in the form of a tiny little figurine, made of plaster or resin. I don't recall a serpent below his feet, but it most certainly was him. I smiled and wandered on. I never went home with a San Miguel retablo or effigy, but at least I found him. Strange things do happen in this part of the world. Strange and wonderful.

Retablos vs. Ex Votos

There is often a bit of confusion about the term retablo. Often retablos are confused with Ex Votos. Retablos are usually representations of a religious figure and the specific miracle that he/she is associated with; for instance, Saint Michael stomping on the devil, or Guadalupe appearing to Juan Diego. The term literally means "behind the altar," so these paintings (whether on wood or tin) would be housed in that location of the church.

An Ex Voto, on the other hand, is an everyday miracle, like surviving a car crash or an earthquake. A virgin or saint might be present because he/she is being thanked for the mystical intervention.

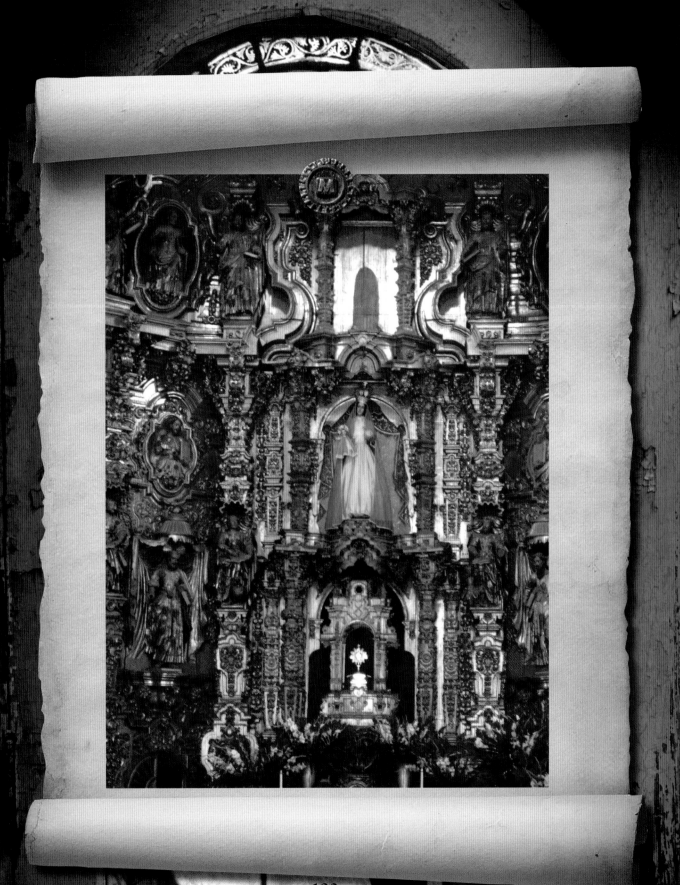

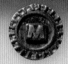

The Process of Keeping the Devil in the Hole

So, I have a confession to make: I am a predator. But . . . I'm jumping ahead; I'll get to that in a minute.

I started this project with a cigar mold that had about forty or so little slots. I bought this from a guy who is what the superhero Wolverine will look like at age sixty—grey-white hair everywhere. In fact, his long, grey chest hair grew up from his buttoned shirt and reached the underside of his jaw, and his hairdo was Wolverine-esqe. Plus, he kept saying, "There is more stuff in the basement." I decided that given his lycanthropic nature, it might not be a wise idea. I purchased my goody and wandered off, checking the phase of the moon as I left.

My original idea was to put little angels in the upper half of the mold and little devils in the lower half—which I did. In fact, I even took the time to apply gold leaf to the angels' little nooks. I did this thinking I should try gold leafing. So I did it. I hated it. And I ended up covering over it anyway. Oh well—happens all the time.

As for the image of San Miguel, I used a vintage photograph in an old frame. I placed the frame on an old wooden board, and painted legs beneath the frame. Beneath his feet, I painted a snake. I added a little of this and a little of that, parts from a loom, a strange gear-like thing that sort of crowned the piece, and bit by bit I decided it was done. In fact, it was one of the earliest pieces finished for this book. I moved on and created other things. Meanwhile, it hung in the studio . . . lurking.

Believe it or not, my studio is a dangerous place for finished art. If my pieces were wise, they would make attempts to be purchased or at least move into the house. Out there in the studio though, their fate is uncertain. All alone, they are helpless to a vicious predator—me.

Well, such was the fate of old San Miguel. As I worked on other pieces, he started to annoy me. Something about that cigar mold was just not right. I would ignore it for a bit, but still, it nagged me. It was like in a werewolf movie (to keep the theme going) where the werewolf is a good guy but just can't help himself, so he eats his girlfriend. That's me with art. The San Miguel piece pushed me to the brink, and I started dismantling it. I took the central piece off of the cigar molds and decided to abandon the original concept entirely. Hours

wasted . . . gold leafing . . . arghhhh. The central figure of Miguel remained, but I had pieces of carnage every-where. At this point, I wasn't sure how to proceed.

In the corner of my studio was a bubble-wrapped item. Out of curiosity I opened it. "Oh," I said, "here is that nice piece, called Adam, that I did for Rice's book, *Living the Creative Life*." It was a piece that I really liked, but little did poor Adam know that he was about to be devoured—assimilated.

In a mad frenzy, parts were flying. Drills were whirling. Hammers whacking. It was a mad mess of screws, and glue, and nails, and wood, and metal. Times like this are touch and go. I could take two pieces and turn them into one spectacular piece, or, on the other hand, two decent pieces can end up being fodder for the landfill. Miraculously, this time was a success; I was a bajillion times happier. Two pieces into one—two great tastes in one candy bar, as the old Reeses commercial used to say.

I recommend you check out *Living the Creative Life* and see the transformation. Undoubtedly, some readers will be distressed by the loss of Adam, but for me, it was worth the sacrifice. As I said, my studio is a dangerous place for finished art.

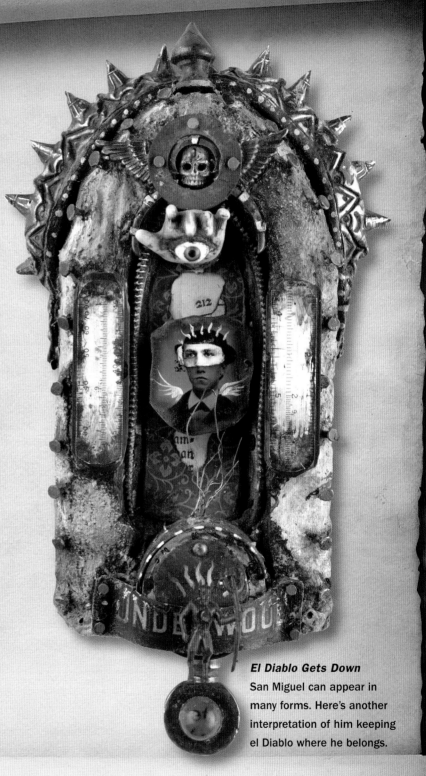

El Diablo Gets Down
San Miguel can appear in many forms. Here's another interpretation of him keeping el Diablo where he belongs.

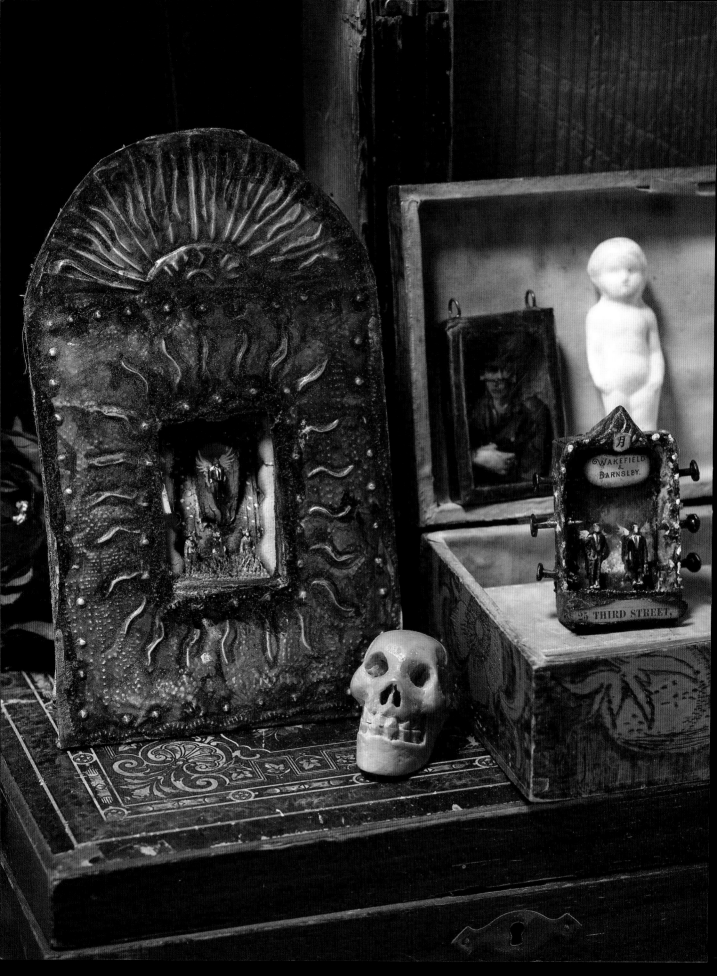

NICHOS

When I started to consider the topic of Nichos, I realized that it wasn't an easy concept to nail down. Some folks believe that the term refers to little tin boxes with saints, or the like, housed inside of them. Well it does, but it can also refer to retablos or even ex votos. And, it can refer to little Day-of-the-Dead scenes. Basically, what makes a nicho a nicho is the distinguishing feature of a little nook or niche—nicho. More specifically, it is a tiny shrine that is shadow box-ish—a little place to put something sacred or devotional. The best part is that they can be, and often are, made of almost anything, from cigar boxes to elaborate wooden forms.

In my home I have a few antique nichos made of wood; a couple copper, embossed boxes with retablos in them; tons of Dia de los Muertos nichos; and, my most recent acquisition, a very kitschy Lucha Libre nicho that houses a little wrestling figure and is made with a plethora of materials—all shiny and colorful. This, of course, doesn't even address the bajillions of items I've made. I've created nichos from shoes, matchboxes and so on. And this is what makes the nicho such a great art form: It can be made from the most elaborate materials or the simplest. The most sacred items can be used or the most outlandish bits of pop culture—sometimes both.

This is what I love about Mexico. Here, art is a continuum of the sacred to the garish. In many instances, these descriptions flow together, like an old wooden saint surrounded by a halo of neon. The traditional flows into the unconventional; the sacred flows into the meretricious; the indigenous flows into the post-Columbian. Opposites aren't divided but are instead fluid, ever-moving and evolving.

Do-It-Yourself Nicho

This is a fun way to make your own little nook. I've actually put an ex voto-ish scene in the one I made here, but any number of elements would work instead.

Stuff You Need

- small piece of Masonite or similar board
- metal foil sheeting
- scissors
- circle template
- stylus or scribe tool
- thin piece of foam
- paper stump
- assorted embossing wheels (Ten Seconds Studio)
- texture templates (Ten Seconds Studio)
- Plexiglas
- heat gun
- acrylic paints (your choice)
- detail brush, other brushes and water
- sanding block
- craft knife
- heat gun
- Dremel and cutoff wheel
- caulk
- paper towel
- matchbox
- collage elements to create scene in matchbox, including miniature person (such as one used for model railroading)
- E-6000

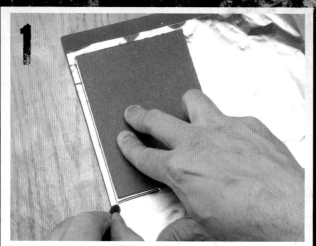

This type of nicho all starts with a pretty piece of embossed metal sheeting. Start with a basic rectangular shape to trace around and one piece of sheeting. Trace around the shape using a scribe, working on a thin piece of foam.

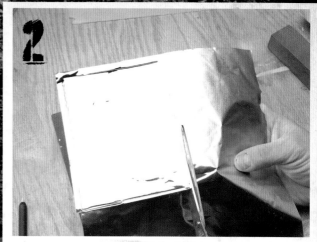

Cut excess metal away from the shape using scissors.

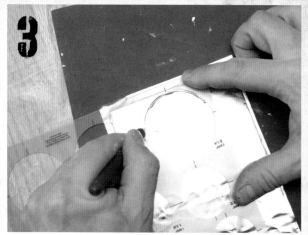

Here I am expanding on the basic shape to add a dome on what will be the top. This is easy if you use a circle template.

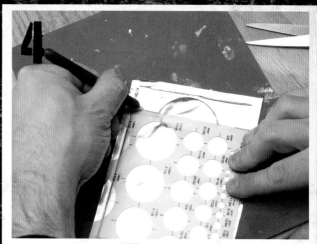

A couple of straight lines complete the final shape.

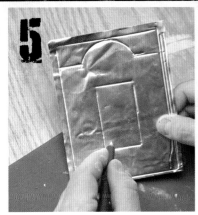

5 I also added a small window to the center that was just a bit smaller than the size of a standard matchbox.

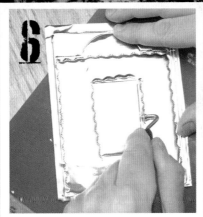

6 Many tools may be used to add design elements. This embossing wheel creates nice wiggly lines.

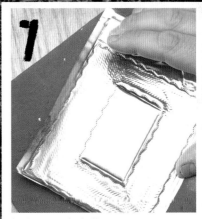

7 And more wiggly lines.

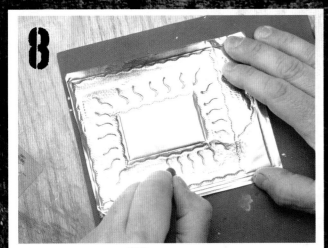

8 Sometimes I like to add a subtler texture over the entire piece using a stylus.

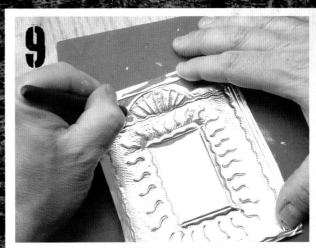

9 I'm now starting to add smaller details, like these tiny squiggles.

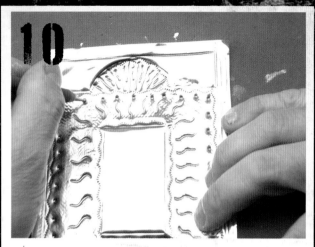

10

To create a riveted look, I first push my stylus into the metal to make a small cup shape.

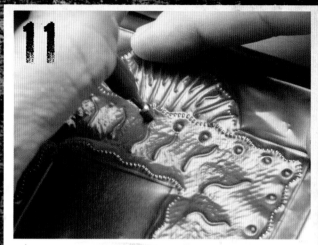

11

Now it's time to work on the reverse side of the metal, which here, is a dark color. Working now on a piece of Plexi-glas, I'm first going to push a ball shape into the circles made in the last step, again, using my stylus.

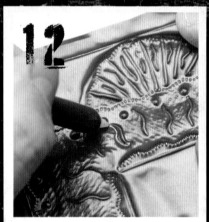

12

Using a fine scribe tool, I am now going to refine all of the shapes/tex-tures that I made on the initial side.

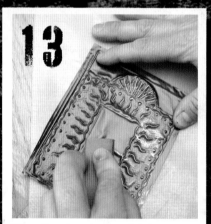

13

When the piece is completely em-bossed, it's time to sand. Using a sanding block, work sandpaper over the entire piece, to reveal silver on all of the raised areas.

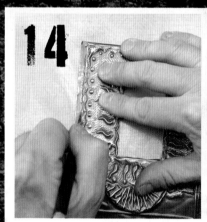

14

Cut the window out using a craft knife. (Cut out the perimeter of the shape using either scissors or a craft knife.)

 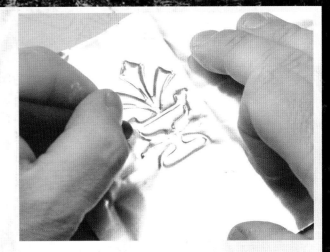

A Lasting Impression

Texture templates are available in a large variety and can be used in lieu of freehand work, if you like.
Put a template under the metal and rub over it with a paper stump to feel out the template's shape.
Then turn the metal over and refine it with a scribe tool, just like you did for step 12.

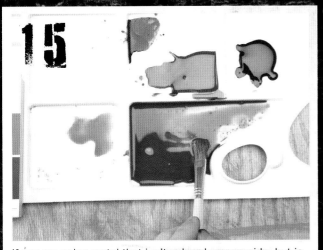

If you are using metal that isn't colored on one side, but is simply silver on both sides, you can always add paint to it to bring out the details. First, complete all of your embossing. Then create a watery mix of about ¼ black to ¾ quin gold. This should be really watery.

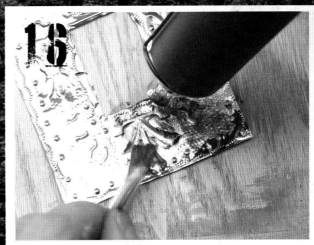

With your paint mixed and ready to go, start by heating up your embossed metal to about a hundred-trillion-million degrees (or, at least, very hot) using a heat gun. Then start adding paint.

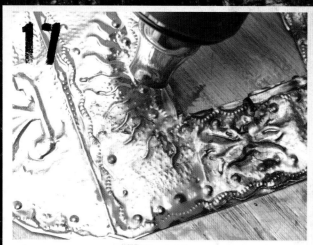

17

Continue applying heat and basically cook the paint onto the surface of the metal.

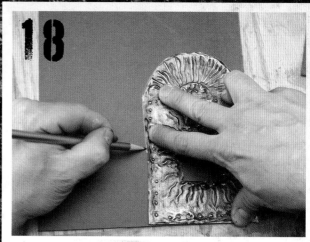

18

With the embossing complete, it's time to build the rest of your nicho. Take your finished piece of embossed metal—one that you are happy with, even if it took you a bazillion attempts to make something you liked—and trace it onto a piece of Masonite.

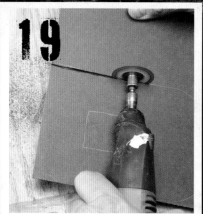

19

Using a wood cutoff wheel and a Dremel, cut out the shape.

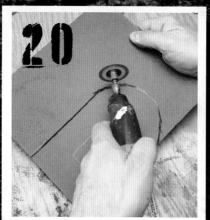

20

Carefully cut around any curved or notched areas.

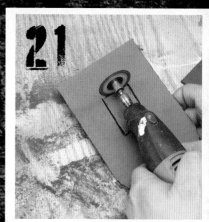

21

Cut out the window too.

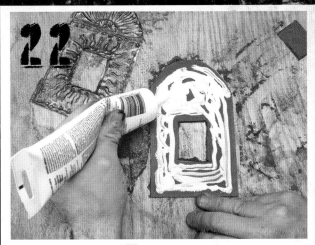

Apply caulk over the surface of the Masonite.

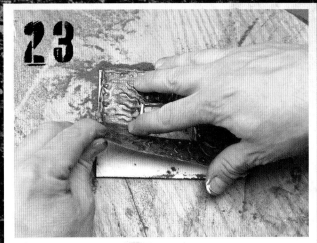

Lightly press the metal onto the Masonite.

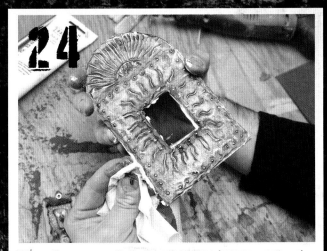

Wipe off excess caulk that oozes out, using a paper towel.

Now you can create a little scene inside of a matchbox, which will show behind the window. I start by lining the box with some found paper, a couple scraps of muslin and some paper along the edges.

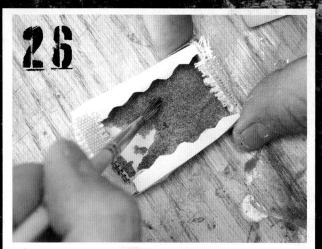

26

I then painted the paper to age it a bit.

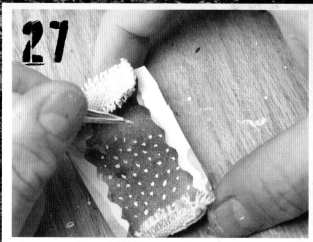

27

Now, I'm adding some dot details to create a backdrop of sorts.

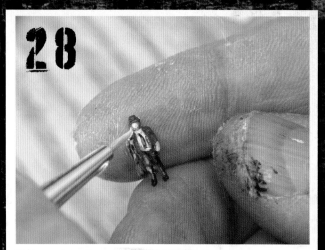

28

Little model railroad people make fun subjects for these little story boxes. Typically, they come painted or unpainted. I like to paint my own, but if you want to spend a few extra bucks and save your eyes, you can splurge and buy them already done.

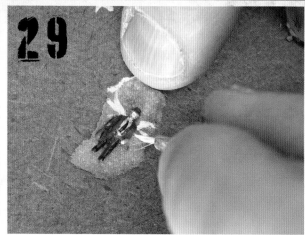

29

Here, I have glued a little man onto paper and am adding wings with paint and a detail brush.

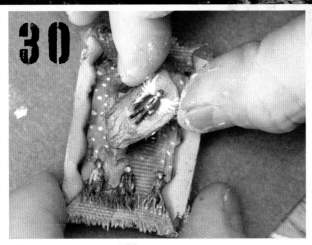

30

After adding a few other little people, I glued the angel man into the scene.

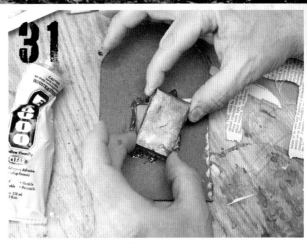

31

When you have your own story box to the point you are happy with it, it's time to glue it behind your nicho's window. I start the attaching process by putting a small dot of glue on the back of the nicho, in each of the window's four corners. Then set the box in place.

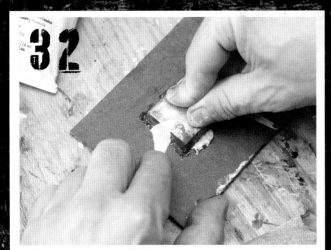

32

Then secure the box in place with some masking tape.

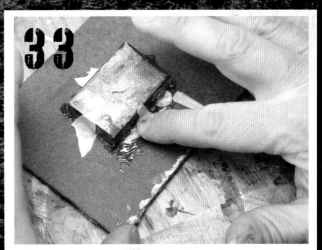

33

Finally, apply a bead of glue around the perimeter of the box and spread it with your finger to work it into the edge of the box for good adhesion. Leave the box to cure.

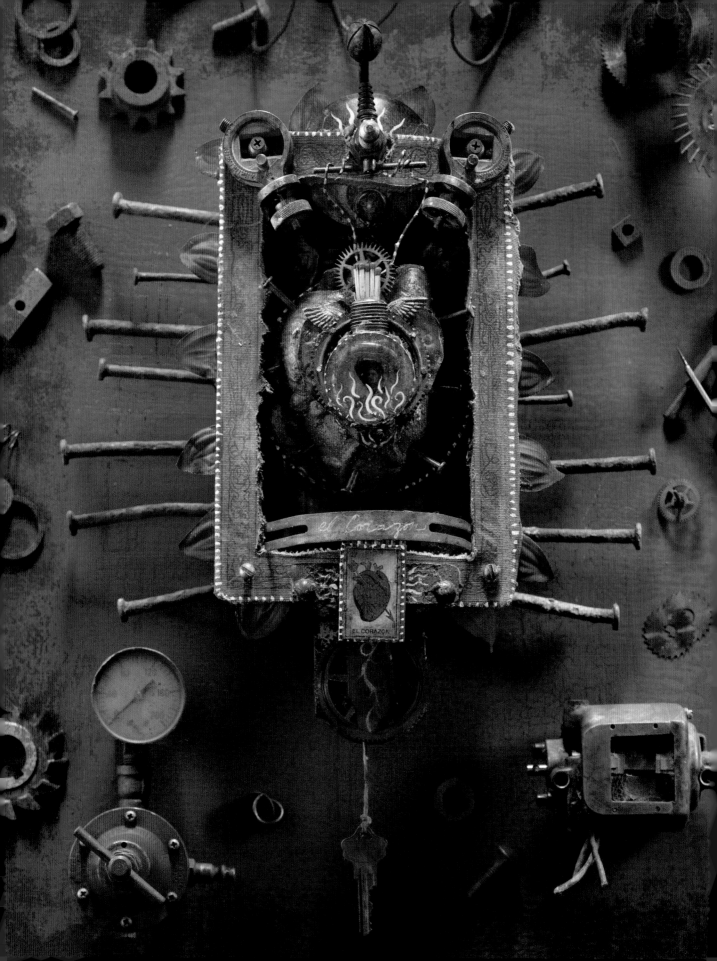

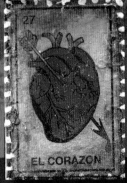

El Corazón

I have often said that Mexicans have a lot of heart. They are kind and generous people. Of course, it can also be said that their culture *literally* has a lot of heart. Everywhere you turn in Mexico you see an image of el Corazón—the heart.

It is an image common in the Catholic tradition and not necessarily limited to Mexico, but one cannot help but see the statues of Jesus or Mary with bright candy-apple-red hearts. These statues are dramatic as well as iconic. Some have rays emanating from them and usually flames coming from the top. Another interesting feature is that they typically have thorns encircling the center of the heart; I've even seen some Mary depictions that have roses instead of thorns. Often, a small sword or lance pierces the heart, symbolizing Christ's wounds during the crucifixion. These are called Sacred Hearts. Another common representation is that of the heart of Mary, and although very similar, its difference is that the sacred organ is pierced by seven swords, or seven arrows, representing her seven sorrows.

I'm a sucker for high drama/maximum impact. I love the visual power of these symbols. Many pieces of this type of art depict the fiery, wounded heart alone without the figure—which, of course, is also popular in the tattoo world. One thing I started noticing though, was that the depiction of the heart in Mexico can be a bit different. Once in awhile you'll see versions that are more anatomically correct, perhaps not always accurate to the degree an anatomy book might display, but still, veins, arteries, etc. You definitely see this in Milagros. I wondered if this came from the Loteria card "el Corazón" or if there is another reason that dates even further back.

It is not uncommon to see a naturalistic version of the human heart in pre-Columbian art. Interestingly enough, it's been asserted that the very first artistic representation of an anatomically correct human heart (versus the Valentine version) was on a ceramic vessel created by the Olmecs—the first complex civilization in Mexico, dated 3000 B.C. Like the Mayans and the Aztecs, it is suspected that the Olmecs were involved in human sacrifice, which would give them some . . . shall we say . . . insight on the structure of the organ.

On a more contemporary level, there is always Frida. I have always loved her painting *The Two Fridas*. It has two depictions of Frida sitting side by side, each with the heart revealed; on one side the heart is exposed yet whole, on the other side it is exposed yet severed, broken. It is a piece that was produced at the time of her divorce with Diego Rivera. The two Fridas represent the Frida that Diego still loved, and the other, the unloved Frida.

It is because of this painting that I learned to love hearts. I always had a tough time with Valentine's-Day-ish designs—they just weren't me—too upbeat for my taste. On the other hand, prior to seeing this painting, the heart as an organ was just that, an organ. It might as well have been a spleen or a kidney—nothing evocative there. After coming across this painting, however, all bets were off. Suddenly, I was able to see a version of el Corazón that was not "sweetness and light," yet not just flesh and gore either. Frida's version had something powerful and otherworldly behind it. Interestingly enough, *The Two Fridas* is what made me look a little closer at the Sacred Heart, as well as the Heart of the Seven Sorrows. Both styles showed the wounds of humanity yet exhibited the mysteries of the heart beyond the physical.

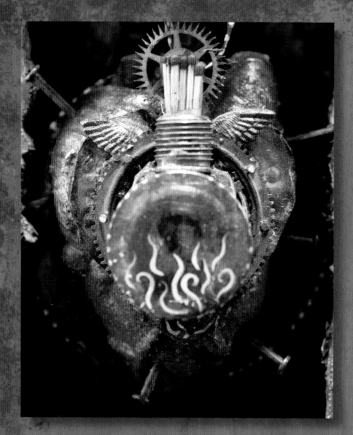

Process

Mold

I've tried to cast things from molds. I've tried to make things from molds. I've really, really tried. It would be so easy to replace the irreplaceable if only I could make a decent one. In all my years I've yet to make one worth a centavo. Something always seems to get screwed up in the end. My lack of patience has something to do with this, I'm sure. I bring this up because a number of years back I wanted to make a bunch of hearts, so I ordered a Halloween Jell-O mold of an anatomically correct version of the organ. My plan was to make it out of resin. Well, along the way, the resin was mixed wrong and all I got was a gooey yuck. Instead of the try-try-again approach, I cleaned out the mold and decided to abandon the idea of mold casting. I'm sure I could have figured it out, but sometimes the timing has to be right to want to learn. Besides, I hate resin, so that put me off to begin with, and the mold screw-up was icing on the cake. But the truth is, no matter what type of material I'm using, when it comes to creating things from molds, in the end it just gets screwed up.

In the case of the Jell-O mold, the internal mold casting part was ruined, but the external portion of the mold (which looked exactly as I wanted my resin hearts to turn out) remained unscathed. So I put it aside for a day when I might use the mold itself for something. That day came when I found myself singing, "If I only had a heart" And so this piece began.

Nails

I've mentioned before how little things are often donated to me for the perpetuation of my art-making endeavors. A couple of years back, I was teaching a workshop in Helena, Montana, and one of my students brought every rusty item that must have occupied her barn. It must have taken her five or six trips to her truck to bring in her supplies. Gloriously rusted things laid out on an enormous tarp swallowed up the entire entryway. Nice thing was that she was sharing her goodies with everyone. Of course, I knew the ploy; this is one way to clean out your space. At the end of the day, she handed me a large bucket filled with large nails, horseshoes and railroad spikes. At the time, I had no idea what I'd do with all these bits, but . . . I never turn down a gift.

It may not seem usable at the moment, but man oh man the things I've used that I never thought I'd have a use for—I could write a book. Hmmm.

Of course, I used the nails from that donation on this piece —with a vengeance, not only in the heart, but also in creating a nice nail-y halo around the box that housed the heart. Really forces the viewer right into the center.

Weirdo Lens

I can't, for the life of me, remember where I got this lens kit. It had all these different colored lenses for, what I assume to be, camera or stage lighting. They had been sitting in their little leather box for years, gathering dust. I opened it and played with them, checking out all the cool effects. Some merely tinted, others blurred or obscured. Many had the strange effect of appearing one way at a certain angle and a very different way when you moved. I ended up finding a nice blue lens that had that effect. It seemed yellow when blocking external light and zingy blue when reflecting. In a way, it reminded me of lenticulars (i.e., those little religious cards that change depending on the angle you look at them: it's Jesus . . . it's Mary . . . it's Jesus . . . it's Mary). Actually, I really, really wanted the cover of this book to be a lenticular. Better still, a lenticular artist photo—it's me . . . it's a skeleton . . . it's me . . . it's a skeleton. Cool idea, huh? Unfortunately, it was a bit pricey. I'll get over it. In the meantime, I have my weirdo lens over the Madonna.

Flower Petals

Time and time again I mention that I hate fake flowers and time and time again I end up using them in a piece. In this case, I used them because I wanted to soften all the harsh elements—in particular, the nails. It is the Madonna, after all, so I needed to balance the pain with a bit of softness and gentleness. The red petals did this nicely—growth and life counteracting decay and destruction. Now if only I could find a way to use real flowers and plants in art, then I could get over my fake plant issues. I know, I know, I could use real plants, but I'd have to water them and then there would be the issue of shipping . . . yeah, like that would work in the middle of winter. For now, fake petals. At least they look good.

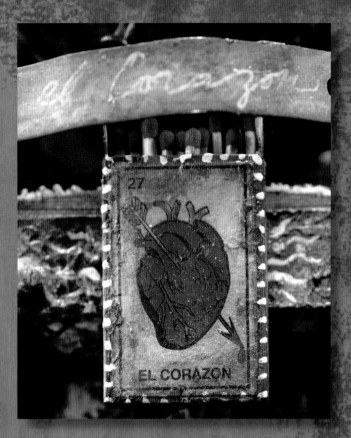

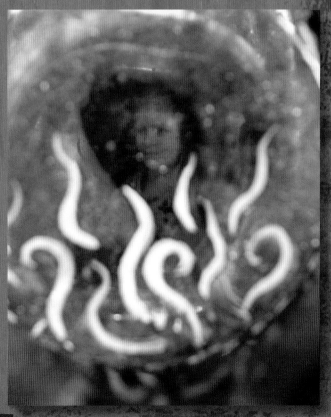

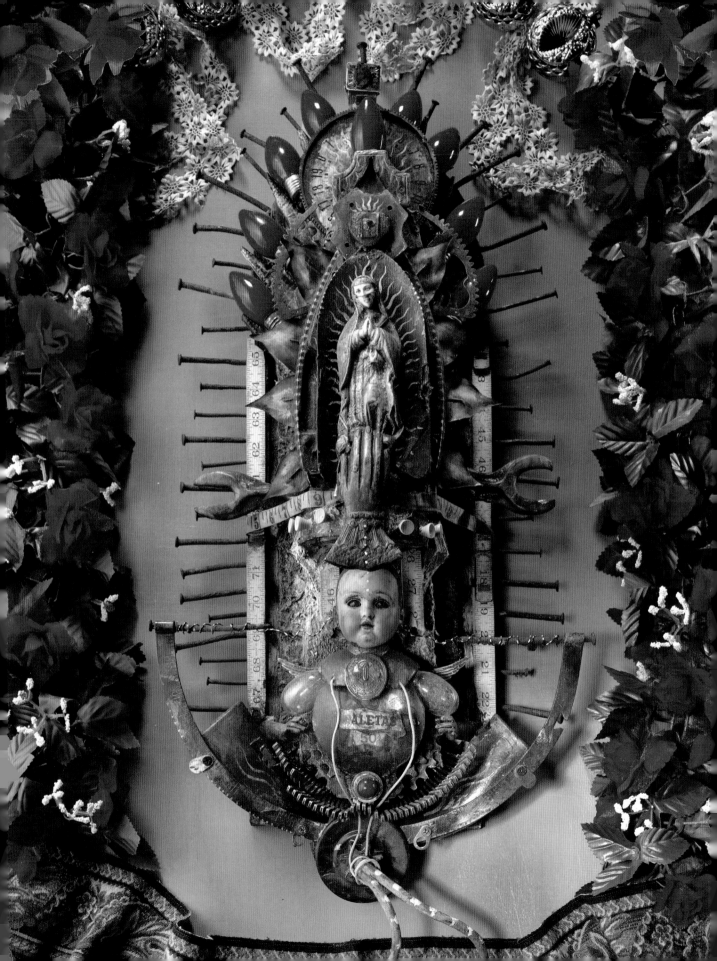

Our Lady

"In Guad We Trust." That's what my friend Lena Bartula's bumper sticker reads, referring to The Virgin of Guadalupe—an incarnation of the Virgin Mary and a local pop cultural as well as religious icon.

So who was this Madonna of the Americas? On a Saturday, December morning in 1531, a lonely and indigenous Mexican named Juan Diego was wandering near the hill of Tepeyac, when he suddenly beheld an amazing sight: a vision of an Aztec princess who proceeded to speak to him in his native tongue of Nahuatl (an Aztec dialect). The princess told the star-struck man to build an abbey on this site. Juan Diego was one of the first indigenous Mexicans to convert to Christianity, so he deduced that this woman was none other than the Virgin Mary. He quickly rushed off to tell the Bishop of his vision, and, as one would expect, the Bishop was left a bit unimpressed with Diego's tale, insisting on some sort of evidence to prove the miracle. Despondent, Juan Diego returned to the hill, now covered in snow. Once again, the Virgin appeared, and he explained to her his dilemma. Roses miraculously began blooming through the snowy ground, and the Virgin instructed Diego to gather them up in his cloak as proof of her appearance. On returning to the Bishop, Diego unwrapped his miraculous collection, and the roses fell to the ground. They were both amazed when they saw that the cloth which held these snow-grown flowers was magically emblazoned with the Virgin's image—and in color. Needless to say, a shrine sprang up in her honor in no time.

Whether you believe the tale or not, what is certain is that the Virgin of Guadalupe is an extremely powerful icon. She is unmistakable: her subtle, gentle lean to the left, her cloak of stars, the angel at her feet that seems to lift her to the sky, and, of course, the amazing rays that seem to emanate from her form.

This is going to sound odd, but my artistic interest in Our Lady actually began with a kiwi. My friend Lena had a nice little (actually not so little) shrine to the Virgin in her home. On the day that I laid eyes on this shrine, I saw that at the foot of the Virgin she had placed a kiwi that had been cut in half. Holy Guacamole! A lightning bolt hit me. I noticed that the rays surrounding the Mesoamerican Madonna were identical to the pattern formulated by the kiwi seeds. In a way I felt a bit like Juan Diego—as if she appeared to me. Weird.

Since that time, I have pondered the idea of how to address this cultural icon in a piece of art. She is pretty intriguing in that she resonates on so many different levels, not only as a religious symbol but as an icon of Mexican culture, an icon for femininity, an icon for the indigenous Mexican, as well as an icon for tattoo parlors (I have more than a few friends adorned with her image). In fact, other than the flag of Mexico, I can't imagine any image that

evokes the culture more than she. She is the beauty, the tragedy, the land, the revolutions, the taxicab dashboards. She is Mexico.

There is something about this particular Mary that Carl Jung, the maestro of archetypes, would love. She evokes something primal and ancient. Personally, I think it's all about those rays. Of course, this resonates with me; it's not like those forms are foreign to my work. For me, they are the symbols of creation: the rays of the sun, the sperm to the egg. Of course, they may resonate to the Mexican people because they seem to reference the cactus needles, or perhaps the leaves of a maguey plant, growing from her form. Perhaps they are snakes. Many believe that this story resonated so profoundly with the indigenous Mexicans because the site of this supposed miracle was also the site where the pyramid of Tonantzin once stood. Tonantzin was the Aztec goddess of the earth, who is associated with what? Snakes. I personally like this theory—I like snakes.

The first time I remember consciously taking note of the Virgin of Guadalupe was during a trip to Oaxaca, the renowned Day of the Dead city. It was early morning and absolutely nothing was open (When I say "early morning," I mean about 8AM. Remember, in Mexico things take a little more time to get started, as it should be. I've tried to attempt this in the states but it seems like the peripheral American pace gets in the way.) I had my camera and was busy photographing some political graffiti when I saw an interesting building that was stucco and very brightly painted—bright pink. The door was little more than some dusty vertical planks. I tried to peek through a dusty window but all I could get was a bit of vibrant color; the objects were a bit hazy. I started to walk off and the planks rattled open. An older man said "Señor? Por favor." And he gestured toward the inside of his store.

Inside, I was able to see the source of the colorful

glow—a bazillion brightly painted Oaxacan wood carvings. I loved these things. I was familiar with the strangely designed animal forms that come from this region, strange creatures covered in elaborate and mind-boggling designs. Perhaps the best way to describe them in American terms would be "far out" or "groovy." There also was a collection of carved devils, angels and people. In fact, high on one shelf, very discreetly displayed, was a strange-looking Madonna. It was carved on a curved piece of wood that seemed to be in the shape of a rhino tusk, which made the virgin lean toward the left. Beneath her was a little boy (or so I thought) holding her up. Her cloak was painted blue with a pattern of stars. I would have probably overlooked this piece had it not been for a bit of morning light that seemed to hit it perfectly with a golden glow. Something magical? Perhaps. Strange things like this seem to happen to me whenever I'm in Oaxaca. I ended up purchasing it, not really knowing the history or the reference. [As a strange side note, I was never able to find this place again. I wandered and wandered but it never revealed itself to me again. I might have doubted that the place ever existed if not for the fact I had the leaning Madonna in my hotel room.]

It's always difficult to work on art that is religiously inspired when you are not of that particular faith, or if you're like me and you are a "buffet" believer who takes a dollop of this and a smidgen of that. As an outsider, you could easily overlook a symbolic detail or put something in that doesn't belong. The way I reconcile this is that, as an artist, it is my job to interpret from my unique perspective; my job is to bring something fresh to the concept. So for me, I start with basic aesthetics: form and structure. One nice thing about the Guadalupe image is that it is very definitive. A standard Madonna form, but it has those rays emanating from it. I realize that this is key, otherwise it wouldn't be Our Lady of Guadalupe. That is the starting block.

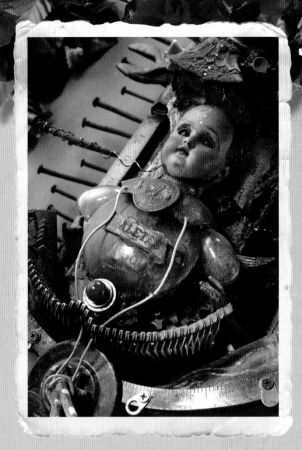
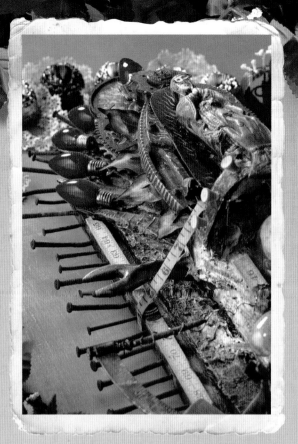
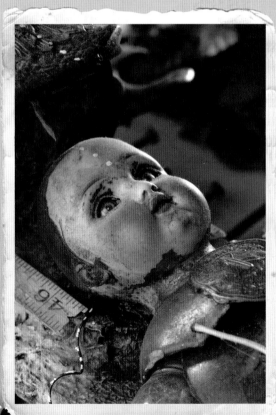
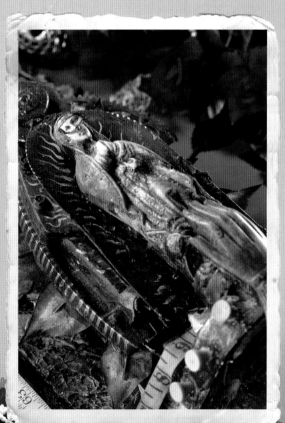

The Process

Before I began, I needed a few things. First, a form for the shrine. I decided to cut a piece of wood into an appropriate triangulated shriney shape and then I chunked it up with other goodies. Check.

I needed a Virgin . . . Let me rephrase that; I needed a statue of the Virgin of Guadalupe. Fortunately for me, Our Lady has become such a pop icon that I found her at Rockin' Rudy's—a local music/novelty gift store. They had plenty. Strange times we live in when it's easier to find religious icons in a record store than it is in the religious shops. Check.

The question now was, what about the angel? That was going to be a toughie. I thought I could probably find the standard "angel with wings coming out of its shoulders" at my local craft store, but that seemed a bit pre-fab. The previous week I was at a flea market. [As a side note, the term "flea market" came from the flea-infested clothing that would be sold at these places. This particular market did not have fleas.] I was wandering around and found a vendor with very little of interest—mostly '70s stuff (which isn't necessarily bad). But then I came across a small white cardboard box with "doll heads" written on the side in ballpoint pen. Inside there was nothing from the 1970s. Instead, it contained five or six ceramic doll heads with glass eyes; some with hair, some without. I don't usually buy dolls, but this was an intriguing find—not to mention a refreshing surprise. A week later, I decided that one of those babies would be my Madonna's cherub. Check.

So the basic forms were in my possession. I decided that the Virgin needed an extra bit of triangulation. I placed a small garden shovel/spade behind her form. [Shovels, by the way, hold a bit of nostalgia for me. My very first piece of assemblage incorporated a shovel as the central shrine form, because the shape was perfect for the concept.] I then decided to add another bit of shrinish dimension; I added an iron.

The dilemma of baby heads . . . I very seldom use doll heads because they are difficult to use without making them seem creepy. They are a bit disquieting to begin with, but then you add some of that deMengish-style painting and they can potentially become down-right nightmarish. I'm not sure where this unsettling attribute comes from. Perhaps it's because babies are supposed to be pure and clean, but when dolls are aged or broken they seem to evoke some unnatural, eerie feel of decay. Plus, like a mannequin, the eyes seem to stare blankly. Okay, okay, I know you're thinking: Why even bother using the little dude? Well, I knew that the odds seemed slim that I could resolve this, but I had to try. I had never used a doll head before and it was a huge challenge to transform it so that it wasn't too cute yet not too icky. I attached him. One thing I realized was working in my favor was that Mexican culture is no stranger to using babies in religious art. There are plenty of old, paint-flaking statues and icons of baby-faced cherubs. I quickly realized that I needed to treat the doll in a manner consistent with those classical Latin forms. The key is to not use shades that are too cool; stay away from the blues. I found that by keeping the tone warm, even sooty, I could reduce the creep factor. [By the way, one of the reasons that the interior of churches get so dark and sooty—which I love—is that they deal with years of burning candles and oil lamps.]

La Virgin seems to hover somewhere between pop culture and the ancient/sacred realms. She's onT-shirts and tote bags yet fills churches and prayer cards. I'm not sure how many arms, backs, necks and chests bear her tattooed image, but I would guess, based on friends and episodes of *Miami Ink*, it's in the oodles. I needed to find a way to add a bit of pop culture, kitsch, and color to the piece. I tend to be a bit hesitant with my use of vibrant colors, which is not consistent with the traditions in Mexican art.

It was time to shake the piece up a bit and go somewhat out of my comfort zone. Some fake leaves—bright green, and some Christmas-tree lights—bright red. In combo, I envisioned them as the radiating rays coming from the Madonna. I came across some old burnt-out bulbs (those big pear-shaped ones) at a garage sale. The color was sooo very red. They seemed to glow without even being lit up. Of course, to really add the kitsch element I would have to also add some working bulbs for effect, but I'd worry about that later. For now, I needed to add a bit of zing to the red. The best way to do this was to add a complementary color—in this case, green. Let me say this: green and red can be a dangerous combo. If not used carefully, you have Santa's Workshop in no time. The movie *Amelie* (if you haven't seen it, run out and get it right now) uses these colors amazingly well. I must have watched the film about seventeen times to figure out how to effectively use this color combo, and what I have to report is that it is all about using the color yellow. By keeping your greens a bit yellowish, like Chartreuse, you can avoid the Christmas effect. So a bit of yellow to the leaves helps—a ton.

After I had everything more or less finished, a few days passed, and I was left wanting. I am constantly asked how I know a piece is done. Well, the truth is that I know when it's done when it stops annoying me. I thought the Guadalupe piece was done but something was nagging me. I decided it was the rays. The leaves and bulbs weren't enough. You would think they were plenty, but I needed something that contrasted with them in style and age. I decided to place a halo of honkin' rusty nails around the entire piece. It did exactly as I had hoped it would. It managed to frame in the entire piece and helped contain those kitschy reds and greens.

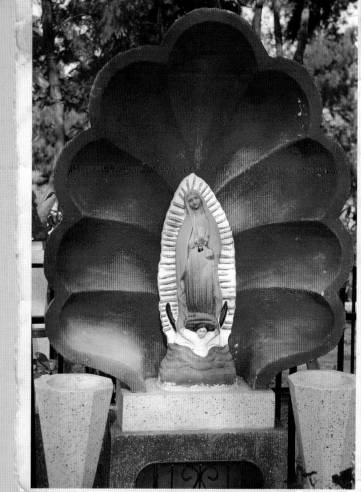

Photo: Connie Cox

One thing about Mexican art is that it's all about balancing old and new. From a gringo's perspective, Mexico's uniqueness comes from balancing opposites: glitter and rust, despair and compassion, blight and splendor. All are present in this culture, and perhaps what fascinates me is how the light is much brighter when compared to the shade. This is Mexico, a candle—not a fluorescent light, perhaps not as efficient, but because of its imperfections, it is spectacular.

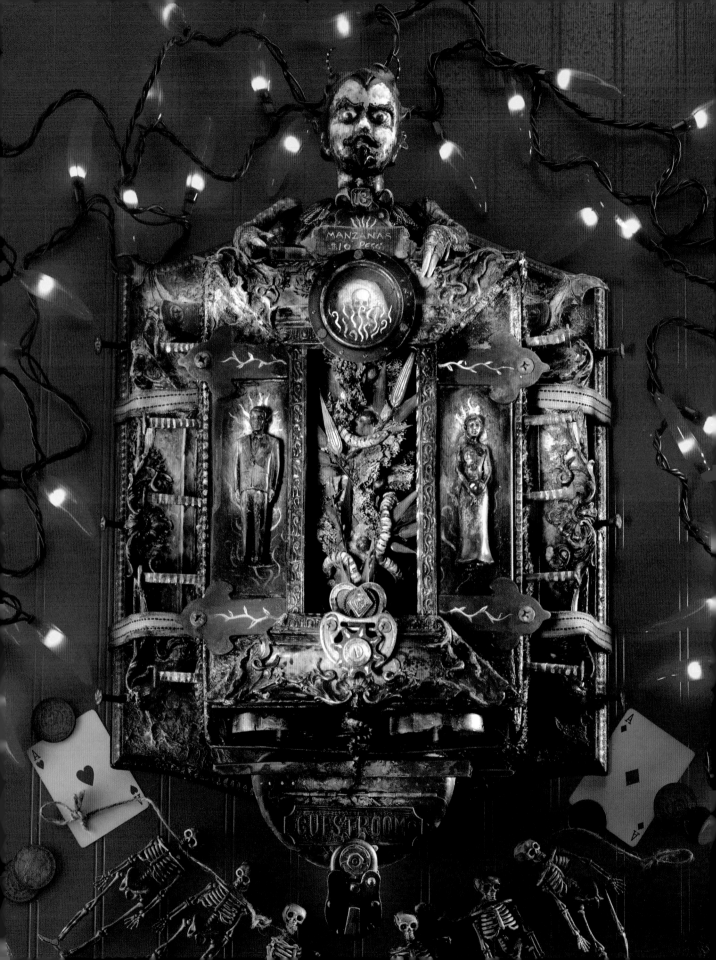

EL DIABLO

My numerous trips to Mexico have forced me to reevaluate the devil. Oh sure, I think he's a bad dude, but he's perceived differently in the United States than he is south-of-the-border. At home, he's things like the Exorcist, Damien, Rosemary's Baby . . . sort of a sadistic mastermind who's out to get you—and often in a really gross sort of way. Did you ever see Robert Blake as the devil in *Lost Highway* with his shaved eyebrows? That is the creepy American devil. I get a different sense in Mexico. My sense is that the Mexican devil (el Diablo) seems a little less serious and not nearly as foreboding. When you see him in folk art he is usually drinking, hanging out with prostitutes, dancing and drinking some more He is less of an evil genius and much more of a guy looking for a good time. He reminds me of the guy you knew in college who had plenty of vices but wasn't quite content until he got you to go along with his reindeer games. You know, the guy who tries to convince you that it's a good idea to streak past the *Today Show* window as Matt Lauer interviews Tom Cruise. One difference between el Diablo and the U.S. version is that usually the Mexican devil is better dressed—a tux, sometimes red, sometimes black—and has a pointy little beard and an exaggerated widow's peak. (I've often wondered if el Diablo is depicted with that Cortés/Conquistador look out of bitterness toward Spanish conquests or if it's sheer coincidence.)

El Diablo—the trickster, the troublemaker. Mothers, keep your daughters locked up! There are various stories about young women who disobey their madres and head to a dance. As one story goes, a girl is asked to a dance by a well-dressed stranger. He is handsome and charming and when they hit the dance floor, they dance the night away like Uma and Travolta. All good things come to an end and, at the stroke of midnight, when the exhausted woman looks down, she sees that the man she's been dancing with is barefoot. No big deal, except that one foot is cloven and the other is that of a chicken (sort of a mutant Cinderella situation). Some versions of this tale say that the girl "poofed" into flames, while in others she is left with a smoldering, sulphuric-smelling wound where the devil had his hand on her back or shoulder. The moral of the

story: Always listen to your mother—or stay away from barefoot men—especially if their feet are nonhuman.

A number of years back—long before I was into all this found-object, assemblage stuff—I was in a little Oaxacan gallery called La Mano Mágica. This place always had some really wonderful contemporary and folk art. On this trip I was doing a bit of holiday shopping, and as I perused a nice collection of Dias de los Muertos items, I came across a little sardine can. This little can was not filled with fish but rather featured a print of the famous painting of Adam and Eve by Lucas Cranach, cut from a magazine or book. (Those fans of *Desperate Housewives* will recognize this painting from the opening credits.) Attached to the front rim was a little hand-painted devil on mat board, cut out and giving the impression of a theater maquette. He was reclined comfortably in a chair and at his feet (yes, one cloven, one poultry) was a barrel of little clay apples with a sign reading "Manzanas (apples) 1 peso." I found this to be so amusing I bought it on the spot.

It is strange what influences you as an artist and what doesn't. This quirky little item totally changed the direction of my art. Prior to this purchase I had been a painter who incorporated bits of collage into his two-dimensional works. This little guy made me want to jump into three-dimensional art. I noticed how a little depth made this simple concept so engaging. I have a saying in my classes: Never underestimate the third dimension. What I mean by this is that the smallest amount of depth can add intrigue because it allows the piece to shift and change as the viewer moves in relationship to it. (Which still makes me wonder why 3-D movies never really caught on.) The strange thing is that I had seen assemblage throughout my life, but it was the devil that really made me do it.

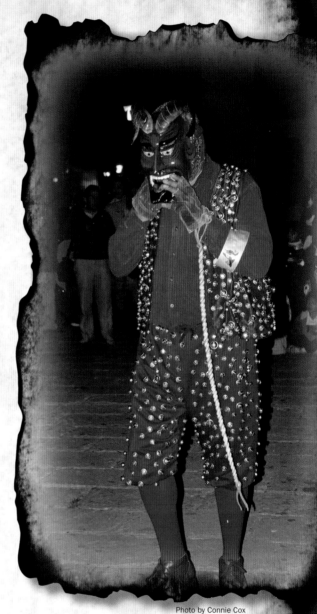

Photo by Connie Cox

The Process

As an homage to this experience, I wanted to create my rendition of that apple-selling Diablo. Originally, I thought of using a sardine can, but I really wanted it to be more grandiose. What I envisioned was a little theatrical scene—larger and a bit more dramatic. First thing I did was look around the studio to see if I had anything that might house my little vignette—always a crapshoot in my studio. Sometimes I luck out and have just the right thing, sometimes I have to hit the road to hunt things down. As it turns out, I had just the thing—the perfect thing in fact—an old wooden floor sweeper. It was one of those devices that had the brush in the middle, and as you rolled it across the floor, the brush would spin and clean the floor. Well, what really caught my attention was the brush in the center of the device. I started thinking how easy it would be to transform that into the Tree of Knowledge of Good and Evil. I could trim down the brush at the bottom for the trunk and add some fruit, perhaps some extra leaves, and, of course, a serpent wrapped around it.

I happen to have various bride figurines as well as groom figurines in my collection of stuff. Who doesn't have multiple versions of the happy couple lying about? For this project, I would have preferred a nude couple, but unfortunately I haven't had any friends married at one of the Club Hedonism Resorts, so I settled for a clothed "Adam and Eve." Of course, what I was really concerned with was the Diablo. He was to be the star of the piece. A little serpent wasn't enough. One thing that popped into my mind was a coin-operated fortune-telling machine. I envisioned a torso of the Devil lurking above like in one of those old devices. Or I needed a ventriloquist dummy. That was about the size that would work.

As it turned out, I didn't have a Charlie McCarthy doll lying about, so off to the Montana Antique Mall I went. I walked in the door and Carla said, "OK, what weird thing are you looking for today?" You see, when I come here, the first thing that I typically say is something like, "I'm looking for something that looks like squid legs" or "Do you have any Dwight D. Eisenhower busts?" So Carla is used to my bizarre shopping requests, and she is pretty good at locating something, among the four floors of antiques in that mall, for me to work with. On this day, I told her that I was making a devil and she took me to a couple of Punch and Judy puppets. I considered them, but they weren't quite what I was looking for. I decided to go hunting on my own—floor after floor. There were possibilities, but nothing that said, "I'm just what you're looking for!" The last floor I perused was the main floor. I typically save this floor as a last resort because it is the most expensive, and when your intention is to rip apart or transform something, it's hard to justify spending tons of cabbage. But hey, I was desperate.

Finally, I came across something that looked like it might be the ticket—a cherubic-looking ceramic bust with a slight rococo flair (if I may be a bit showy with my terminology). The face reminded me of William Blake's version of Lucifer, where he is portrayed as a beautiful angel (albeit fallen), and I decided it would be great fun to

transform this innocent-looking thing into something sinister. The only problem was that I couldn't see a price because it was in a locked display case.

I hate a locked case. It requires calling someone over to open it, and then if the price is not to my liking, I have to pretend that it's some defect in the item and not expense that changed my mind. Usually, before I call someone over, I exhaustively look for a price tag. Glass shelves can be a big help in these situations, assuming the price is on the bottom of the object. Another decent scenario—a good ol' mirrored case if the price is on the back; a bit of backward reading and you're golden.

With Carla I don't have to put on the false pretense bit. So I called her over. She gave me sort of a funny look which I deciphered as, "You have got to be kidding me; this is your idea of a devil?" Before she actually said the words, I said, "Trust me, this will be a devil by the time I get done with it." I wanted to add a mad scientist "bwaaa-haahaa" at the end of that sentence but I resisted.

When I got home, I plunked my little bust on the top of the piece. I used to always get a bit nervous when using porcelain or ceramic in a mixed-media piece because of its fragility. A slight shift could make something crack or break. What I found to be a solution is the Great Stuff Gap Filler. This is the stickiest stuff on the planet. (Seriously, I haven't found anything that it won't stick to.) It's an expanding foam that will fill in any space. For me, this means any space that might allow the piece to shift. Here, I planned to place a big bolt in the top of the sweeper and place the cherub's hollow bottom opening over that bolt, then fill it with Great Stuff. The idea was that the gooey, oozy, yucky stuff would stick to the interior of the ceramic piece as well as the bolt, then fill in the empty spaces. It's sort of like preparing a box to ship, where you try to make the contents fit as tightly as possible to eliminate any shifting. For good measure, I also wrapped some rebar wire around the bolt, so that the expanding foam would get into those nooks and crannies too and be just one more thing for the goo to hold on to. [Note: It is possible to add too much foam and have it expand everywhere—places that are undesirable—and sometimes even break the container.]

After the devil form was set, I promptly got some action-figure arms and attached them, but I decided that the regular old hands wouldn't do. I needed something more dramatic . . . like, say . . . armadillo claws! I just happened to have some in my stash—a present from my girlfriend, Judy. We were having a nice romantic dinner in Portland, Oregon, when she handed me a pretty little wrapped package—oh, how romantic. I opened it up, and inside the box were two little armadillo claws. The funny thing was that it was romantic. I suppose there is a reason that her pet name for me is Gomez (of the Addams Family).

What's a devil without horns? I needed horns. So, I pulled out another gift: Devil's Claw, also known as Proboscidea louisianica, Aphid Trap or Unicorn Plant. This is an amazing plant that looks more like a bug, or something from a Sci-Fi movie. A few years back, a woman named Mary sent me a bunch of them. What was killer about them was their arm-like appendages—sharp and horn-like—perfect for devil's horns.

Once the devil was figured out, the rest of the piece went pretty smoothly. I even added a couple of rubber batwings behind my devil. (This may have been because I was listening to the audiobook of *Dracula* as I made the piece.)

I did make a conscious effort to try to keep the colors fairly vibrant (well, vibrant for me, anyway): pink on Eve's side of the Tree of Life and blue on Adam's—I know, pretty stereotypical. One of the toughest colors for me is the color of plants. I don't really use much of this color green, but I needed it in this piece not only for the tree but for the snake too. This did turn out to be the hardest portion, but surprisingly, by adding the little red apples the process became easier. I have found that sometimes adding a complementary color gives you a better shot at controlling a color. In this case, red helped me get a handle on green.

The last thing I added was the little sign "Manzanas 10 pesos." Now, this was a little higher in price than the devil charged in the sardine-can inspiration, but remember, that was several years prior. Inflation, you know. Besides, this is no ordinary apple.

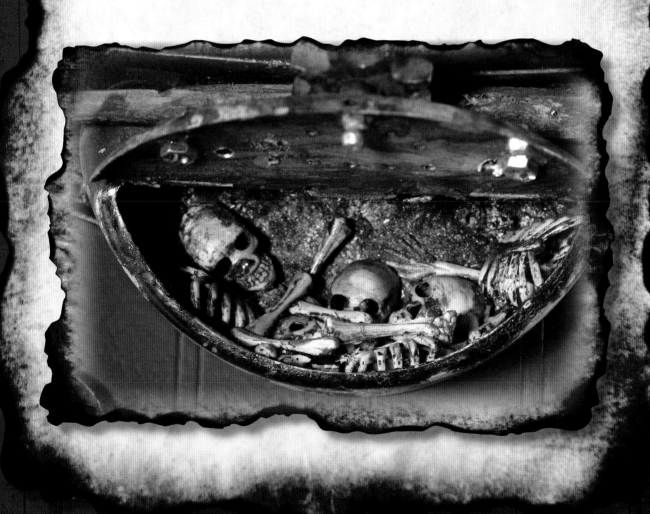

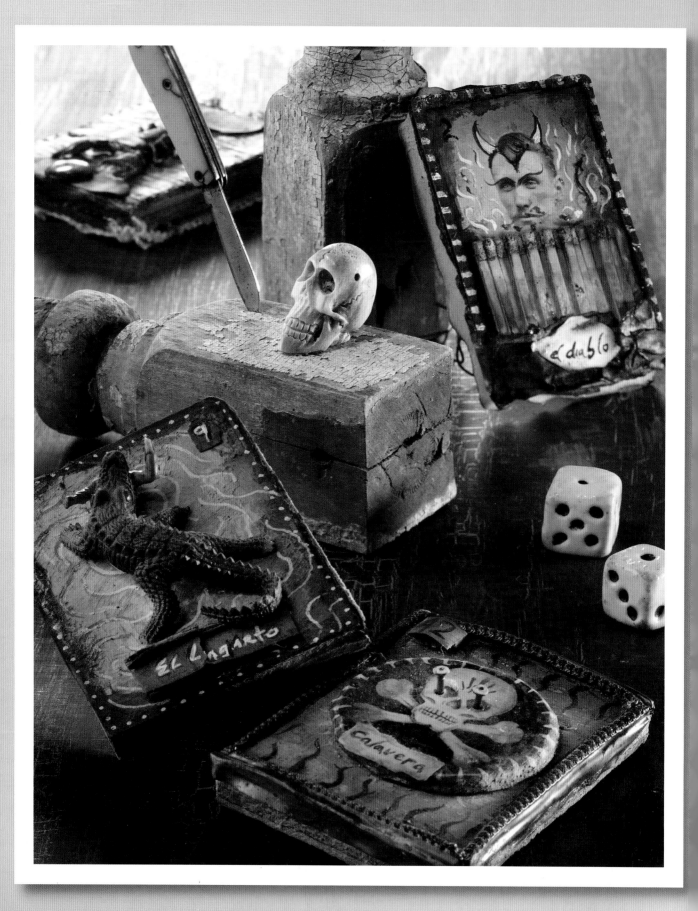

Loteria Cards

If you're like me, you may have had some misconceptions about the Mexican Loteria cards. Before I knew better, I always thought that they were some sort of divination tool, used similarly to tarot cards. It was only recently that I learned otherwise. For those who are unfamiliar with Loteria cards, they are colorful cards with various images on them, ranging from roosters to umbrellas to drunkards to devils to death. It is probably the latter two images mentioned that led me to my belief that they must be used in soothsaying. After all, the devil and death are cards in the tarot deck, and there is also a big Corazón (heart) card, which could easily be interpreted as the "lover" card. As it turned out, I was wrong, and I've yet to find anyone using the Loteria cards in such a way.

The primary use of these cards is for a game that is very similar to Bingo. Players are given a random sheet with a variety of random images arranged in a grid, four high by four wide, and instead of numbers on ping pong balls, cards are picked by a caller and particular image names are announced—at least that's one version. A more interesting way to play has the caller read a poem or a riddle hinting at the image, instead of coming right out and announcing it by name. For instance, the reader might say, "For the sun and the rain." This would indicate that the umbrella card had been drawn. Or for the moon card, "The lantern of lovers." It is my understanding that this game was once a common method of teaching children

language skills.

With this in mind, I've often thought how handy it might be to carry around a deck to assist when language poses a barrier. When you need something you would merely reach in and grab an appropriate card. If it is raining, you quickly show the vendor an umbrella card. Unfortunately, many of the Loteria cards do not correspond to typical needs for a tourist. It is not often that you need a cello, or mermaid, or cactus. Of course, you never know when you might need a good flag; I say this because I am reminded of a funny story involving my friend Steve when he and I were in Coyoacan. It was toward the end of a very nice excursion through Mexico, and he was in need of a restroom. Of course, the first thing you learn as a tourist is how to say, "Donde esta el baño?" (Where's the bathroom?) Steve sees a man sitting at a little table and he says to him, "Donde esta la banderas?" The little man looks at him quizzically, looks around, and then hesitantly points up. Steve looks up, sees a Mexican flag, and realized that he just asked where the flag was.

I'm picking on Steve, but the truth is that this type of thing has happened to me plenty of times. So how cool would it be to have a deck of Loteria cards for tourists: El Baño (bathroom), la Cuenta (the bill), Cerveza (beer), Sin Hielo (no ice), Imodium (Imodium). All you'd have to do is whip this deck out and show the card. Though, the more I think about it, I think the misunderstandings— embarrassing as they may be—are also a source of great memories and stories.

The Process

When I started making Loteria cards, the most important thing to me was that they have an element of playfulness to them; I didn't want them to be too dark. Sure, they're made by me, so they are going to be a little dark, but dark in a playful way? Or would that be playful in a dark way?

I started with just basic pieces of wood, cut to the dimensions of a playing card. From there it was easy. I merely picked a card and went with it. Mostly these were little bits of collage but, of course, how could I be playful without incorporating a few toys?

I do want to touch on the subject of toys. One thing I have noticed is that the more I use toys in workshops, the more adults stretch their creativity. I've seen students explode with inspiration while using childhood items, whereas, if using more formal approaches they may have frozen up. Adults want to play. I think that art is a form of play that has been sadly adulterated in some cases. But, when using things associated with childhood, adults are given permission to play and have fun without restriction. I highly recommend to anyone who is not feeling creative, or is feeling intimidated by doing art with a capital A, to grab some old toys and mess with them. Could be making little pieces of relief work, like my Loteria cards, or it could be dismantling and reassembling. I think what you'll find is that you'll shake those cobwebs off and be back in the days when monsters lived beneath your bed and your mind ran free, without fear of criticism.

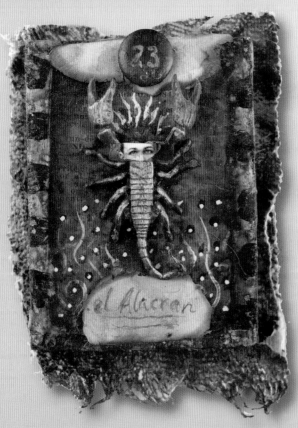

Highlighting Existing Images

So maybe you're not all that keen on chopping up blocks of wood to create your own Loteria cards. You could always alter an existing deck by painting over the cards and adding your own doodads. Here is a teeny bit to get you started.

Stuff You Need

- detail brush
- white acrylic paint
- Quinacridone Gold acrylic paint (Golden)
- Mars Black acrylic paint (Golden)

1. If you want to pop something from the background a bit, begin by using a detail brush and white paint and outline the figure or portion of the piece you want to draw attention to.

2. With a dry brush, graduate the white from the inside out to create a sort of supernatural glow.

3. When the glow is dry, yucky-it-up—the brightness of the white—with a wash of Uszhhh (see page 23).

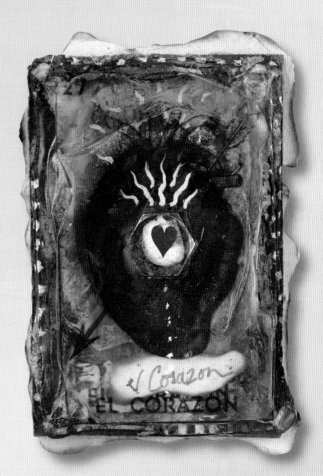

About the Gringo

MICHAEL DEMENG

Michael deMeng is an artist who traverses the globe teaching the methods of "assemblage" (using the French pronunciation, of course, as in awsome-blahzhuh). He enjoys taking things apart, going to flea markets and likes taking walks on rainy days (assuming rusty things are strewn about). When he is not teaching or making art he is usually busy trying to upgrade to business class. He lives in Missoula, Montana, but spends as much time as he can with his partner, Judy, making art and hanging in Sydney, Australia.

If you ever find yourself down in Southern Mexico, treat yourself to a tour by Juan Montes Lara. Not only is he knowlegable and funny but more importantly he speaks from his heart about the culture that he loves and desires to share. Worth every single peso.
jmonteslara@yahoo.com
951.515.7731

Discover more inspiration with these North Light titles

Altered Curiosities
Jane Ann Wynn

Discover a curious world of assemblage with projects that have a story to tell! As author Jane Wynn shares her unique approach to mixed-media art, you'll learn to alter, age and transform odd objects into novel new works of your own creation. Step-by-step instructions guide you in making delightfully different projects that go way beyond art for the wall—including jewelry, hair accessories, a keepsake box, a bird feeder and more—all accompanied by a story about the inspiration behind the project. Let *Altered Curiosities* inspire you to create a new world that's all your own.

ISBN 13 978-1-58180-972-5 | ISBN 10 1-58180-972-7
paperback | 128 pages | Z0758

Objects of Reflection
Annie Lockhart

Objects of Reflection embodies visual journaling disguised in the form of dimensional assemblage by creating art that is so personal it resembles a page from the artist's journal. Inspiration pours from every page of the book through a gallery of projects designed by the author. In addition, over 20 step-by-step techniques include tips for attaching elements with simple materials like string, wire and tape; aging objects; adding texture with modeling paste, and more. You'll learn how to tell your own stories through your art as you turn symbolic objects into your "words."

ISBN 13 978-1-60061-331-9 | ISBN 10 1-60061-331-4
paperback | 128 pages | Z2974

Amulets and Talismans
Robert Dancik

This in-depth guide is almost two books in one. Not only will you receive the guidance and insight to create jewelry that is embedded with personal meaning, but *Amulets and Talismans* also features extensive instruction on a wide variety of cold-connection techniques that can be applied to any style of jewelry making. Incorporate found objects, personal mementos and more into one-of-a-kind pieces of art.

ISBN 13 978-1-60061-161-2 | ISBN 10 1-60061-161-3
flexibind with flaps | 144 pages | Z2510

These and other fine F+W Media titles are available from your local craft retailer, bookstore or online supplier, or visit our website at www.mycraftivitystore.com.